# *The*
# TEXAS RANCH SISTERHOOD

*Portraits of Women Working the Land*

*Alyssa Banta*

## ALYSSA BANTA

Special thanks to Sterry Butcher, Editor
Alyssa Coppelman, Photo Editor
Anna Barzin, Researcher

THE
History
PRESS

Published by The History Press
Charleston, SC
www.historypress.com

*Front cover*: Rachel Mellard and her youngest son, Jacob, ride out.
All photographs are courtesy of the author.

First published 2019

Manufactured in the United States

ISBN 9781625858481

Library of Congress Control Number 2019942879

# CONTENTS

# INTRODUCTION

When I began this project in 2016, I had intended it to be a straightforward oral history, an ethnography of sorts, about several working women ranchers in Texas. I wanted to give the reader a look into life on a working ranch from a woman's perspective—candid photographs and text that would allow readers to lean closely into a world not usually seen. Most people think of ranchers or cowboys as being men, but ranch women work equally as hard and are under-chronicled and lesser-known in American culture. They work alongside their hired hands, their husbands, in-laws, parents, brothers and sisters. Sometimes they work alone. They cook supper and feed bulls. They are fierce and feminine and powerful, and I wanted the world to see them as I do. I had only hoped to create a document that would show what life on a Texas ranch, and the women who work on them, looks like at the start of the twenty-first century. I thought it might be organized by season.

But as this book was contracted, I was in the midst of some very big events in my own life that ultimately flavored every part of the project, including the way I photographed and wrote. Among other events, my father had died fairly recently and I was still very sore from his sudden absence, and my mother was ill. After starting the project, her health worsened, and she died about halfway through. I found myself highly introspective and in full-blown existential crisis. The actions of getting in the car, driving across the state and sinking into the hard, physical work of someone else's life—armed with curiosity and a camera—provided an emotional poultice that soothed. I drove more than thirteen thousand miles from my home in Fort Worth during the course of the project, looking for peace of mind as I photographed and interviewed these women.

The book, then, turned more personal. As a documentary photographer and writer, you can't make a good photograph without the events of that photograph passing through you. You can't write documentary-style assuming that what you're writing about is carrying on as though you weren't there. No matter how good a fly-on-the-wall you try to be, your mere presence changes—a little or a lot—everything around you. So it was, and early on, I became friends with these women. And as they opened up their lives to me, I opened up my life to them.

They were patient and generous with showing me how to help them, and I worked next to them and rode alongside them when I visited. I was there when they got married, sorted out finances, held the hand of their dying family members and wondered about their futures, living as so many of them do on hair-thin margins. And they were there too, calling me when my mother died and staying at my house when they came to Fort Worth, sending me hello texts when too much time went between visits. I soaked in their strength and grit; they inspired. I wanted their powerful and graceful selves around me. I needed to see ability, fragility and authenticity in action. And I wanted to be small in their natural world, a world that depends so much on good, quenching rains and hard freezes, a world that sparkles with starlight and gets very close to pitch black when there's no moon out, a world where the piquant smell of un-shorn sheep's wool lingers on your fingers, a world that quivers when hundreds of cattle are pushed through a pasture. These are Texas women ranchers, and this is how they live.

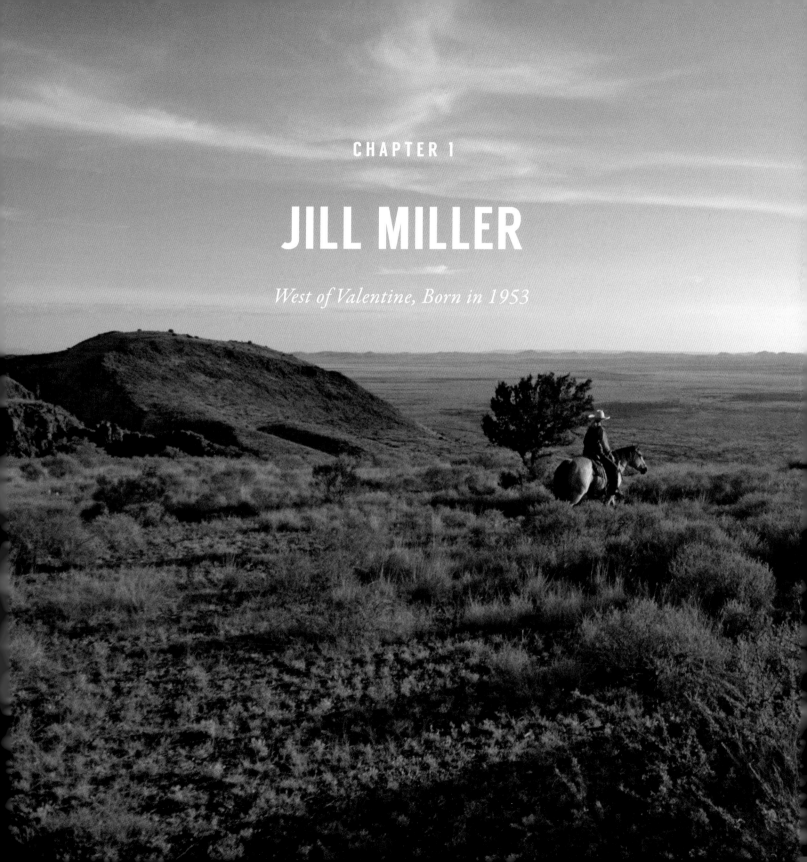

CHAPTER 1

# JILL MILLER

*West of Valentine, Born in 1953*

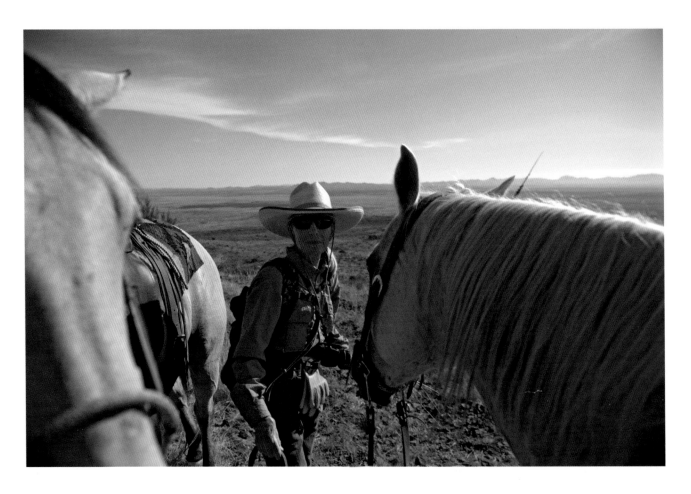

*Previous* After riding out to look for cattle, Jill waits for her husband, Bill; her brother-in-law, Albert; and their hand, Mario, to meet her at the top of this rise. Because there are so many possible places for cattle to hide—in the wide crevices between two mountains, in and among clumps of trees, behind brush and rock—the Millers must systematically gather the herd. In addition to moving them from one section to another to rotate pasture land, "we gather once a year to ship," Jill says.

*Above* Jill stands between two of her horses—a buckskin named Dulce, *left*, and Bujio, a grey. Dulce translates to "sweet" in Spanish, and the word *bujio* is the slightly changed pronunciation of the Spanish word for spark plug. Both quarter horses were born on the ranch and are veteran ranch horses—sure-footed in the rocky, rough terrain.

*Opposite* Jill, Bill, Albert and Mario move cattle off one of the Millers' mountains in the Sierra Vieja Mountains. Three ranch dogs, Belle and her sons Oso and Samuel—all border collies—help them. Looking down from the rimrock you see the ranch, a vast flat at the base of these mountains, and looking down from the other side, about ten miles away, you see the Mexican state of Chihuahua. "The drought lasted five years," Jill says, "and it just ended last year [2016]. When we were in drought, we could only sustain fifty-four head of cattle on all this land. We left the gates open so the cattle could move between pastures and eat what they could find."

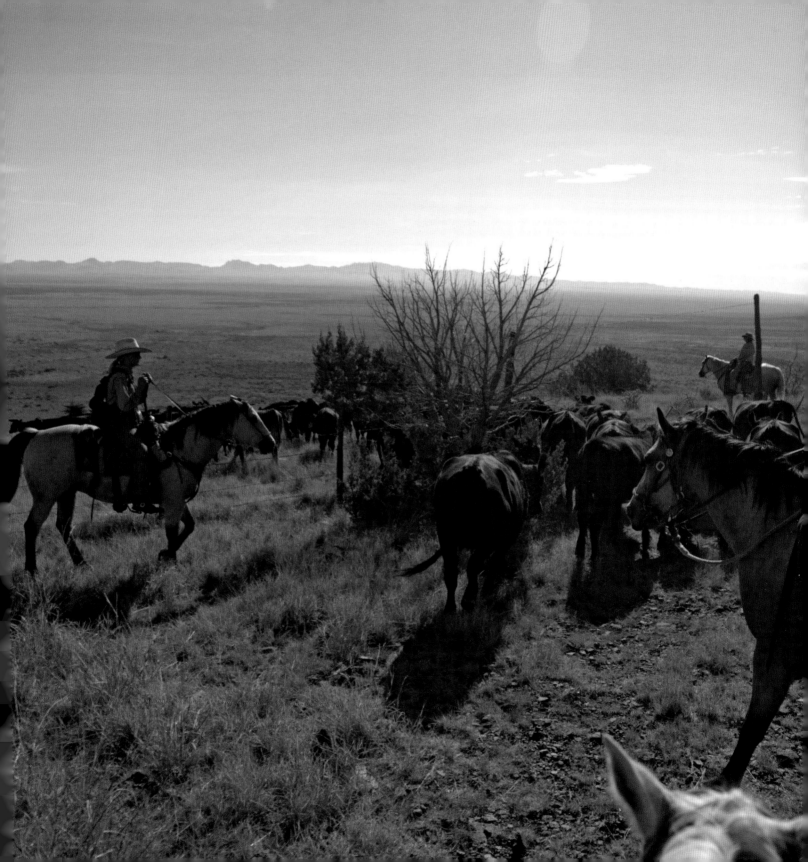

*Opposite, top*  After working for hours moving cattle out of this pasture, Jill ties the horses to the trailer until she's ready to load them.

   Bill's grandparents started the ranch in 1925, and Jill moved there with him in 2000 after teaching computer lab, reading and English to junior high schoolers in Van Horn for twenty-seven years. "The entire ranch is intact from the original," Jill says. "In fact, it was added to. Nobody's sold anything. The reason ranches are dying in Texas is all the heirs. We've got thirty-six heirs to this land. So far, it hasn't been split up and we've managed to keep it together. We're not expanding; if we can just hold onto this, that'll be something."

*Opposite, bottom*  Jill has photographed scenes of nature, landscapes and the wildlife she sees on the ranch since the early 2000s. She's often hired to take pictures at the Valentine school and document their sporting events. She also photographs team roping events in nearby towns.

*Above*  The troughs and tanks on the ranch are filled with water transported by fast pipe from a windmill in one of the Miller's pastures and by a solar-powered pump at the ZH Canyon. Metal bars over the troughs keep the cattle—and anything else—from breaking the float that controls the water level and ensure water isn't over pumped and wasted. "We do have the little ramp-ways in them so if baby quail or something else gets in, they can climb out," Jill says. "In the big tank, we have rocks stacked along one of the edges in case an animal jumps in, it can get out."

Jill picks a peach from the tree growing next to one of the water tanks on the ranch. In this drought-prone part of Texas, the peach survives on the dripping well water from a small hole in a supply line. The fruit is as big as a fist, pocked and damaged from birds and small mammals. Jill harvests all the fruit in the tree and leaves the most damaged ones on the ground. She brushes off the wasps from one and takes a bite.

*Opposite* After a day working cattle, Bujio drops to roll in the dust. Jill was raised in Lancaster, California, in the Mojave Desert. "My father was in the FBI," Jill says, "and he bought a house with two acres and bought me and my sister each a horse when I was in third grade. I named my horse Blaze. When I started showing horses, I had another horse called Sunny Morn, like the morning. I learned very young to ride and show." Her father moved the family to El Paso to be closer to relatives in 1967 when Jill was entering high school. She and Bill met when Jill was a junior counselor at the nearby Prude Ranch summer camp and he worked for his uncle in Fort Davis. "He would come out and check out the chickies," Jill says.

Jill photographs a hawk. She shows the best of her wildlife photography in area galleries. "Once in a while I'll have them at a farmers market," Jill says.

*Opposite, top* Horses and riders cool off in the shade of a juniper next to a water tank.

*Opposite, bottom* Jill's ranch dogs help gather and sort cattle. Jill and Bill have trained their three border collies to respond to work commands: "Watch 'em" means they need to make sure no cattle run off to the side; "come by" means travel clockwise; "away to me" means go counterclockwise; "on out" means the dog should move to the front of the moving cattle; and "look back" means the dog should turn around to see if any cattle have been left behind.

"So much of it is instinct, so much of it they have bred into them," Jill says. "It's really cool to see it turn on in a young dog. They are bred with that wanting to gather. Belle's basically deaf, and we're looking for another one."

Jill also has an Akbash, a breed typically used on ranches to stay with and protect goats. "Now that we've sold the goats, Curly's job is to guard the chickens and whatever's in the pens and, of course, us," Jill says.

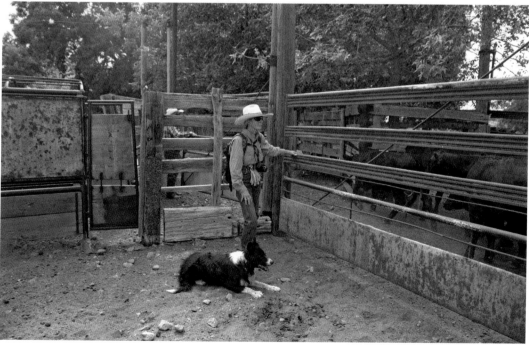

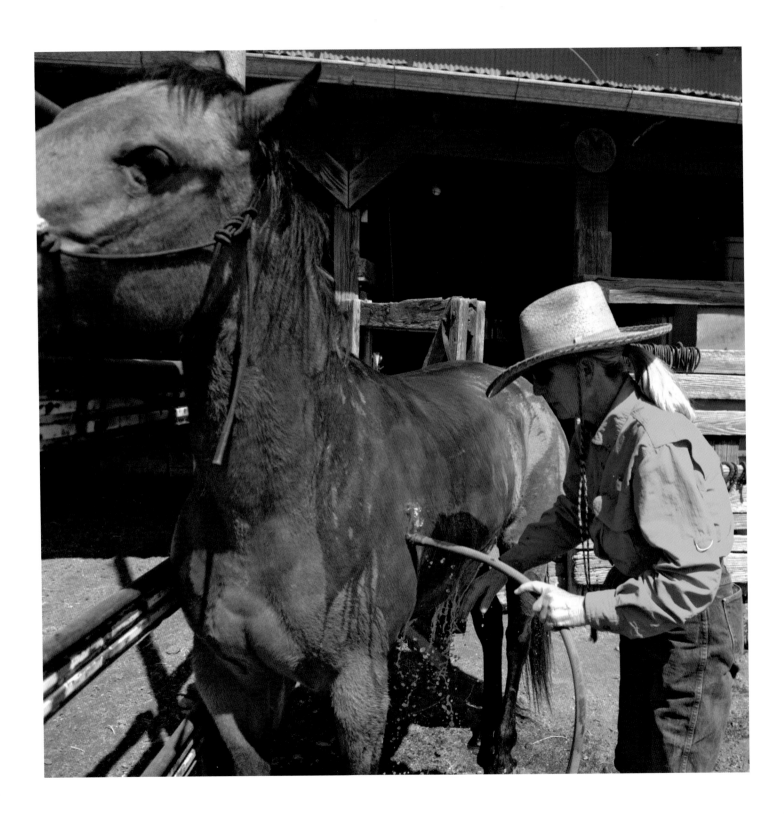

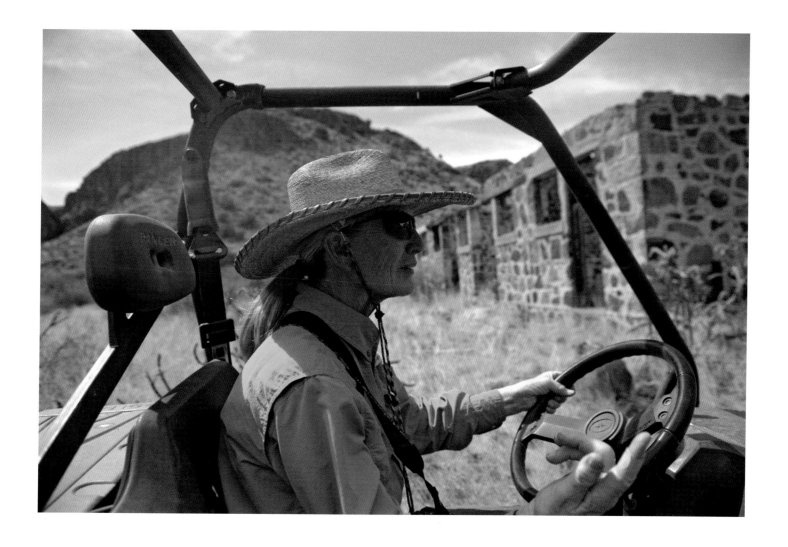

*Opposite*  After working, Jill runs water over Dulce before turning her out.

*Above*  Jill drives her four-wheeler to Camp Holland, a U.S. Army camp built in 1918 as a facility to house soldiers during the Mexican revolution. At that time, John Holland—who settled the land, developed the water and built the first house on it—owned the ranch. His brand was ZH. "The army never fully occupied it," Jill says, "and by the time they got it built, they didn't need it." In 1910, Mr. Holland sold the ranch to a Mr. Finley, and in 1922, the camp was declared government surplus and Mr. Finley bought it too. In 1925, Bill's grandfather Clay Epsy Miller bought the ranch and its original ranch house, which is still occupied by family. "It's been added to through the years," Jill says, "and there was a fire in the late '70s when most everything burned except part of the kitchen and the milk house."

# FAWN KIBBE

*Southwest of Alpine, Born in 1975*

Fawn and her husband, Justin, manage a ranch for owners who live on the other side of the state. "We've been married twenty-one years and have worked side by side for twenty-one years," Fawn says. She's recently purchased a building on the main street in Alpine, twenty miles away, and opened up a shop. Among more ordinary western-themed inventory, she sells items made by local craftsmen such as goat milk soap, big rustic furniture, decorative crosses that hang on the wall, jewelry, pocketknives and new-made arrowheads chipped from stone by hand. "I just got the shop in town," Fawn says. "I didn't need to go into town; we make enough out here. But I kept thinking—what's going to happen when we can't work as hard as we're working? So getting the building in town and now the shop will let us have something to go to when we're older. This is the first time we've worked apart. And I miss him."

"We kill a lot of rattlesnakes out here," Fawn says. "With the Mojaves, the cattle'll die from one of their bites. We've lost four in four years to lightning strikes and two in four years to snake bites." Most cattle survive snake bites from western diamondbacks, though the venom causes the inflicted leg to "get huge" and the hair to fall off.

   We drive through a pasture to check on cows. "Cows want to be with other cows," she says. "They'll start bellowing and crying if you separate them. They'll break their necks to get out of a pen to be with the herd." She and her husband manage for drought conditions. When water becomes scarce, the grass dries up, and eighty acres are needed to sustain a single animal. "It'll take a pasture years to recover if you over-graze it. Sometimes it never recovers," Fawn says. In the pasture, she likes the smell of whitebrush (aka bee brush, *Aloysia gratissima*). "It smells like perfume when it blooms," Fawn says.

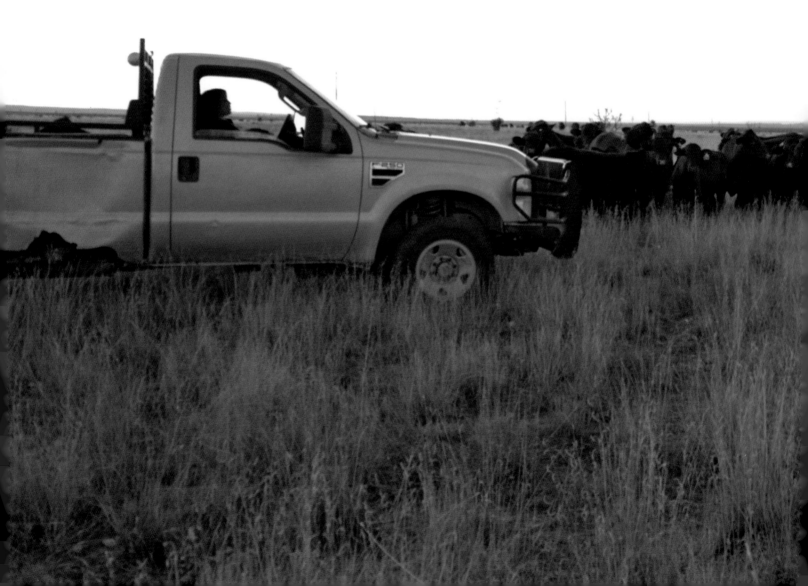

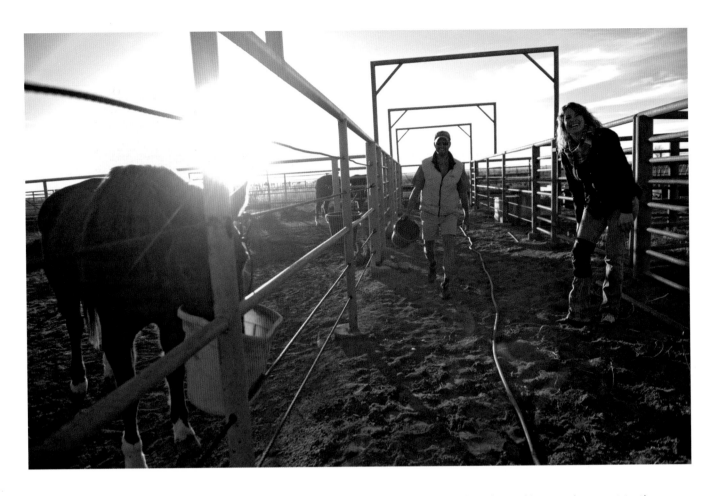

Years ago, Fawn had the job of breaking horses for a rancher near Falfurrias. One day, she and her mother went to the veterinarian in the area, and she "saw a boy who was cute." He asked her out a couple of days later, and three months after that, he proposed. "I tell everyone who asks—this is not the way to find and marry your husband. But it worked for us," Fawn says.

*Opposite, top* "The thing with ranch women is that they're real," Fawn says. She has three sons. The oldest, Walker, is in his first year at college, and her other two, Wyatt and Clayton, are almost out of high school. When Walker competed as a steer wrestler in high school rodeo, Fawn was his hazer, keeping the steer running straight for the steer wrestler to catch and throw. Since steer roping is a timed event, the hazer and the bulldogger move as fast as possible and the spooked steer, a little wild with excitement and flight, runs hard and sometimes erratically. "We figured out a system; we didn't even look at each other," Fawn says. "We won a lot; we were a good team. I couldn't stand sitting in the bleachers, and I didn't want to see him hurt. They don't let a parent even step out in the pen in college, so he had to find a new partner." Walker might want to be a taxidermist and he might want to work on a ranch. Fawn says, "I told him he should own it and not just work on it."

*Opposite, bottom* Fawn "grew up with no money in the house" and left school after high school. "Poor is a state of mind, broke is a situation," Fawn says, repeating what her mother often said. She's always ridden horses and has held many ranch jobs, including as a horse trainer. She also worked in a feed store.

In addition to letting the cattle forage, Fawn and Justin give the cows a compound feed milled to the specific nutritional contents directed by the ranch's owners. "It's a special blend," Fawn says. Fawn and Justin use a rotational grazing method—Fawn calls it the "Slice Method"—rotating the herd from one five-hundred-acre parcel to the next every three days. Fawn and her husband have fenced the entire ranch into slices laid out like a great pie, and in the center are pens and water and feed troughs. "The ground is stomped there," Fawn says, "but you'll see that anywhere around water troughs, cows will drink, laze and loaf." She says this method helps avoid overgrazing. The ranch has invested significantly in new fencing to replace old, fallen fences. "When we first got here, all the fences were too low, and cattle were moving from one section to the next where they shouldn't be," Fawn says. They've also repaired the rock water tanks, known as *pilas*. Several weeks before Fawn moved here, Justin arrived to start work. "He said he went up to one *pila* and it smelled like my perfume, so he named it Fawn's Pila," Fawn says. "That's the first thing I wanted to see when I came out here."

*Opposite* At the water and feed troughs, Fawn feeds a Santa Gertrudis cow. "It's a special breed they made up over at the King Ranch in Kingsville," Fawn says. "They are hardy and they eat the tabosa and tumbleweed that other cattle won't eat."

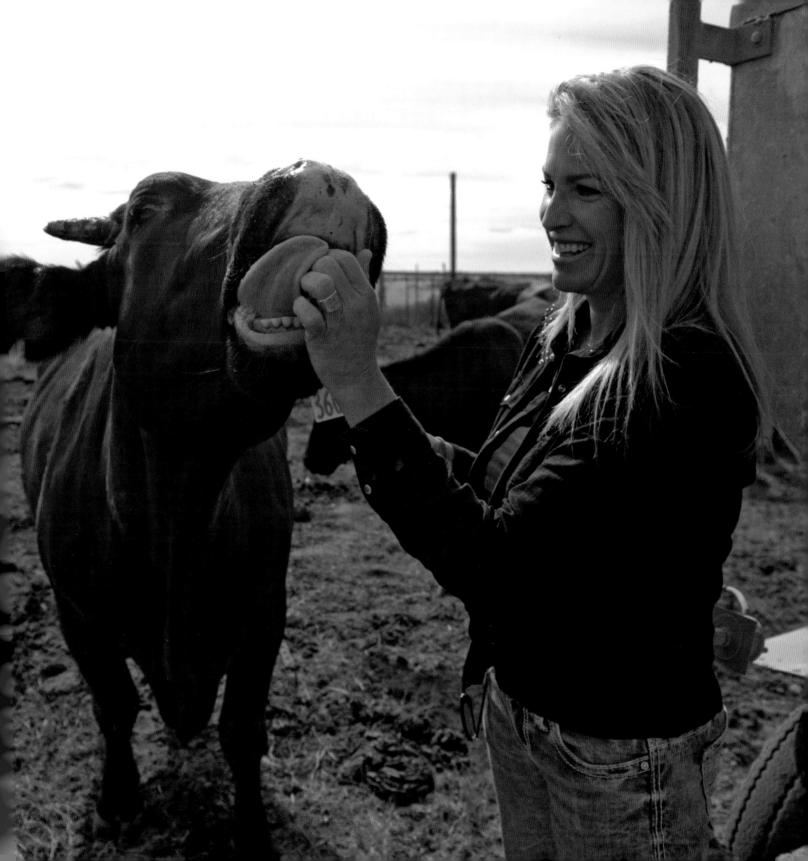

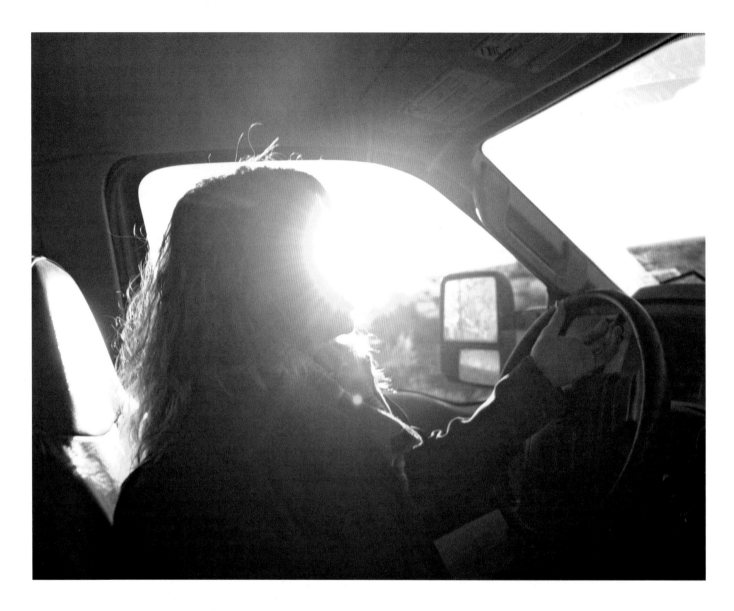

Fawn drives through one of the pastures, checking on cows.

*Opposite, top* Fawn at the supermarket.

*Opposite, bottom* The ranch manager's family lives in a house in the middle of the ranch. "I'm kinda used to living on a real big place like this," Fawn says. "I don't know how it would feel if it were smaller."

Sarah feeds alfalfa hay to the
McKenzie Land and Livestock
herd cows from the back of her
truck. She does this daily to make
up for the lack of forage in winter.
Cows are raised to breed, and if a
cow does not produce a calf, she
is culled from the herd. "The idea
is to make calves, and if they don't
get their job done, we fire them,"
Sarah says. "If we don't eat them,
someone else will."

# SARAH McKENZIE

*Southeast of Fort Stockton, Born in 1975*

## AND

# LYDIA McKENZIE MAY

*Southeast of Fort Stockton, Born in 1977*

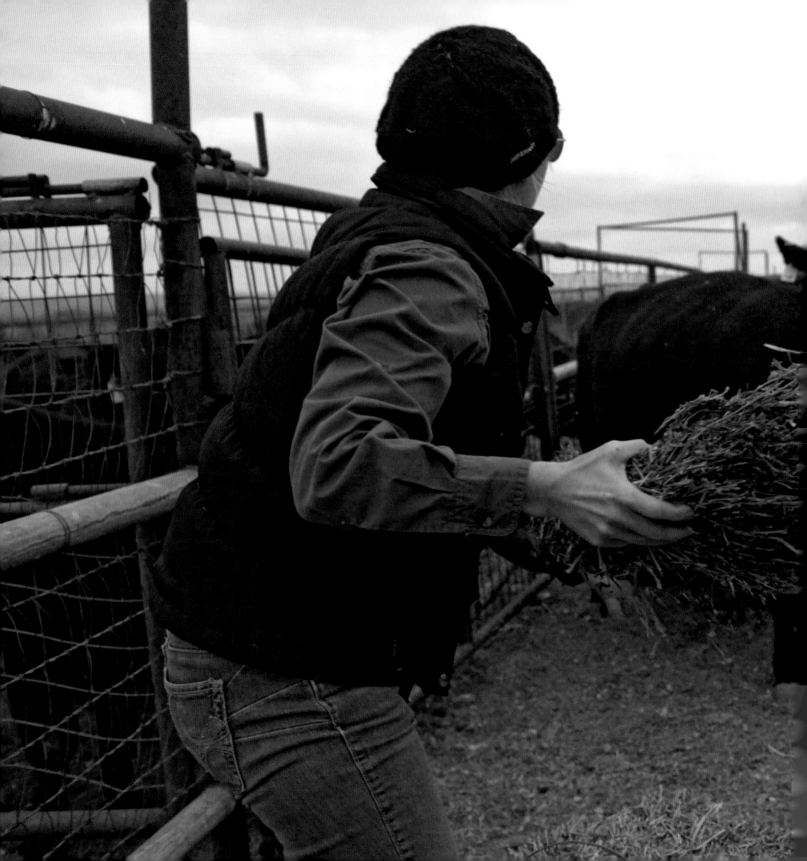

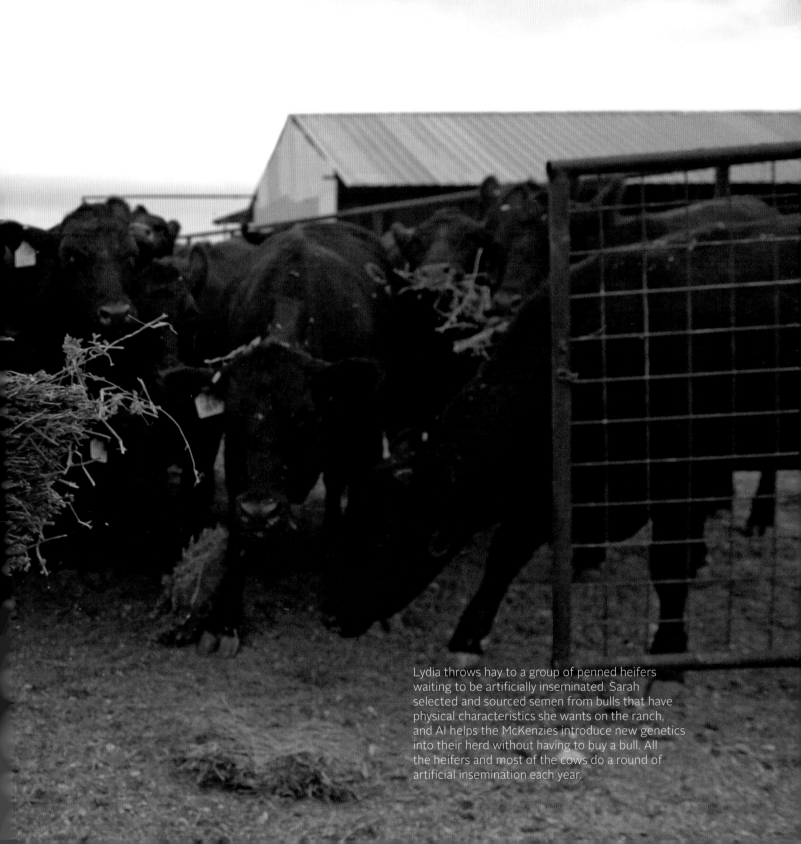

Lydia throws hay to a group of penned heifers waiting to be artificially inseminated. Sarah selected and sourced semen from bulls that have physical characteristics she wants on the ranch, and AI helps the McKenzies introduce new genetics into their herd without having to buy a bull. All the heifers and most of the cows do a round of artificial insemination each year.

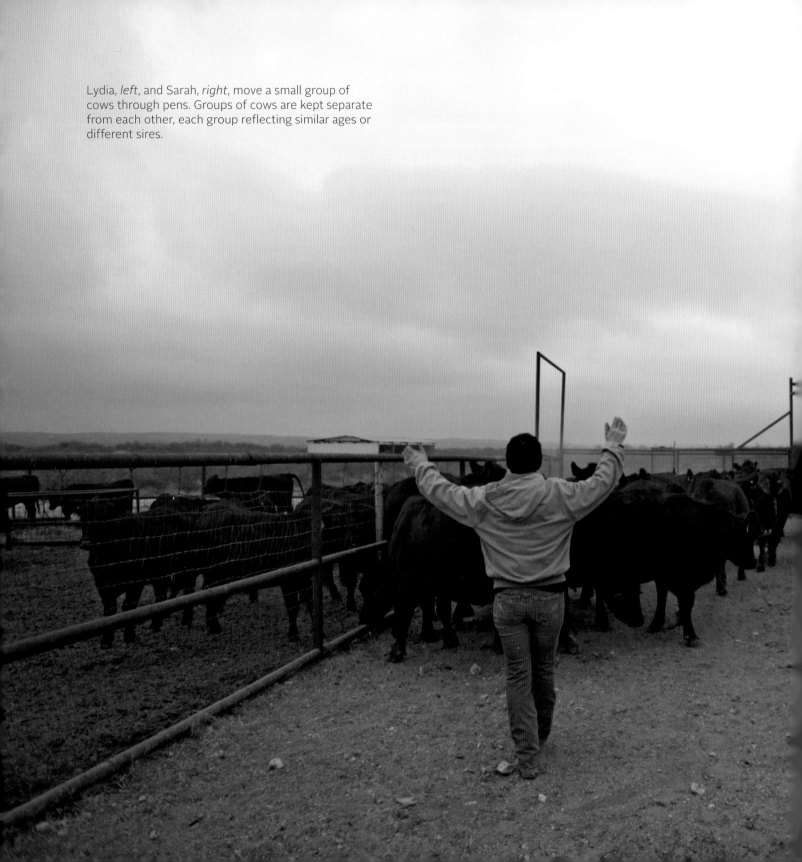

Lydia, *left*, and Sarah, *right*, move a small group of cows through pens. Groups of cows are kept separate from each other, each group reflecting similar ages or different sires.

In the winter West Texas dark, I exit off I-20 and head south toward the McKenzie Land and Livestock ranch headquarters. I pass through Pleasant Farms, Crane and McCamey. There is more starlight visible than any other kind of light, but despite the twinkle, there is not enough to illuminate my way. The sun set more than an hour ago, and it is windy, cold and empty.

After hours of driving and going through an unmarked gate, I've arrived at what I hope is the McKenzie headquarters, deep in rural Pecos County. I'm not sure I'm in the right place, and if I'm on the wrong property, the first noise I may hear is the cocking of a shotgun. So I call out, "Sarah, it's Alyssa."

Sarah McKenzie opens the door, and Rosie, the family's Chihuahua, barks and runs in circles at our feet.

Sarah's two youngest children, Sawyer, nine, and Brenna, seven, sit at a round table next to the kitchen eating Frito pie, spinning the lazy Susan with a bowl of cheese and an opened bag of Fritos next to each other.

"Want to ride with me?" Sarah asks. "I need to go into town to get Henry; he's there with some friends." She zips a duck cloth jacket over her sweatshirt and pulls on boots.

In her SUV, she takes a call. "Hi there, this is Sarah," she says. "You're selling it? We'd be interested in talking to you about the price." She drives, holding onto the wheel with her hand in her lap. Her face glows from the light of her cellphone. "Yes, we're interested in the property," she says.

The heirs of a nearby, generations-old twenty-two-thousand-acre ranch are considering selling it, and before they formally list it for sale, Sarah has called the family to make inquiries about the details and its price. She is still and listens to their answers and explanations and talks slowly and thoughtfully back to the person on the phone. "Thank you for calling me back," she says, "let me talk it over."

"It's a really pretty ranch with the house up on a bluff," she says after hanging up.

"People in town" are buying ranches, she says, people who use the land for recreational hunting instead of running cattle. This new sort of demand from the non-ranching world has driven land prices steadily upward to a level that neighboring ranchers cannot, or are not willing to, afford. Like other properties she's heard of and called about, this price is too steep, and the McKenzies will pass.

"It's not possible to buy the land or to lease cattle on it or to run your own. You still won't make enough for the bank payment," she says. "It will sell for about $350 an acre. The only way to have land is to inherit it."

She exits into Fort Stockton and parks in a small alley between two buildings. She telephones. "Where are you, son?" she says and turns around in her seat, spatially orienting herself in the world. "Okay, I'm east of there. Come on out and I'll go back around."

Once Henry, who is eleven, is picked up and settles into the back seat, we turn back onto the interstate. "I don't consider myself far from town," Sarah says of her twenty-minute drive from town to the turnoff.

At home, Sarah moves plates and glasses from the dishwasher to the cupboard. The kids have gone to bed. The only light on in her house is the one recessed in the kitchen ceiling above the sink, and she is lit dramatically underneath it. Sarah dates a man from Fort Davis named Curtis who is a cutting horse trainer, roper and rancher. He's older than Sarah and divorced, with a grown son. With the house now quiet, she telephones him. "Hi, sugar," she says. "I couldn't get to your call earlier."

Soon, the entire house is still and dark and sleeping. The guest room bed is laid out with pale green-and-white throw pillows and a feather-stuffed matching comforter. There is a pillowtop mattress pad on the full-sized mattress and soft cotton sheets. I turn off the bedroom light, close the door and crawl in. There are no curtains on the windows. There is no moon tonight.

In the morning, Sarah makes cinnamon toast—buttered white bread with cinnamon and sugar, toasted in the oven—and sets the coffee maker to drip a pot. The children fill their cups with coffee, take a piece of warm toast and sit at the round kitchen table. Henry gets up often, going first for his belt, then to change his socks, then to select from his collection a leopard gecko in a small plastic box that he places on the kitchen table. ("Keep all of your lizards in the bathroom!" Sarah says when she sees it.) Sawyer sits quiet. Brenna calls for Sarah to comb her hair. She turns her chair out and hands a brush to her mother. "How do you want it, Sissy?" Sarah asks, and Brenna touches the spot on her head where she'd like the braid to start. Sarah combs out her daughter's hair, holding a hair band between her lips. "Free-range child raising," she says.

The school bus stops in front of Sarah's house at 6:52 a.m. to pick up Sarah's three kids and her sister Lydia's two boys. Sarah sends her kids out the door with coffee in a cup and toast wrapped in a paper towel for the driver. In the afternoon, when her boys are dropped off after school, Lydia will send out a snack to the driver. Lydia's house is just up the dirt lane from Sarah's and across the lane from their parents' house.

"All my kids are smart and doing well in school," Sarah says. They rush out the door with calls of "Love you, Momma."

"I'm going to whip up a quick slaw," Sarah says and moves back under the kitchen light. The sun still hasn't risen. "I prefer to make things from scratch because then at least I know what's in it," she says. "I like making pies and home-cooked desserts."

Today, Sarah and Lydia will meet Bruce Carpenter, a livestock specialist with Texas A&M's Agriculture Extension Office, and together they will artificially inseminate sixty-four McKenzie heifers. Sarah's been looking through bull semen catalogues for the last several months, comparing metrics of different Angus bulls, including the birth weight, yearling weight, daily gain, weaned calf weight, phenotype, performance, muscle and yield of their get.

"That's my cow porn," she says, pointing with her chin to the pile of catalogues on the table, her hands in a pile of shredded cabbage. "I go to bed reading that stuff."

She's settled on bulls named KCF Bennett Absolute, B3R Pioneer Wave and Sydgen Fate and bought semen straws from each of them, hoping their genetics mix well with the genetics she's cultivated in her cow herd. She aims to produce heifers and bulls suited for the family's property, since not all cattle are equipped to thrive in the harsh West Texas landscape.

"I pick them thinking about which is going to make the best offspring," she says. "I won't pick a bull that isn't good for this country." Sarah wants to introduce genetics that create medium-framed, fast-growing cattle with good legs to support them and good feet so the rugged terrain doesn't cripple them. "We have about thirty cows on more than two thousand acres, and when you're spread out like that, your cattle have to travel to get back to food and water. And if they're bulls, they have to cover a lot more country to visit their girls."

Artificial insemination results in about an even split between male and female calves; AI carries a conception rate of about 50 percent. If the AI does not result in a pregnant heifer, that animal is pastured with a bull on her very next cycle so they'll breed. "If it's dry and the heifers are a little thin, we'll have a 35 percent rate with AI," Sarah says. Cows and bulls left to breed naturally have a conception rate of about 90 percent, but it's tricky to introduce new bloodlines into the herd. "We want to get new genetics into our herd, and you can't afford to buy fancy bulls. You can bring about genetic change quicker when you bring it in with AI. You can handpick certain traits that might not be available in your price range if you bought a bull." The McKenzies AI all of their heifers and most of their cows.

In a more traditional calving cycle, calves are born from January to the end of March, when the grass is greening up and there's plenty for the animals to eat. The McKenzies, however, have moved their calving to the fall so that by their March bull sale, they'll have eighteen-month-old bulls. Sarah says people prefer them "a little older" and think twelve-month-old bulls aren't ready to service cows. "Our method is not natural because calves are born in the winter and there's not much forage in Texas in the winter," Sarah says. "It's also proving to be more expensive and resource-intensive."

The McKenzie herd is certified Angus beef, which means these are purebred animals that are hardy and solid black, known for being attentive mothers that calf with ease and have a ten-to-sixteen-square-inch ribeye area. Angus and Angus-cross cattle make up just over half of commercial cattle production in the United States. Being certified is highly marketable, Sarah says, and a certified Angus brings more at auction than one that is not.

Sarah has a BS in agricultural marketing from New Mexico State University and an MS in entomology from Kansas State University. In 2011, she moved back to the family ranch where she grew up. When she returned, she was still married to an alcoholic husband. "It took years and years for me to leave him, but I did, and we're very divorced now," she says.

Sarah's paternal great-grandfather lived and had an office in El Paso and bought the McKenzie land and land in New Mexico and Arizona in about 1882. "It was huge," Sarah says, "and went from here to six miles south of here." According to family lore, he lost his fortune and most of his land sometime in the early 1920s, when he missed the chance to sell a large shipment of cattle just before the market collapsed. He ended up selling at a loss in a bottomed-out market. He managed to hold onto the McKenzie homestead made up of several square miles of land and the two original ranch houses—one in which Sarah's parents live and the other in which her sister, Lydia, and her family live. The University of Texas eventually ended up with the rest of the property, and Sarah's great-grandfather then leased most of it back from the university. "As long as we stay in their good graces and we're good tenants, we can stay," Sarah says. The ranch stayed unworked until 1979, when her father, Houston, and her mother, Laura,

moved from New Mexico into the old stone ranch house with their two little girls. "My parents were a team," Sarah says. Houston and Laura ran the operation until Sarah came back in 2011 and Lydia moved back in 2015.

When she first returned to the ranch, Sarah initially sought more of a say in ranch operations. Now, several years later, she looks at ranch management differently. "When I was younger, I felt like I was a hand. Our operation was so small and everyone is completely hands-on, and I didn't understand that as well and wanted my own program. Now I understand we all do grunt work, we all work together and it's not about being the boss."

Lydia has a BS in public health from New Mexico State University and an MS in physical therapy from the University of Colorado Health Science Center. She works as a physical therapist twice a week at Fort Stockton's county hospital. She's married to Anthony, and they have two sons, Mason, six, and Cato, four.

"Mom and Dad taught us to go out and see the world before coming back," Sarah says, pulling on her boots before heading out the door to meet Bruce, the agriculture extension agent, and Lydia.

We drive to the main road and through a set of gates to the pens where their hand, Santiago, and his niece, Diana, have gathered first-year heifers from the neighboring pasture on horseback. Sarah and Lydia set the cryogenic container filled with liquid nitrogen and semen straws on the ground next to the hydraulic working chute and unfold a table, where they lay out notebooks, a box of shoulder-length plastic gloves and a couple of insemination guns.

"Let's keep the gate open so these flow," Lydia says. She opens the connecting gate between the holding pen and a smaller crowding pen that is connected on the other side to a curved, walled, metal working chute. This creates a distinct passage for the heifers to follow, and they do, filing behind one another. Santiago and Diana stay on their horses at the back of the pen, guarding it so the cattle sense they must move toward the chute and not back to the pen. Everyone

here is quiet, and the heifers steadily pass into the curved chute. "We try to run an easy, quiet operation," Sarah says. "No use yelling and getting mad."

The lead heifer walks into the hydraulic working chute. Lydia closes the head gate that pins her in place and tightens the walls around her sides a little. The heifer stands without struggling, confined and still. Only her head is distinctly visible, the long chute curving behind her as though she were a huge, arced, black-faced, black-eyed, black-nosed snake.

Bruce takes his right arm out of his jacket, letting it hang off his shoulder. He slips a clear, loose-fitting plastic glove all the way up to his shoulder over his work shirt, patting at the top hem and pulling it as far over his shoulder as it will go. The plastic glove is dye cut, and Bruce's hand takes up only some of the space. Half an inch of glove extends beyond his fingertips. He holds his arm in the air and wiggles his fingers so the glove stays on.

Lydia stands at the heifer's head with her notebook and pen. She reads the heifer's ear tag and, keeping place with her finger, looks at the handwritten list of numbers on the notebook page until she finds this cow on the list. She reads the number—the same number will be on the semen straw—and calls it out to Sarah.

Sarah has spent the last few weeks studying bulls and heifers and matching up which crosses she wants to make. Heifers are young, virgin cows ready to be bred for the first time. Sarah is careful to match heifers with bulls that will produce smaller birth weight calves for these first-time mothers. Her notes include data on the heifers' mothers, sires, their birth weight and the month of their birth. "If you put a good bull on a bad cow, you'll improve genetics of the herd and the quality of the meat," Sarah says. "If a cow's a little short, we can breed her with a bull that will bring some height to her offspring. One bull won't fix everything in a cow, but we can match up some traits we think are most important."

She pulls the rack of semen straws from the cryogenic container, a steel container the size of a small barrel about two feet tall and as fat as a sack of groceries. Inside, with

liquid nitrogen swirling and smoking among the straws, the frozen sperm is safe and alive. She reads the small labels stuck vertically to each straw. "We put a lot of a bull called Absolute on these heifers," Sarah says. She finds the label she's looking for and takes the straw out of the rack.

Bruce steps into the chute at the back of the heifer.

The semen-filled part of the long straw is a little longer than a grain of rice. After Sarah pulls it out of the liquid nitrogen tank, she thaws it in warm water for forty-five seconds and warms the insemination gun—a metal tube—inside her jacket or under her armpit. She attaches the semen straw to it, cutting off the sealed tip, and slips it into a loose, thin condom, which keeps it clean. She hands it all to Bruce, who lifts the cow's tail, pulls it off to the side and reaches into the rectum with the gloved arm, feeling for the uterus and nut-like cervix. He feeds the inseminating gun into the cow's vagina, avoiding the urethral opening that leads to the bladder on the way, up through the cervix, his fingertips and the insemination gun tip meeting at the uterus, separated by vaginal wall. He opens the top of the condom, and then he presses the plunger.

"We lost a bunch of semen one time because we didn't put liquid nitrogen in the tank," Sarah says. Between heifers, Sarah changes the plastic condom and sips at coffee. "And semen is expensive."

Sarah and Bruce trade off inseminating heifers and loading the semen straws. Lydia takes notes. After each heifer is inseminated and Lydia opens the hydraulic head gate, the cow joins the others standing in the corner, and another heifer feeds into the chute. Sarah says she likes to breed first-year heifers because they have a "higher cervix that's shorter and tighter and easier. Older cows tend to have stretched-out vaginas, and their cervix is harder to find."

Bruce talks Sarah through inseminating a heifer with a hard-to-find cervix. "You'll feel a hard, round spot," he says and waits with his hands in his coat pockets until Sarah, her arm in the rectum of a heifer, her face nearly lying on the heifer's rump, looks back at him and nods. "Now just to the right," Bruce says.

"Write abnormal on her phenotype," Sarah says. The front of her jacket is smeared with manure, blood and mucus, her arm lost in the heifer. Gray fog has come in low and thick and all around. Sounds are muffled now; our voices don't go very far, and the low fog makes the light painterly and exquisite. "I don't feel a reproductive system," she says.

Lydia takes the note in her notebook and Bruce slips on a glove, replacing Sarah at the back of the heifer. Bruce says the heifer's a freemartin, a calf born with no reproducing female parts, something that sometimes happens when a female calf is born as a twin with a male.

"Is she a twin?" Bruce asks.

"No," Lydia says.

"If she doesn't have a uterus, we'll cull her," Sarah says. The head gate opens, and the heifer leaps out to join the others.

The McKenzies have two breeding seasons, one in December and one in the spring. Sixty-two days postpartum, cows are ready to be bred again. If a cow ever fails to be bred, she's culled from the herd. "If people run bulls all the time when the grass is green, nature will have them bred during this time. We start getting green in April. A lot of cows will breed up in May or June, so calving will happen in April or March," Sarah says.

A pickup truck rolls down the caliche road and stops at the pen. We don't hear it coming, the fog dampening so much sound, and it's suddenly there. A man leans out of the rolled-down window, extends his arm and holds up his pointer finger. Lydia sees him before Sarah does. "He wants a bale. You going to run the tractor or am I?" Lydia asks, and without answering, Sarah sets down her artificial insemination gun, Bruce turns to look to see who's pulled up and the two women shuffle-run toward the gate. "Uno?" Sarah says, nodding to the man. He nods back and rolls toward the hay barn in his truck.

"I'm going to go check on Cato," Lydia says and shuffles past the pens to the office, a single-wide trailer parked on the other side of the road, where her four-year-old son has been inside playing. "I'll see if he wants to come with us."

Sarah heads to the hay barn, a tall, two-walled structure with a gabled metal roof where the McKenzies stack, store and sell homegrown one-ton bales of alfalfa for $150 to $200, depending on the market and their grade, and smaller eighty-pound square bales. The hay barn is down the road from the pens. "We've got badger and gopher problems," Sarah says one day, driving along the fields pebbled with the dirt mounds piled by varmints that have tunneled in the pasture. "Look at the holes they've dug. It makes it hard to cut," she says.

At the hay barn, Sarah positions a John Deere tractor with attached bale spears until it's square with the huge bales. She controls all parts of its movement with levers she pulls, pushes and slots into place with her hands. The hay barn is tightly packed with bales, and a wrong bump here could cause thousands of pounds to shift and shatter anything they fall on. There are supporting corner poles to avoid hitting and the smaller bales stacked to the left. She's got to consider the tractor's turning radius and the likelihood of getting it irrevocably pinned. The bale spears make the tractor longer, and Sarah raises them into the air to better maneuver. It's a powerful, non-nuanced machine, four very tall steps up off the ground.

She leans forward and looks up and picks a bale at the top of a row. She spears it with the tractor and partially lowers the bale. Lowering it too much would cause the tractor's back wheels to come up off the ground. She pushes and pulls levers until the bale is balanced, and she steers out of the barn and to the customer's truck.

The customer stands to the side of his pickup, and Sarah lowers the bound, rolled and tied alfalfa bale into its bed. The truck sinks with the bale's weight.

"The alfalfa farm keeps the ranch open," Sarah says. "We sell enough to keep the ranch alive."

Sarah takes his money, while Lydia thanks him in Spanish. Sarah returns the tractor to the shelter, and the sisters shuffle-run back to the pens.

"He's okay," Lydia says, and Sarah nods, her sister answering a question she's not vocalized about her nephew.

The two women pick up the work where it was left off. They do not stop working when they talk. Lydia takes notes in her notebook, setting her hand into her armpits from time to time to warm her fingertips. And Bruce loads semen straws one after another on the insemination gun.

At noon we break for dinner and drive back to Sarah's house to warm up with her homemade beans, slaw and brisket.

"Do you feed your dogs table scraps?" Lydia asks me.

"All the time," I say.

"What we feed our cattle changes the flavors of their fat," Lydia says. For bull development, the McKenzies feed a combination of corn, fiber and dried distillers greens for four or five months. Forage for the cows is supplemented with hay and cow cubes, depending on how much grass is available.

"There are two different parts of the beef industry," Sarah says, "One is commercial cattle. High-quality, graded meat. Weaned calves get sent to grass wheat pasture or high-quality forage at about three months, then to the feed lot, which changes the flavors of the fat. They grow fast on high-calorie food there. They get to weighing 1,200 to 1,400 pounds in about twenty months. Then we slaughter them. They're tender because they're young and good because we fed them grain-based feed. The stocker industry also includes old animals, or a lot of time it's animals that don't breed, or something's wrong with them. Those aren't fed out and go to slaughter and get ground up a lot of times with good cows. Most of those cows go into ground beef."

"Or two," Sarah says, "the seed stock providers. They breed cattle for other ranchers and sell breeding stock."

We return to the pens after dinner. The fog has lifted, and the afternoon light is bright and warm yellow winter sun. In the last hours of the day, as the sun starts sinking down, it gets colder and the light goes blue.

Santiago and Diana push in a few dozen cattle from a group that will be inseminated in two weeks. We walk along

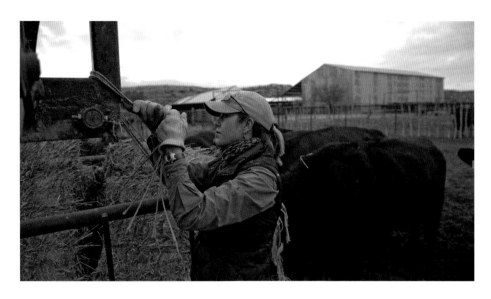

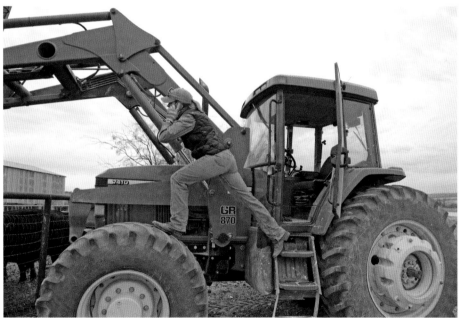

*Top* Sarah ties baling twine to the tractor. The hay barn behind her is stacked to the roof with large and small square alfalfa bales the ranch farms itself. The McKenzies produce enough for their own animals and to sell to other ranchers.

*Bottom* Sarah talks on the phone while moving a large alfalfa bale into a pen.

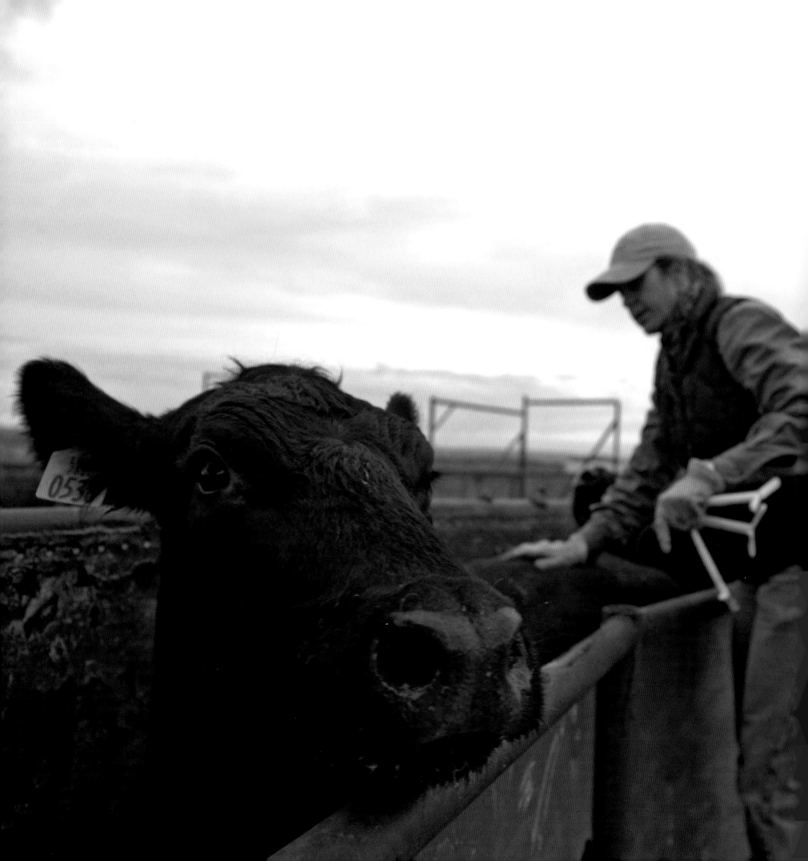

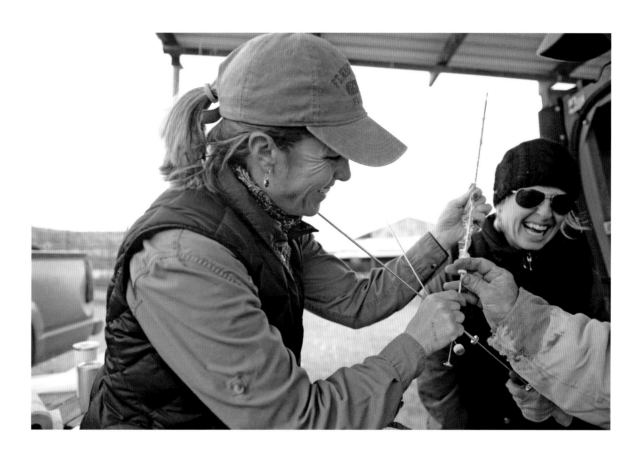

*Left*  Sarah pulls a CIDR (controlled internal drug release insert) from cows standing in line at the ranch's working pens. CIDRs are part of Sarah's synchronization protocol for her artificial insemination plan. They effectively narrow the fertility window of a herd down to hours.

*Above*  Sarah, *left*, and Lydia, *right*, cover an insemination gun with a protective condom. Attached to its end is a semen straw.

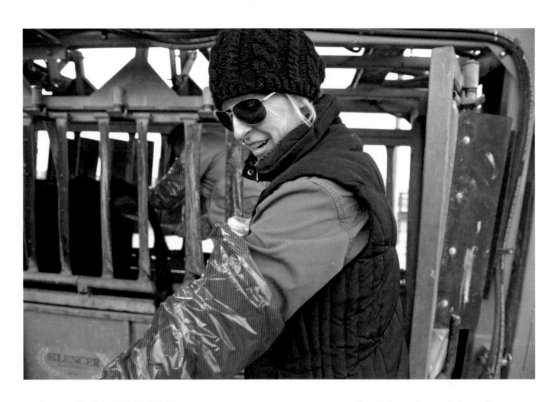

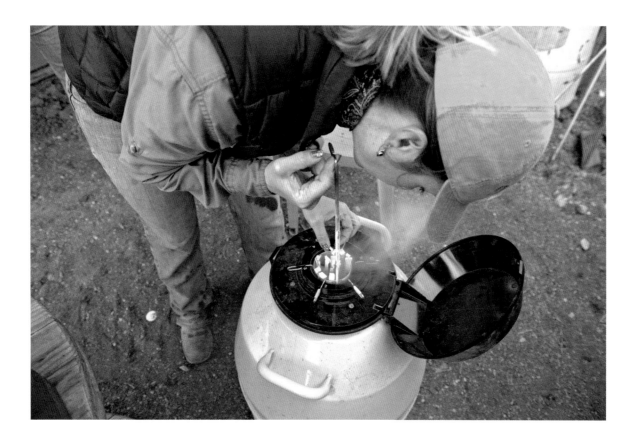

*Opposite, top* Lydia puts on a shoulder-length glove while Bruce, the local Texas A&M agricultural extension livestock specialist, performs AI in the chute.

*Opposite, bottom* Sarah feels for the cow's cervix as a guide with one hand while feeding in the insemination gun with the other.

*Above* Sarah pulls semen straws stored in a liquid nitrogen tank. Each straw is labeled, and each is intended for a specific cow.

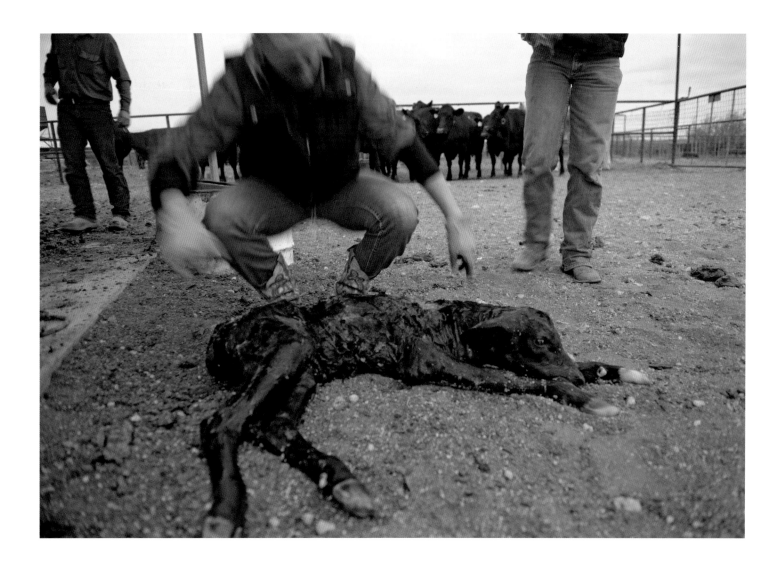

A baby bull in the moments after being born. Despite the freezing cold and the unexpected birth, the calf was healthy.

*Opposite, top* Lydia moves one of the ranch's large square alfalfa bales onto a rancher's truck.

*Opposite, bottom* Sarah and her youngest son, Sawyer, stand in the hay barn where the bales are kept out of the weather.

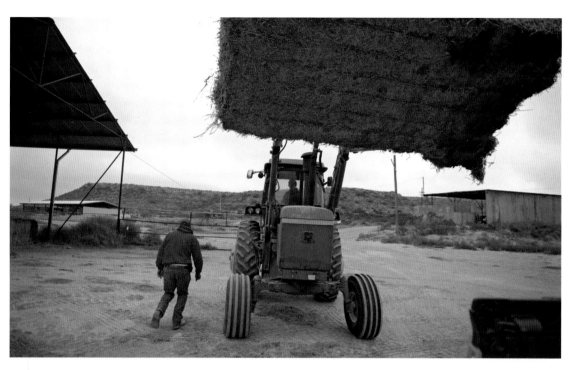

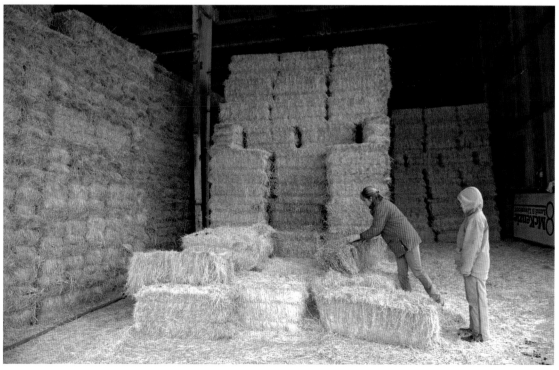

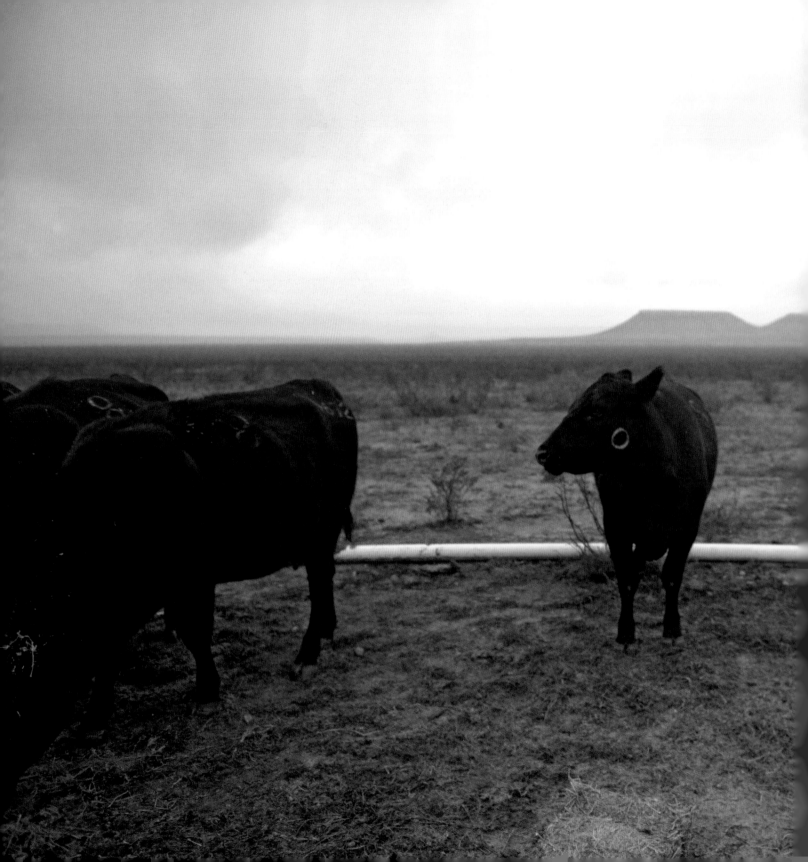

*Left* McKenzies cold brand a "0" on the cheek and an "8" behind the shoulder on herd cows.

*Top* Sarah's daughter Brenna, *left*, talks with her uncle Anthony. "It's a family business," Sarah says. "What other job can you get to know your kids as individuals as good as this job?"

*Bottom* Anthony, Lydia, Brenna and Sarah dress to step outside at Lydia's house while Rosie, Brenna's dog, looks on. Lydia and Anthony live in one of the ranch's original structures—an adobe home steps away from her mother and father's house and down the lane from Sarah's house.

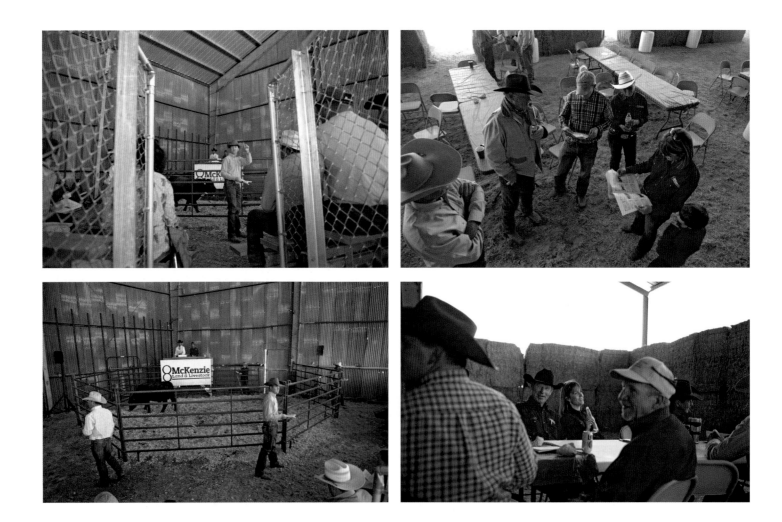

*Top, left*  An auction ring man takes bids at the ranch's annual bull sale. Behind him, a bull walks in circles in the pen, and the auctioneer moves the bids up fifty dollars at a time. Sarah sits to his right and looks on. Per pound and per animal, the 2017 bull sale brought in less than half of what it had the year before. "This is the most uniform stock we have," Sarah says. "I like selling yearling bulls, but a few of these are eleven-month-olds. We have very little AI in this sale."

*Top, right*  Sarah, *right*, looks through the bull sale catalogue and visits with neighbors and friends who have come to the sale. "The bull sale's a great social event," Lydia says.

*Bottom, left*  The McKenzies sold 137 bulls at their 2017 bull sale.

*Bottom, right*  Sarah sits with her father, Houston, *left*, after the bull sale.

*Opposite*  Lydia talks with a rancher in the pens behind the bull sale. After buying bulls, ranchers line up with stock trailers to load their cattle. Lydia keeps the loading process organized.

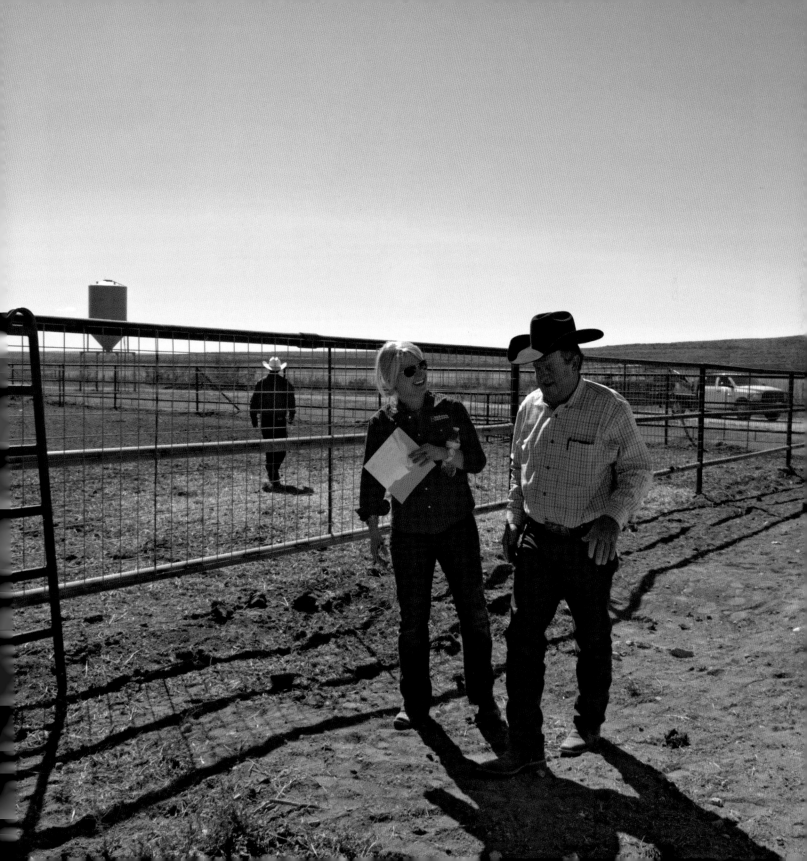

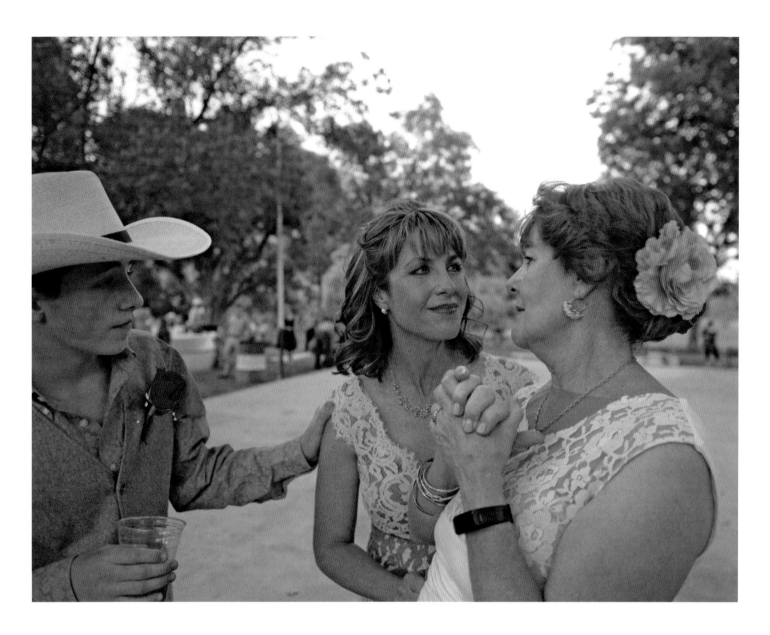

Henry, Sarah and her mother, Laura, talk during the reception
and dance following Sarah's and Curtis's wedding.

*Opposite, top* People dance to the live band playing country
music following Sarah's and Curtis's wedding.

*Opposite, bottom* Sarah and members of her family pack up
after her wedding reception and dance.

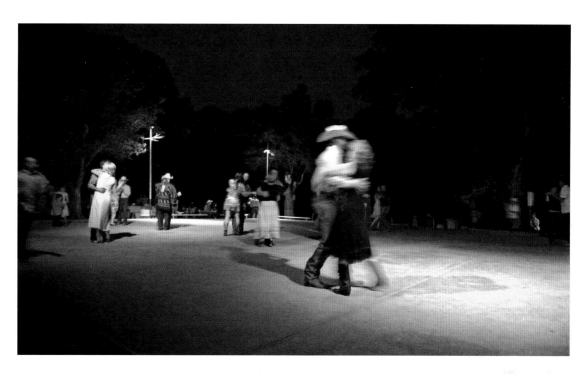

the wood plank scaffold next to the chute, designed to let cowboys reach in. Our hips are level with the top of the cows' backs. Two weeks ago, Sarah and Lydia inserted these heifers with CIDRs—controlled internal drug release inserts—an FDA-approved intra-vaginal progesterone instrument used to synchronize estrus in livestock. These cattle will come into season at the exact same time, a window of opportunity only hours wide that makes AI possible. We grasp the CIDR's plastic bar and string hanging from the cow's vagina and pull, then throw the wet and mucus-covered hard plastic in the dirt to gather them up later. Lydia lets "the girls" into the pen with the others through the hydraulic head gate one at a time.

The last animals advance through the holding pen. We are all dragging now, worn ragged from the day. I stand on the wooden scaffold photographing and see a blue tongue and the tip of a hoof poking out between vulvar folds on a heifer. I say so. As the heifer steps into the hydraulic head gate, Santiago takes a length of rope from his saddle and steps into the back of the chute. He wraps the rope around the increasingly exposed hoofs and pulls steadily very, very hard. The calf, blue and black and slick with wet, resists leaving the tight vaginal canal at first and then suddenly appears in a single slippery release.

Lydia opens the hydraulic head gate, and the cow walks out. Santiago drags the calf along the ground by its two feet and unties it. The calf is a very deflated, long and limp thing. Sarah, Lydia and I kneel down and rub it and talk to it: "There you go, buddy," "You're here now, buddy," "Sweet thing." Santiago, curling up his rope, standing next to us, smiles with closed lips and rigidly shakes his head in the affirmative and says, "*Macho. Es un macho.*"

Sarah and Lydia are surprised to see the calf, since it was conceived and developed despite their manipulation of their mother's cycle. "We just missed her," Sarah says. "She was a late-calving cow. The calf survived the hormones unhurt because he was ready to be born anyway." We step away, and after a moment of orientation, the cow walks over, nudges at the calf and licks it. By the time we've folded the table and put away the cryogenic container, trembling now in the cold wind, the calf is up and standing, looking like a heavily burdened table might—its legs in four corners, its weight squarely between splayed-out legs. The calf is nearly under its mother, the cow defensive to anything that might want to come near.

"In these situations, one of the things is you don't take off," Lydia says. "You stick around to make sure it's all normal." So we stand there in the cold. Looking. No prolapsed uterus, no bleeding, no aggression toward the calf, as first-time mothers sometimes hurt the calf for not knowing what to do with it. The calf nudges its mother's udder for its first mouthfuls of hot milk. All is well.

A few days later, we are driving through morning fog with bales of the ranch's alfalfa in the bed of the truck. Sarah pulls to the side of the road and steps onto the truck's side wall. She throws armfuls of rich alfalfa over the barbed wire fence to the bellowing cows on the other side. "I'll give them a little," Sarah says, "otherwise they're all forage."

Save for the few summer months of rainfall, this country is usually dry, rough and hardscrabble. On average, says Sarah, it takes about eighty acres of forage to keep a single cow, bull, steer or heifer alive in this part of Texas. "This year with all the rain," she says, "we'll go to about forty-five acres a head."

Cattle have come off the rise and crowd around the fence. The ground looks hard and rocky. "They can walk anywhere," Sarah says, watching them eat. They line up along scattered yellow and green alfalfa as though it were in a trough. They are black and strong and have the McKenzies' white freeze mark "0" on their jaw and an "8" just behind the left shoulder to show they are part of the McKenzies' permanent breeding herd.

The best females from their breeding efforts are kept back as replacement breeders for the permanent herd. Females that don't meet the standard are slaughtered for the McKenzie family dinner table. Most of the bulls are sold

at the McKenzies' annual bull sale; a few bulls are kept to breed non-related females.

"Houston was the one who started selling bulls," Sarah says. She and Lydia call their father by his first name when they talk about him in the context of work. "We all thought it just sounds more professional," Sarah says.

"People buy our bulls to improve their genetics," Lydia said on a different afternoon. "We are, everyone is, always on a quest to improve the genetic stock of the herd."

The rest of the winter passes, and in the spring, driving west on Interstate 10 heading back to Sarah and Lydia's, I hear the radio DJ advertise the annual McKenzie Land and Livestock Bull Sale. "I bought spots in a three-hundred-mile radius," Sarah says when I get to the McKenzie Ranch. "There's a lot of competition with other sales. I have radio spots all over West Texas." She's also sent five hundred e-mail notices about the sale to clients, neighbors and buyers on a list she's added to for years.

The eleventh annual McKenzie Land and Livestock Bull Sale is held in the middle of March. On offer in 2017 are 137 eighteen-month-olds and yearling bulls, some of which are the result of Sarah and Lydia's AI work and some of which came from the family's Palma Ranch in New Mexico. The previous year's sale earned a record amount for the family, and everyone is optimistic this year's bulls will bring in even more.

"I like selling yearling bulls," Sarah says. She doesn't like to sell eighteen-month-old bulls as much because "I have a lot of money in them and it's harder to get that money out when they sell."

McKenzie family members have driven in from New Mexico: Houston's brother Kenneth; his wife, Robbie; and two of Kenneth's sons, Travis and Malcolm. Cousin Malcolm always holds his wife Sandy's hand when they walk, and when he sits, she often sits on his lap. They all live on the McKenzie Land and Livestock Palma Ranch, forty miles west of Santa Rosa. "It's the New Mexico part of the operation," Sarah says. "We're a family business."

All of the McKenzies are wearing red button-down, long-sleeved cotton shirts with "McKenzie Land and Cattle" stitched over the heart. Lydia hands a shirt, still in its dry cleaner plastic, to one of the men who works the auction. "We hold onto them between auctions," Lydia says, "otherwise people will use them and they'll fade and look not so good." The auction won't start for another five hours, and already visitors have arrived. The McKenzie pens open at 8:00 a.m. on sale day. All morning, prospective buyers walk into the hay barn, visit a bit, pick up a donut and coffee and study the catalogue before walking through the pens. The McKenzies have ordered enough enchiladas and sweet tea to feed 175 people at the noontime meal. Sarah smiles and is friendly and walks toward people to say hello. She hugs them like she means it. Her father leans on a chair listening to someone at a table. Sarah's son Henry sits with a group of people drinking coffee. Sandy and Laura, Sarah and Lydia's mother, check people in at the registration table next to the coffee urn and hand out catalogues. Lydia's boys play with the other little kids. Curtis and some other men are out of sight, pushing animals in and out of pens out back. "I've got the best-looking sales team in West Texas," Sarah says.

Sarah's sale catalogue is two columns wide and twenty-one pages long, describing each bull up for auction. Each animal has its own information-packed square on the page: its date of birth, tag number and auction lot number, sire, dam, scrotal circumference, mature weight, carcass weight, ribeye area and docility. A higher docility value indicates a more tractable animal.

At the bottom of each square, Sarah has included some shorthand notes that expand on the bull's characteristics and numbers. "Calving ease"; "Use on mature cows"; or "Trust calves tend to be very gentle and deep bodied. We really like the Trust daughters we have." Some of this information is cryptic to an outsider: "AI SIRE Moderate framed easy fleshing bull that has a rare combination of high $E and high $B. A good mating cross for 10X daughters" or "AI sire powerful overall EPD profile."

The catalogue includes a glossary of terms along with the algorithms used to derive certain values, as in: "A predictor of a sire's genetic merit for milk and mothering ability as expressed in his daughters compared to daughters of other sires. In other words, it is that part of a calf's weaning weight attributed to milk and mothering ability." An animal's values are expressed across a wide range of differentials that encompass pounds, pounds per day, centimeters, difference, fraction of the difference, percentage, inches, square inches, dollars, dollars per head, yield grade and quality grade. All that data allows buyers to extrapolate bloodlines and predict the usefulness of their progeny.

The bulls are photographed standing in piles of straw. They are fat-bottomed, big-bellied, square-headed, broad-shouldered, flat-backed and low and heavy to the ground. They stand as if they know they are being posed against the corrugated wall behind them, as if they know a picture says a thousand words. Most photographs feature single bulls. Another image is a dozen bulls in a pen looking straight at the camera as though it were a class picture. Lydia's and Sarah's children appear in the catalogue too, smiling under their cowboy hats and wearing their embroidered McKenzie Land and Livestock shirts.

A welcome letter takes up the catalogue's front cover, thanking patrons for attending the sale and expressing gratitude for "three good years in a row to grow grass and raise calves." The 2016 calves were the most uniform calves the ranch had ever raised, it says. The letter promises continued refinement and a discerning eye toward selecting superior sires that improve the herd. "Given that our ranching conditions are more challenging, we do our best to select sires that are going to bring growth, efficiency, carcass traits and longevity," the letter reads. "Good Angus bulls that are raised here in our rocky, dry, tough country have added value. McKenzie Land and Livestock bulls know prickly pear, burro grass and chamisa and are grown out in large rocky traps; they are in good condition and ready to go to work."

Another note to prospective buyers appears on the page of sales terms and conditions. "Please Remember," it's written, "it is important to consider that these are young bulls; they will need to be taken care of to ensure that they continue to grow out good and will be able to serve your herd. It is essential that a young bull not get too thin and is turned out at a stocking ratio of 15 cows per one bull."

Bleachers face the pen where the auction will take place. This pen is bedded deeply with clean straw, which Lydia walks through, kicking at it to fluff and spread it out. Someone tests the heavy steel sliding door that closes off the sale ring from the chute, making sure it opens and closes with ease. Behind the door is a chute, empty at the moment. The chute leads down to the pens where the bulls are kept. When the auction starts, men on horseback and on foot work these pens to push bulls, in the order designated by the sales catalogue, down the chute and through this door. Once the bull is sold, it is shooed off the new straw, back through the door and down a lateral chute into a set of pens where the sold animals will wait to be loaded up into gooseneck trailers and taken to ranches all over Texas and New Mexico. On their new ranches, they'll be tasked with one thing: spreading their seed and "breeding up" the ranch herd.

This sale is the culmination of the last twelve months of work, and the McKenzies know they've raised quality animals. Hopes are high for record sales and confident buyers, but in the cattle business, there is no sure thing. In the hours before the auction begins, Sarah wonders aloud at their prospects. "If we get $10,000 for a bull, I'll be surprised," she says. "People have said to me—I'll buy every bull you have left after the auction for under $3,000 a bull, but I'm not looking for that number. I'm hoping our bulls sell for a lot more than that."

Out in the pens, the various lots of waiting bulls are separated into adjacent pens that feed into the alley leading to the sale ring. The prospective buyers, who are almost all men on this day, let themselves into a pen, close the gate behind them and walk toward the bulls, which tend to cluster

together in the corner. The men shoo them until the cluster breaks up, so they can size up the creatures and read the green left ear tag numbers that correspond to the sales catalogue.

Joe Williams is a buyer for Superior Livestock. After meditatively reading through the catalogue, he studies the cattle before him in the pens and summarizes what he sees, what he looks for. "I look at their height," he says. "Their weight. Their shape. Their feet. I look in their eyes. I look at their heads. I look to see how they look at me. Do they look masculine enough? Because they only have one purpose. Their data and statistics can tell me who their momma and daddy are, but who are they? People out here in West Texas with twenty-thousand-plus acres may only see their animals once every two weeks. Sarah doesn't breed for garden ranching—ranching and farming six thousand acres where it's greener and easier. She breeds for this area out here, specifically for out here."

Standing with crossed arms, the fingers of one hand absently tugging at his mustache, Joe appraises bull after bull.

"My strategy is this. I walk through the pens twice. Then I go in, have some coffee and a donut. Then I'll walk through the pens again." He nods at a bull in front of him. "He has a nice finish," he says, meaning the bull has a nice layer of fat. "Houston wants their bulls a little lighter so they're ready to breed and don't have to be put out to lose one hundred pounds. Females are in cycle every twenty-one days for about fourteen hours. She's built to be serviced in a very short amount of time. They are built to breed."

Not every bull is suited for every cow. A heavy bull that breeds a heifer that is not fully mature can seriously injure the cow.

Joe draws out the distinction and points out a particular bull. "Everything is modest on this animal," he says. "A good strong back. A breeding bull is about principle. Your strength depends not on your hands or your feet but your back. He's a perfect example of masculinity. He's an attractive animal. These are mature cow bulls. First calf heifers won't tolerate a huge first calf; they are too big. These bulls are good for

mature cows who have had several calves. Yearling bulls are used as a teaser bull. They'll run themselves crazy in a pen with cows. After twenty-one days, you pull them out and put a bull in, and the cow's waiting. That's how you teach a young bull to be a bull—give him a reason to be."

"To get their job done, bulls must be close to feed or they'll lose too much weight," Joe adds. "If they're running around for their feed, they're losing a week's worth of weight gain. It's easy to run off 1 percent body weight on an eight-hundred-pound animal. That's eight pounds lost on two hundred head at $1.28 a pound. That's a good $10 a head, a $2,000 loss by not setting feed near the animals."

The McKenzie bulls all seem to embody the aspects of a quality bull. They are all masculine, finished and balanced to me. Each animal is thick, black and very beautiful.

The crowd finishes their enchilada luncheon and begins gathering in the sale ring. Up on a riser, visible to all, is auctioneer Joel Birdwell from Oklahoma. Standing at the auctioneer's table, he pinches the front rim of his hat and lowers his head in a head-only bow when someone calls out to him, or holds his elbow straight, hand palm out and still in the air, or just smiles and meets someone else's eyes. "Bill!" "Nice to see you." "Good to see you." "Hi there," he says, almost to himself, the barn too noisy now for anyone to hear him.

Sarah gets up from a red plastic-covered table where she's sat with neighbors, buyers, cowboys who are here to help move and load bulls, Lydia, Houston, Bruce the agriculture extension agent and Curtis, her fiancé. This is the sixth year they've held the auction inside with tables and served dinner. People spread out, seeing friends they haven't seen in a while, visiting with people they're glad to see now.

Stray bits of different conversations fly around:

"There's a lot of good bulls out there."

"We're so isolated out here. Only a few people do AI out this way."

"He does a good job with the enchiladas, doesn't he?"

"We had a heck of a time."

"Pecos is a madhouse all the way to Carlsbad."

"I had to pull a bull because he got his head stuck in a feeder and had a huge bump on his head and an eye swollen shut. He scraped up his eye pretty good."

And then, to Sarah: "We've gotten a lot of compliments on our calves since we've been using your bulls."

She steps up the riser to the auctioneer's table, looks around at the settling-in crowd and takes the microphone. "I've got a wedding to plan," she starts, "but I can't do that until I do this auction. I hope Curtis will stay patient with me." There is scattered laughter. "This is a family affair," she continues. "We all work together. We've got good bulls this year, a complete set. I hope you enjoy them."

Joel, the auctioneer, steps in. "Calving ease," he says. "Right here you could find a bull that will work for you. The McKenzies will stand behind them. Great set of bulls. They work for the country. Selling in catalogue order. A few bids some people are carrying for people who can't be here."

He talks quickly, each word distinct. He holds the microphone and his body still, looking quickly down at a pad of paper, then up at the bleachers. His cowboy hat is wide, his belt buckle shines and he looks handsome and august.

"Here we go," Joel says. The door slides open, and the first bull steps into the fluffy straw. He snorts, looks at the crowd and walks to the edge of the pen. "A green garden bull on top and bottom," Joel says, "a real unique one. I don't know what his phenotype is, but he sure is pretty. One plus one ribeye and marbling," he says. "Calving ease—this first bull is from a first-year heifer. He'd work for any program."

Joel starts the bidding at $5,000, and when no one bids immediately, he drops to $2,000. Two ring men face away from the pen and keep track of who bids what in the bleachers. One of the ring men is Radale Tiner, the regional manager for the American Angus Association. He travels from Angus auction to Angus auction and knows many of the people here, has been on their ranches. The ring men hand-sign numbers back to the bidder: two fingers held up means two, a thumbs up means six, a crooked pointer finger means seven, the middle and pointer fingers twisted together means eight. The bidder nods and looks at the bull, then back at the ring man who is following his bid and either nods his head yes or shakes his head no. Joel watches the ring men's fingers. The ring men look only at the faces of the bidders.

"Two then," Joel says, "do I have three?" The bull is still and looks at the people in the bleachers. He is strong and bold indeed.

"Yes!" Joel says. "Do I have three and a half?" The ring men look at their bidders and cajole each incremental bid. "Four," Joel says. "Now four and a quarter. Four and quarter, four and a quarter, four and a quarter. Going once, going twice—sold at four and a quarter!" The winner holds up his auction number. Sarah writes it down. The door slides open, and the bull slips through.

"You wish you had!" Joel chides the buyers.

Over the next few hours, Joel and the ring men go through dozens of bulls. The top seller brings $10,000, but most sell much more modestly, around $2,800. Some go for less than $2,000. Sarah watches one such bull leave the ring. "I could have sent them to the packer for that price," Sarah says quietly, her face expressionless.

Cattle sold for about $3 a pound in 2015, and a five- or six-hundred-pound calf would sell for between $1,200 and $1,800. Back then, bulls like these in the auction sold for between $4,000 and $7,000 each. Following the 2015 price spike, ranchers flooded the market with animals, and today, cattle are sold for about $1.20 a pound. The more recent market was termed "the bottom low" and "the worst it's ever been" and "terrible" at every ranch I visited.

A few buyers wait outside for their new bulls to be sorted and loaded into trailers. "The price of a bull is painfully low," one rancher says. "I'd come here to get one and ended up getting six for about the same money. I'm going to have to come back, pick them up in two loads. They won't all fit in one trailer."

Lydia collects the pink duplicate sales sheets from ranchers. She directs the cowboys working the pens and keeps the loading traffic moving. This year's sale numbers are disappointing. Back inside, Laura says, "The auctioneer says everyone here's been suffering. We knew it was going to be low; we just weren't sure how low. Two years ago and last year we did really really good. Nothing sold for under $5,000."

In the months following the sale, the ranch returns to its routine. In April, the cows are bred and the heifers ultrasounded to check the quality of their carcasses. Bulls, cows and heifers for the herd are freeze branded, and the ones intended for the packer are hot branded. The McKenzies plant the alfalfa field. Sarah and Curtis are married in May and host a reception and dance after the ceremony at the Post Park near Marathon. Their first date was there; it's special to them. A band from Fort Worth sets up in the corner of the cement slab dance floor. As the sun sets and the birds stop cawing from the oak trees, the place gets cozy and dark.

"We're older," Sarah says. "We just want to have a party, and that's exactly what happened. Both families, everyone, is here and the wedding was just about perfect."

Dancing, men hold their women tight and push and spin them around the dance floor as the band plays country music. The men wear pressed jeans with faded crease lines down the front and back, the hem long and a little frayed at the heel, and vests and colorful starched long-sleeved shirts and boots. Most carry a pocketknife in a leather sheath held on their belts. All wear cowboy hats either low down on their brows or pushed back.

They do not pause or rush or bump into other couples dancing. Each holds his lady around her neck and down her shoulder with one arm, his hand spreading out across her back and, with his other hand, holds her hand chest-high. Each couple dances close. Women are in dresses or skirts mostly, in heels or in boots, and move backward in step, with either their thumb hooked around the back belt loop of the man they're dancing with or up under his arm holding onto his shoulder from behind.

There are steps in these dances, teachable moves, but each man takes the dancing into realms of his own expression, and the lady he's with follows. Lovebirds dance. Old friends dance. Just-met folks dance. Parents with their children dance. Brothers and sisters.

They move in and out of scant pools of light. The music surrounds.

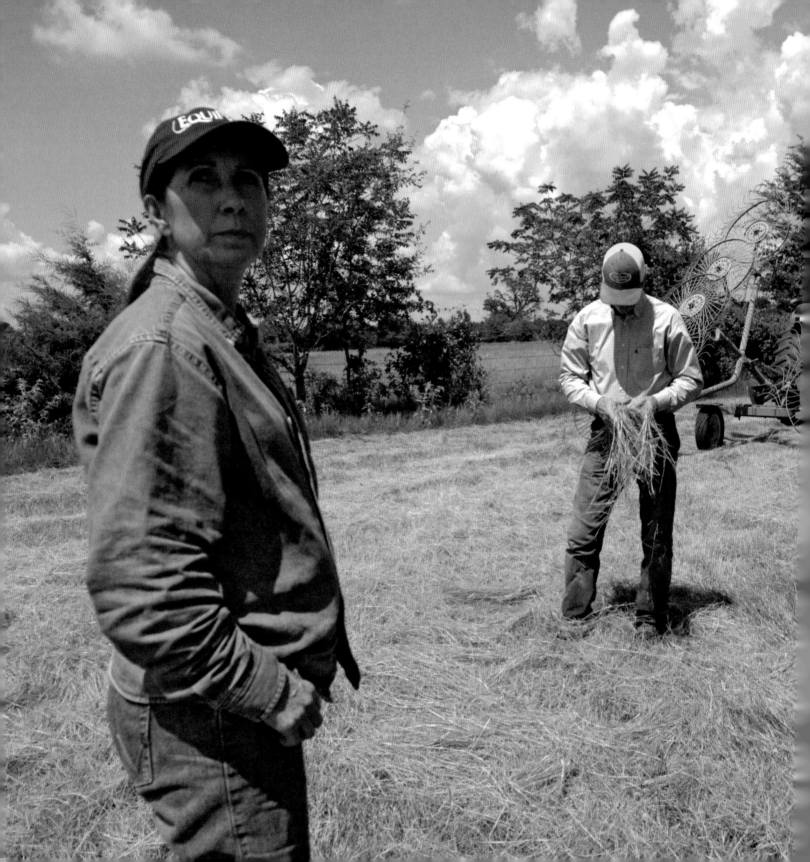

# DEBBIE JO HOLLAND

*West of Carthage, Born in 1959*

Debbie Jo, *left*; her husband, Terry; and their daughter, Khakie Jo, stand in their field of Tifton 44 grass they cut two days before. Terry pulls at a clump to see if it is dried enough to bale, something that usually takes one or two days. "It could also be dry within hours," Debbie Jo says. Knowing when to cut the grass and when to bale it is a vital skill on the ranch. If it's baled too soon, it will rot and be useless as feed for the horses, F1 and F2 cattle and rodeo stock the family raises. "But if you wait too long, the nutrition value goes down each minute you wait," Debbie Jo says. "It's a demanding master."

Her father-in-law experimented with different varieties of grasses on twenty acres of test plots before deciding on several varietals of Tifton in 1978 because of its hardiness in dry, wet, hot or cold weather. "He would compare the grasses side by side, year after year—the ones they said would be better than another, the ones everyone was planting, the ones he wanted to test and see," Debbie Jo says. "You have to see what's going to work for you. Some grass will work in the next county better than it works here."

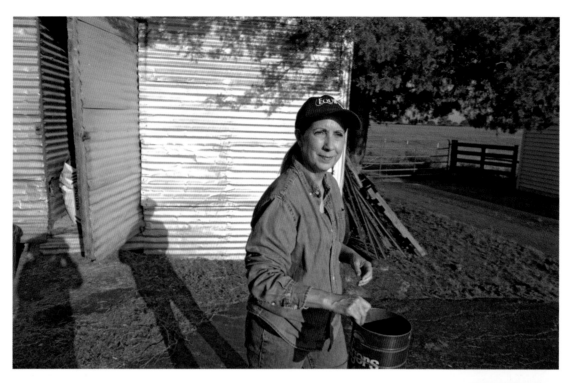
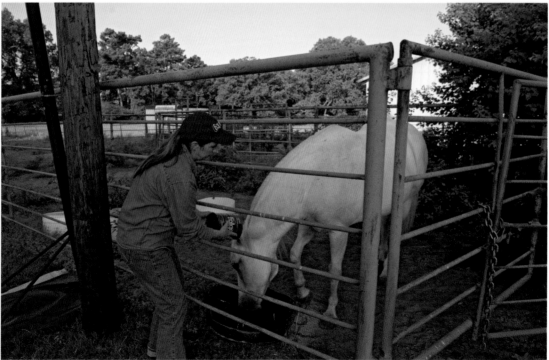

*Opposite, top* From December, when there is very little forage in the pastures, until mid-March, when wheat starts sprouting, Debbie Jo feeds the ranch's F1 and F2 cattle, the rodeo stock, the horses and the goat. She first feeds Cadillac, a gray mare that lives next to the house, then Hitch, a cat that lives in the shed. Then she drives the narrow road to the Holland Ranch pens and stops at the shelter there, where she keeps different kinds of horse feed in thirty-two-gallon plastic trash bins. She sets a handful of kibble down for MLF (My Little Friend), a gray and fluffy Maine coon.

Debbie Jo scoops earthy-smelling horse feed into buckets using a coffee can and then sets the buckets into the bed of her truck and drives a short distance to a spot in the middle of several pens. She stops first at the fifteen-ton cake bin and fills thirty-two of the five-gallon buckets that are stacked next to it with cattle feed, squatting under the bin holding the buckets while cubes pour out the open chute. She loads them all into the truck, covering its bed. "The truck filled with feed comes every eleven days from Foreman, Arkansas, to fill it," Debbie Jo says about the cake bin. Then at the hay barn, which is right behind the cake bin, she sets hay on the open bed of her pickup and drives behind the barn to feed the goat. "He doesn't have a name," Debbie Jo says. "He's not a pet. We used to have four, but they've all died." The goat is Khakie Jo's leftover 4-H project. Tufts of his hair on the chain-link fence mark his favorite scratching place. It would be easy for the goat to jump out of this enclosure, but he does not.

She drops feed and hay in Babe's pen. On the clearing's far side, she stands on a bucket in order to drop hay over the fence for the two other retired horses, Alf and Jet. "Jet's off a racetrack in southern Louisiana," she says. "He's a pole bending and barrel racing champion."

At the bucking bullpen, she pulls buckets from the bed of the truck. The bulls have walked steadily from their pasture, and now a dozen of them bawl and paw the dirt in anticipation of being fed. They are thick, heavy, low to the ground, horned, 2,200-pound animals, each with differently colored coats. Their black noses are as wide as my hand is long. "He's something, isn't he," Debbie Jo says about a gray bull with an extensive dewlap. "Their real names are just numbers," Debbie Jo says, numbers that Khakie Jo gives them indicating the year they were born, their sire and their mother. Their rodeo names are more creative: Monkey John, Swamp Ghost, Mr. Scratch, Friendly Frank and Squawk Box. "Bar 86 is always trash talking and causing a ruckus," Debbie Jo says of a black bull with a white face. When he bellows, he extends his neck, points his snout slightly upward and cries out with his mouth big and open. "He's on the bubble," Debbie Jo says. "None of the other bulls like him; he's always talking smack, and he could get sold any time."

Debbie Jo empties half a bucket each into troughs set in a great circle on the ground. She moves quickly, but not suddenly, and she keeps her attention on the bulls and their movements. The bulls find their place in the circle, each bull claiming a trough. "Hey, pumpkin," she says to Code Brindle, a tiger-striped bull. "Even if they're bad, even if they're on the muscle, even if they're a man hunter in the arena," Debbie Jo says as she reaches down behind the bull's horns, "some of them want to be scratched."

She leaves the bullpen and walks with a bottle for an orphan calf through the narrow alley between two pens, passing a retired bull named 11X. "Take care here," she says, walking quickly past his pen, "he means business with his horns." Terry found the bottle baby in a pasture on the other side of the fence from some yearling rodeo bulls the day before. "She lost her momma about a week ago," Debbie Jo says, "and she was just out there, eating grass and bellowing." At first, the calf runs away from Debbie Jo when she goes into the small pen. "Hey, sugars," she nearly whispers, and she taps the side of the liter-sized bottle until the calf takes it. I ask her if the baby will recover. "That's my specialty. She'll make it," Debbie Jo says.

*Opposite, bottom* Debbie Jo feeds Cadillac pelleted feed and hay twice a day. "The little green bits of grass in the pen is just gravy," Debbie Jo says.

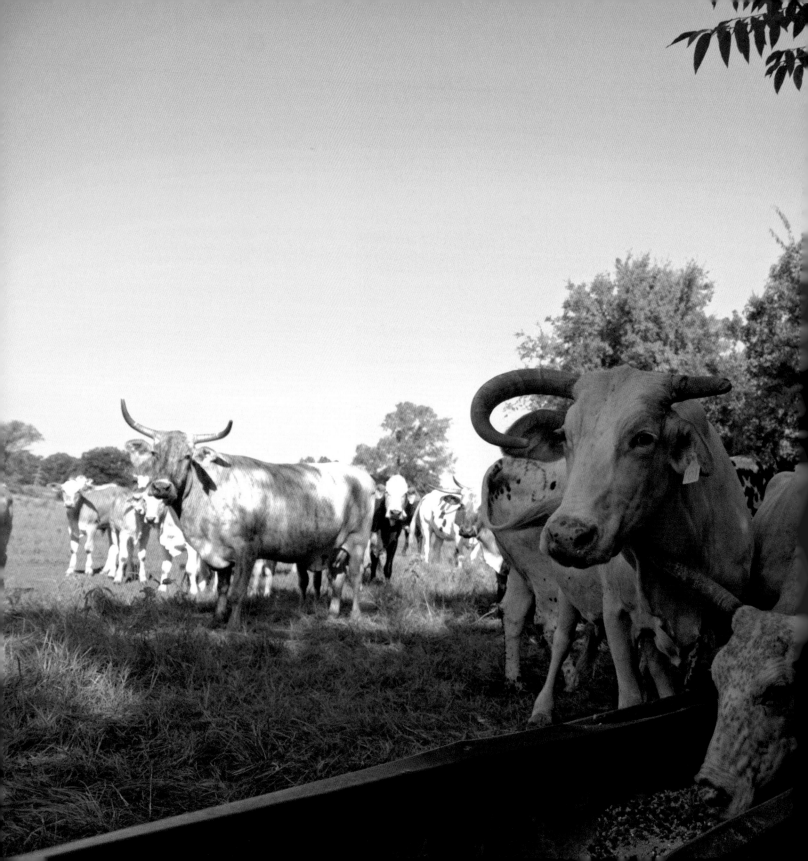

Rodeo stock cows and calves feed at a trough. "They're not regular cows and they're no particular breed," Debbie Jo says, "but these cattle have super bucking bull stock bloodlines." The Hollands' rodeo stock bloodlines come from well-known bucking bulls from the 1990s and early 2000s, like Mr T, Woflman and Rooster. Khakie Jo raises and leases bucking bulls to rodeos in nine states, including New Mexico, Oklahoma and Nevada, and Debbie Jo and Terry—who won a number of titles in his twenty-year career as a professional bull rider—help her. "I have a daughter from Houdini," Khakie Jo says, "and she's one of my main producers. All of her bulls have bucked and all of her daughters have produced buckers. She's a cornerstone."

The herd is motley and more feral than the ranch's F1 beef cattle.

In the late 1990s—during and following a four-year drought—Terry and Debbie Jo had to sell off more than half of their beef cattle and figure out how to keep the ranch solvent. "We were in danger of losing this lifestyle," Debbie Jo says. "Terry opened our cows to be bred to other people's bucking bulls at that time, and whenever they came to breed, they'd give Khakie a bull or a heifer. Pick of the litter, sort of," Debbie Jo says. Khakie Jo built her herd around them, and twenty years later, the Hollands' rodeo stock is a successful line of rodeo bucking bulls.

The family breeds "bulls who have made it" to their own F2 cows with the right combination of bone, body size, temperament and athleticism. They allow themselves time to see which young bulls hold promise as bucking stock. Once they are weaned, "we'll start feeding them and get them used to being handled," Debbie Jo says. "You start trying different things, see if they stand or buckle in the chute, see if they're scared or too wild. In the old days, 10 percent would buck. A buck is kind of like an extension movement, different than a bull scratching at a cinch or belt around them. The bucking's in their blood."

Debbie Jo and Terry talk in a field of cut grass just before they begin baling it. "People will cut and bale anything," Debbie Jo says. "As Daddy used to say, you can bale anything, but it's not much better than a snowball." Debbie Jo and Terry's hay has 14 percent protein "because of Terry's father's hard work."

*Opposite, top*  Debbie Jo and Khakie Jo line up feed buckets outside a pen. "We do what we do, all of it together, and we make it work," Debbie Jo says. "What God has provided for us to make a living in this world is our work and our fun. Looking at our new calves, watching some be born, the spring grass coming up—that's my fun."

*Opposite, middle*  Debbie Jo and Khakie Jo feed penned young rodeo bulls. After a couple of months, the family will make a decision about which bulls have the temperament and physical characteristics to be rodeo bucking bulls. "We'd do whatever we had to to keep Khakie's bulls," Debbie Jo says. "If we had to put them on life support, we would. We think about how it would be without bucking bulls. We feed them every day. But we couldn't ever get rid of them; Khakie Jo and Terry love it so much."

*Opposite, bottom*  Khakie Jo lines up buckets of cattle feed in the back of the truck. "The feed we order is good for young things and their growing and for maintenance for the grown bulls," Debbie Jo says.

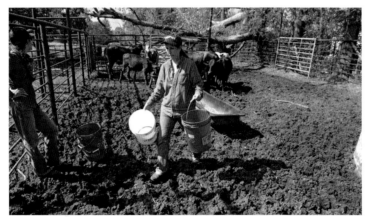

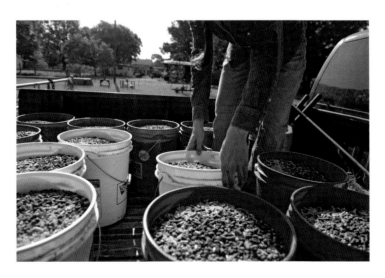

Khakie Jo and Debbie Jo set the table for dinner in the house the family shares. It is the house Terry grew up in.

Before marrying, Debbie Jo earned a BA in animal science and an MA in land economics from Texas A&M University. Terry was a champion bull rider and a brucellosis inspector. "I love watching animals eat," she says. "My love is genetics and nutrition. You want it to live, produce, flourish. I love things to grow. To nourish. The scientist in me wants to try to make it better. Then you temper that with being grateful. I'm using all the education I've got since I was little bitty and doing everything I've ever learned how to do."

After college, Debbie Jo worked at the General Land Office appraising land for a veterans' loan program in North Texas. "I was a single person and on the career track," Debbie Jo says. "It was a fabulous job." Her supervisor opened a private practice in Lufkin and invited Debbie Jo to work with him, so she moved to Lufkin.

"I prayed for God to send me someone to complete my life," Debbie Jo says, "and he sent me Terry." They'd known each other growing up and ran into each other again when Debbie Jo was in town selling culled cows at the sale barn. They started dating. "One night, he told me he had something to tell me, and I thought he was going to ask me to marry him," Debbie Jo says. "He was talking and I was so nervous I couldn't hear what he was saying. I finally realized he was still talking and he was asking if I'd go into the cow business with him. He saw my rancher's daughter's heart."

Terry gave Debbie Jo fifty-five cows as a wedding present when they married in 1988. Khakie Jo was born in 1992. Debbie Jo homeschooled Khakie Jo, who earned a rodeo scholarship to Stephen F. Austin State University in Nacogdoches, where she graduated.

Though working the ranch is hard, it's fulfilling and meaningful. "We've sacrificed in a huge way to have this way of life," Debbie Jo says. "We're not running the rat race, climbing the stairs. Our sacrifices have been financial. Our life now is our life in the future. We won't retire. What we do now is what we're always going to do. We're not packing away money so we can take a cruise. This is what we do and what we like to do. We work, and the work tells us when everything else happens."

Debbie Jo pulls a rake behind a tractor through a field of cut hay while her husband follows and bales it.

"It's not assured your children will love what you love," Debbie Jo says. On a piece of land next to one of the Hollands' pastures, a neighboring rancher fenced a parcel for his children to come back to, and houses were built for each of them. But it often does not work out; the land and the houses were sold. "That house there," Debbie Jo says as we drive down the small lane between her pastures, "is on its third or fourth owner, and they don't have anything to do with this land. They just bought the house."

"Seeing houses makes my heart do this," Debbie Jo says, and she interlocks her fingers and squeezes her palms together. "I want land to stay in production. One day, production land will be gone. You can't have a house on every speck of land and still have food. When people move in close to production, they don't like the smell or the sounds, they don't have a clue about what's going on on the ranch. They're not making any more land. They're not making any more. And they're not making any more water. I would like to see the country stay the country. All these houses are starting to infringe on my spot."

*Right*  Debbie Jo sits in the back seat of a truck between Terry and one of Khakie Jo's friends.

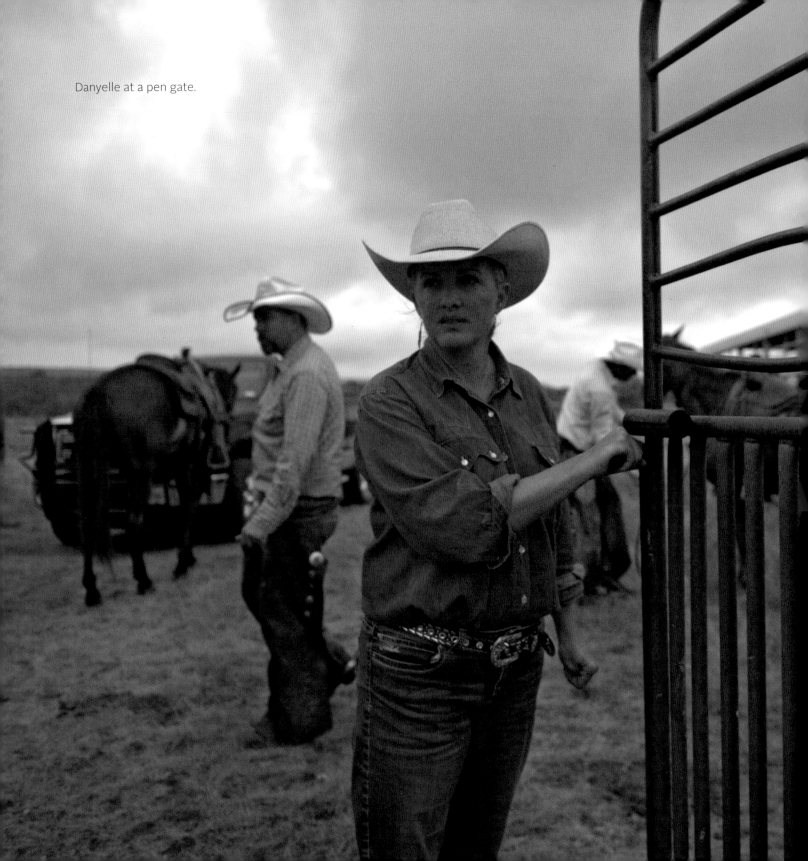

Danyelle at a pen gate.

# DANYELLE HEMPHILL

*North of Coleman, Born in 1976*

This narrow blacktop road toward Abilene was once part of the Great Western Trail, a thoroughfare route for some three to five million Texas cattle bound for northern markets in the last quarter of the nineteenth century. Cattle were walked this way to railheads in Kansas and Nebraska and shipped to ranches in the Dakotas, Wyoming, Montana and two provinces in Canada. The trail started in far South Texas near the Nueces River and ran roughly parallel to the better-known Chisholm Trail. The Hemphill Ranch, now in its sixth generation of family ownership, is in this broad, rolling country.

"Just come straight to the barn where we loaded in the horses last time," Danyelle Hemphill messaged a few days earlier. "We'll go from there at 7:00 a.m. with the cowboys."

The barn's light is faint from the road. A few hands sit in their trucks with the heaters running, but most are near the barn, leading horses to fenceposts and gates, where they are tied for saddling. Other cowboys cluster together on the caliche road, their hands deep in their pockets, stomping their feet now and then to keep warm.

Danyelle pulls up. "My car's thermometer says nineteen degrees," she says, getting out of her SUV. "That's Texas. It's going to get to seventy-five at dinner and we can go in and take off some layers." She's running a few minutes late after dropping off her grade-school twins with her husband's cousin. That part of the family manages the deer lease side of the Hemphill Ranch's business. "When they get busy with hunters, I help them," Danyelle says. "And they help me out when we've got a cattle working day."

Danyelle lives on this ranch with her husband, Heath; their nine-year-old twins, Ethan and Hadley; Heath's parents, Joe Pat and Alice; Heath's brother, Brent; and his cousin's family. Their four houses are connected by miles of narrow caliche roads crosshatched with cattle guards. As far as the eye can see, there is nothing but multigenerational Hemphill land. "We wanted our kids raised here," Danyelle tells me as we walk toward the barn. "I only ever wanted this kind of life."

Originally, the northernmost section of the ranch bordered the town of Albany and the southernmost boundary was Coleman, eight miles south of the barns. Over time, the ranch has been reconfigured and fragmented. "Six generations down the line, with all the inheritance, has made a lot of ranch fingers," Danyelle says. "Every generation divides the land more." Danyelle and Heath have tried to buy neighboring land, to buy back what was once part of the larger ranch, but so far that hasn't worked out. "Every time it sold, overpriced, to people who aren't from this area," Danyelle says, "and it's sold as recreational land, not cattle land." There still may be opportunity to make a deal in the next few years, if they're patient. "On bigger ranches, the land gets broken down between cousins, and that makes running it complex," she explains. "At some point, it gets so diluted down that some cousin will say, 'Let's sell it and be done with it.'"

Danyelle wraps a silk black wild rag around her neck twice and then ties it, leaving the ends long. She pulls out her low, blond ponytail from under it. Her black felt cowboy hat sits just above her eyebrows. She's painted her lips and nails and has on mascara. She hugs me and smiles and asks if I'm dressed for the cold. "In layers?" she asks and then nods in approval as I show her first the cashmere sweater against my skin then the thermal shirt and the wool sweater on top and my wild rag.

She pulls on yellow leather gloves as we walk. The rowels on Danyelle's spurs clink like tiny bells with each step.

"Our crew—pretty much everyone here," she says, "was born and raised nearby." These cowboys are not full-time employees of the ranch but rather part-timers, called dayworkers, who help out occasionally. "They're just a hired hand for the day," she says. "They get to be here without making decisions." Danyelle walks her young sorrel gelding, Goose, out of his pen, ties him to the wall, puts a wool blanket in the middle of his back and disappears into the tack room. She returns carrying a heavy leather saddle low in front of her, leaning back as a counter weight and stepping widely. She walks up to Goose's left side and, in a single motion, throws the saddle up onto his back. She pulls the front cinch tight to secure the saddle and then fastens the flank cinch loosely around the horse's barrel before tightening the front cinch again. She pulls hard on the left stirrup to flatten out the leather and get the stirrup to lie right and then walks around the horse, her hand on him the whole while, and pulls on the right one. She puts on his bridle, feeding the bit into his mouth and catching an ear at the loop. She crosses the leather reins over his neck. Goose is dressed now, from his bridle to his saddle strings.

The horse I ride at the Hemphill Ranch is a ten-year-old palomino mare named Jewel, a good, solid ranch horse. "In the pasture you're in the big wide open," Danyelle says, "and she'll keep you safe."

We stand with our horses as the men load theirs into the covered trailers. When it's time to load Goose and Jewel, the cowboys shoo the horses in one after another. Ours go in easily. The clomp of hooves is loud and sounds as if the animals might break through the floor. Horses are herd animals with a pecking order, so it matters which horses ride near each other in a trailer. You would not load, for instance, the boss mare next to the lowest-ranking horse because they might squabble inside the trailer and upset everyone inside or, worse, hurt each other. As horses are brought to the trailers, voices call out, "They'll ride together" or "They won't bother each other" or "He can ride up in the front with the other two" or "She's got to ride alone." Heath's gelding steps halfway in and then abruptly changes his mind, backing quickly all the way out of the trailer and rising up as he does so. The cowboys call out, "Whoaa," "Get on in there" and "Quit it!" until he loads. "He's a hard one to load sometimes," Danyelle says.

With the trailers loaded, men jump into the trucks or into the truck beds. Ed is family who works cattle for the Hemphill Ranch in exchange for culled calves. He sees an empty seat in Danyelle's truck and jumps in. "You got the long straw," Danyelle says, smiling at him as we bounce toward the pasture on the other side of the main road and slide into each other on the truck's slippery seats.

Today's crew includes Danyelle, the 1998 Miss Rodeo Texas and an Abilene native, married to Heath since 1999; Heath, serving his third term as Coleman County's district attorney; Joe Pat, aka JP, a large animal vet and Heath's father; Ed, a Hemphill family member; Danny, a neighbor and a retired Texas Ranger; Lanham, a childhood friend who runs a few cattle on leased land nearby; Jody, another childhood friend who runs cattle on leased land and green-breaks Hemphill foals; Walt, a high school senior who bulldogs in rodeos; Jesse, the ranch foreman; and Rustin, who is "trying to get his own herd going" and buys culled calves from the Hemphill Ranch.

It is early December, and almost all of the Hemphill Ranch's cows have calved. "If they are tiny-tiny, we'll leave them in the pasture," Danyelle says as the horses are being offloaded, their reins handed to each of the riders. Riders take the reins in their left hands and grab a handful of mane at the saddle horn. They step into their stirrups with their left feet and throw their right feet over the backs of the horses in a single pull-up motion. It looks as smooth and easy for them to get up on these animals as it does for someone to step into a car. Danyelle pauses for a second at the top of her swing to stand on one foot before deliberately throwing her leg over.

The riders gather at the gate. The horses snort and stomp, knowing that the workday is starting. "My horse is gonna wanna take off first thing," Danyelle says. The cold air and early morning light make it look as though horses and riders blow smoke when they exhale. "Jewel will keep up about the first hundred yards then want to walk. You do not have to keep up. I'll get Goose settled down in a minute," she says and turns Goose around, trotting quickly up the fence line with the men as they leave. Winter grass is brown and burned by the dry and cold and touches the underbelly of the horses and the bottoms of our boots. Mesquite trees grow irregularly all over, either small enough for the horses to step over or tall enough to scrape at your hat when you ride under them. There is prickly pear cactus. For protection from the thorny brush, everyone rides with either ankle-length chaps or the short-legged version called chinks, most of them custom made with the wearers' initials stamped into the tooled leather at the hip. Many riders wear big, round, prize belt buckles, won over the years in steer wrestling, bronc riding or barrel racing at local and state rodeos.

Today, this crew will move several hundred animals from two different pastures into the distant pens. The calves are very young and will be close to their mothers or tucked away and hidden by them in the brush. "This pasture is doglegged," Danyelle says, "and the cows and calves like to hide over in the dogleg by the road."

The pasture is tackled by different groups of cowboys so the wide-open space gets covered as efficiently as possible

and every animal is found. Heath decides on three groups. Danyelle, Danny, Rustin and Jody make up the group closest to the pens, the crew closest in. The second group will stop toward the middle of the pasture, and the third will go until they reach its back boundary. The farther they have to go, the farther they'll have to ride, and they move quickly. Within seconds, the other two groups are out of sight and the pens, trailers and trucks are left far behind.

At the pasture's farthest point, the group of riders turns around and spreads out as far as they can while still being able to hear one another call. More than a football field of hill, brush, grass, trees, prickly pear cactus and dry creek bed separates each of them. They begin riding toward the second group and the pens, sweeping the land for cows as they go and chasing any that try to make a break from the herd or head in any direction but south. Each subsequent group of cowboys assures the growing herd stays together and pen-bound.

In the pasture, on their horses, the cowboys don't talk. Instead, Danyelle and the men listen for the calls of the other cowboys farther down the line, listening for short howls that signal the location of the individual riders and the herd on the move. They must rely on listening to figure out what's happening and when.

"We should get to our spot," Danyelle says. "You've got to imagine an invisible line and we're each on it." Goose walks down a wide *sendero*, an open area through the trees that's been graded by a bulldozer. Danyelle stops from time to time to let out a "woo-hoo" and waits for a similar call to come back. "Jody's ahead of us and so's Danny," she says. "We'll need to catch up."

Another series of woo-hoos drifts in the air, and we know that the cowboys farthest away have reached the end of the pasture. Jody appears on horseback and pushes a few cows and calves toward Danyelle. They run out into the *sendero*. She rides hard toward them and turns them south. She stops, listens and then walks Goose again.

"Woo-hoo," the cowboys call.

Riding is a mix of loping, trotting, walking and standing still. It's everyone's job to keep all the animals moving toward the pens. Any cows and calves that rush out are pushed back into the herd and sent into the right direction by whomever is closest. There are bursts when Danyelle pedals her horse to get in front of the cattle, bursts when another group of cattle makes a break for it and requires redirection. Jody comes out of the trees and then goes back in, zigzagging fast and scraping under mesquite branches to turn a cluster of black Angus on the run.

Danyelle hears the second and third groups of riders approaching. "Here they come," she says. She moves quickly to the top of a small rise just ahead. Cowboys are all around, galloping in front of cattle that are trying to break away and walking behind the slower cattle to keep them moving. Danyelle adds the cattle she's pushed from the *sendero* and chases after a pair that try to split. "Get their noses pointed in the direction of the pens," she says. Jewel knows this work much better than I and tears off through brush to chase down a cow and her baby, turning mid-step as the cow does, moving between and under trees. I nearly come off. Danyelle hollers encouragement. "Keep your feet out in front of you, your heels down and push your Dickies into the back of your saddle!"

There are almost two hundred cows and two hundred calves in the herd, and having been chased, gathered, goaded and pushed from the four corners of this great pasture, there is movement everywhere. The herd takes up more room than a city block. Each adult animal weighs more than nine hundred pounds. The ground shakes as they move along, a great roiling of trotting cattle, darting horses, yelping cowboys and bleating calves.

As everyone and everything goes over the top of the last rise, the pens are in sight at the bottom of the hill. The cowboys string out alongside the herd, pinning the cows and calves against the fence line and creating a kind of tunnel for them to travel down. Others ride at the back, pushing the herd forward. The horses come over fast. My cowboy

hat blows off. Danyelle turns her horse, picks it up and then trots up next to me. "Your owl feather's still there," she says, knocking dust off my hat by banging it on her knee. The hat's stampede strings, which are tied under a rider's chin, are meant to keep a rider's hat from flying off. "Your stampede strings didn't do you much good, did they?" Danyelle says, handing me the hat.

The cattle run through the pen's open gate, and the cowboys stop short and let the animals by. Everyone counts the cattle as they go. Heath and Danyelle compare numbers. "The count's good," she says. "We didn't leave any in the pasture."

The riders walk their horses into the pens behind the cows and separate the babies from their mothers by letting small groups of the herd, a little at a time, into a smaller pen. Then, from horseback, the calves, hip high and between forty-five and sixty days old, are peeled from their mommas and funneled into another pen. They bawl for their mothers. The cows, separated from their calves for the first time and moved on to yet another pen, stand by the fence with their mouths open and bawl to their babies, sending out distress calls like great foghorns. One cow keeps turning, putting her body between the horse's legs and her baby. Rustin, on horseback, takes his rope and catches the calf's back legs, dallies the line to his saddle horn and slowly drags the calf behind his walking horse over the dusty, trampled ground and into the pens with the other calves.

The crew rides on to the next pasture, closing the working pen gates from horseback behind them as they go. They'll clear this pasture too of cows and calves and drive them here.

I walk Jewel to the side of the horse trailer and talk to her: "Thanks for working so hard, Jewel, and thank you for not throwing me; I'm sorry I'm not a better rider." She rubs her face and head heavily against my back. I pat her hot neck and tie her reins to the side of the trailer. She bends her head down for some grass at her feet, reaching for the tops with her lips. "As long as she can't get bound up," Joe Pat

tells me as I walk back into the pens to help him set up for what's next while everyone else is out gathering cattle. "It's as good a spot as any."

The ranch is the assemblage of what was once Joe Pat's father's family ranch, his mother's family ranch and other acreage Joe Pat and his wife, Alice, managed to acquire over the years. Hemphill Ranch uses several brands. "CV" is the oldest Hemphill Land and Cattle Company brand; it goes back to Joe Pat's grandmother Carrie Morris, who was the daughter of Jasper McCoy, the original Hemphill forefather to acquire and settle this land. "This land was passed down through the women," Danyelle says. Jasper McCoy passed it to his daughter, Carrie Morris, who passed it to her daughter Jo Morris Hemphill, who passed it to Joe Pat. The "JZ" brand was established by Jo Morris Hemphill and her husband, Zeno Hemphill, and the "HB8" brand is used by Heath and Brent.

Except for his years at college and veterinary school, Joe Pat's been here his entire life. "If I don't die before Monday, I'll be seventy," he says.

A variety of equipment is arranged on the flat bed of Joe Pat's Dodge truck. There's a large can of WD-40 to spray on locks and gate hinges on the chute; a generator; ear tag applicators; a blue metal tackle box with a pen, some wire and a variety of screws and nuts in it; a gallon jug of blue disinfecting chlorhexidine; two Igloo coolers that keep the vaccinations chilled; one Arctic cooler stocked with Dr Pepper and water; a roll of blue shop paper towels; orange insecticide ear tags that smell strongly of chemicals; and two half-gallon buckets containing a dehorner swimming in chlorhexidine and a single-blade pocketknife and whetstone, also swimming in chlorhexidine. Joe Pat hangs this last bucket on the chute with a bent piece of wire.

The sun warms the day by a few degrees. There's a winter light, a bright, sharp light that make you think we could all be out here in shorts and T-shirts, grilling meat and drinking beer. But the wind blows dry and cold and chaps our lips, cheeks and hands white. Everyone stays bundled.

As a rancher and large animal vet, Joe Pat has spent years selecting cows, bulls, calves and horses for the traits he wants to perpetuate on his ranch. The cattle born here without the specific traits he wants are hot branded, left unbred and sent to market before they turn one year old. The Hemphills breed their horses too and keep the top ones for themselves and usually find buyers for the rest by the time the horses are three years old. "Just like our cattle have a reputation of being high-quality beef animals," says Danyelle, "our horses have a reputation of being good ranch stock."

All of the Hemphill Ranch horses trace back to a stud named Two Eyed Jack, a well-known working ranch horse bloodline. The mare Joe Pat is riding, a speckled gray beauty, is the one his granddaughter Haigen usually rides. "Haigen and her mare have a special relationship," Danyelle says. "They understand each other." Joe Pat expects teenage Haigen to help work cows at the end of the week, and he wants to make sure the horse remembers what she's there for. "Most of these animals need a little adult supervision from time to time," Danyelle says.

The Hemphills' stud, Cinco, is a great sorrel stallion whose bloodline goes back to Colonel Freckles and Two Eyed Jack. Danyelle keeps him in a pen near the house; in a pen next to him is Leroy, their nine-year-old daughter Hadley's horse. "Leroy's an old man," Danyelle says.

Cinco fits the description of what the Hemphills seek in a stud, she says. "We want a sweet disposition, chill, strong bones so they can work three days in the rocky terrain we have. Strong feet. We don't want a horse that's fragile. And it's all about the disposition—what's between their ears. He's got cow sense, something you can't teach. You can do anything on them—go fast, go slow, take them to town if you want to. When you're around horse trailers and barns like we are, we can't worry about anyone who is walking around. We do not have a horse that kicks." Some ranchers have moved away from using horses in favor of four-wheelers or helicopters, but not the Hemphills. "We do all our ranch work on horses," she says. "Horses pose some uncertainty;

they have moods and personalities just like people. You may get on him and he may be in a frisky mood, or he may think he knows something and not listen. We try to keep up with the changes in our world but still keep up roots in the heritage it was built on."

Joe Pat agrees. "Used to on ranches," he says, "you'd have a broodmare and that's the one you'd breed to. You'd ask everyone on the ranch why they'd pick that mare, and they'd say she was the one no one liked to ride, so why not breed her instead. What was happening is that ornery streak was getting bred into the horses. Here, we ride them to see if we even want to breed them. We'll only breed the ones we like. For us, we won't breed her until we see she's good enough to be a ranch horse."

While waiting for the second round of cattle to arrive, Joe Pat and I stand in the sunlight while he fiddles with his calf processing tools and connects a propane tank to a branding pot. He sets the branding irons in it, letting the propane-fed flames blow over them. Then we walk around the pen near the parked truck and cut mesquite tree shooters out of the ground. We throw the thorny branches over the pole fence and into the pasture.

We talk about a lot of things: President Trump (he's against), euthanasia (he's for), abortion ("That baby is in her body; I have very little to do with that"), castrating with a sharp knife as opposed to a band ("A sharp knife is mostly what you need. Banding is inhumane and is sure to give you a festering wound; it's too open for too long"), being intimidated by a horse ("You most definitely have to insist your will upon the horse, otherwise they'll do what they'd like and it probably doesn't have anything to do with what you want; she'll know how you feel before you know how you feel and she'll use it to her advantage"), his three heart valve replacements (both porcine and artificial porcine) and alcoholism. Joe Pat's youngest son, Brent, died just a few weeks before, mostly from complications due to his alcoholism. "His problem started a long while ago," Joe Pat says. "Hell. We all drink. But through a series of choices and

friends who aren't really your friends, he couldn't find his way out. I'll drink a couple of drinks, and if I go out with my buddies to fish in a cabin somewhere I might have some more, but I won't let it run me. At some point, you have to choose what you're going to do."

He's been talking and looking toward the fence where the speckled gray mare is tied, watching her stretch and adjust. She has her hind legs extended and locked behind her, putting as much distance between her back hooves and her front hooves as she can and letting her belly hang down. Her head is raised high. She'll stand that way a while, then step to the side and swish her tail and get into the position all over again.

"Something's hurting Haigen's mare," he says. "She's very uncomfortable." He walks up to her and palpates her belly, her side and her back with both of his hands. He looks straight into her face and under her tail. "It looks like she either needs to pee or have a bowel movement," he says.

He drives out in one of the trucks back to the barns and returns with an analgesic and a mild sedative he squirts into her mouth. The horse spits out a ball of grass, and Joe Pat picks the wad up off the ground and smells it, checking to see if she spit out the sedative too. "I remember now what a terrible patient she is," he says. After a few minutes, the horse quiets and stands as any other horse. Joe Pat keeps an eye on her.

I can hear and feel through my feet the herd coming before I can see them. Someone has ridden ahead and opened the gate, and soon, cows and calves rush in, the cowboys stopping on the pasture side of the pen, counting. Danyelle ties her horse and then shoos calves into the calf pen as mounted cowboys separate them from their mothers. "Haaaa!" she says, holding her arms out above her head, her feet spread wide, taking up as much of the calves' view as she can. The calves bunch and surge in a group.

Gathering this group had taken longer than usual. The cowboys had moved the herd through most of the pasture when a very young calf too small to keep up started bawling awfully. Its mother broke rank and doubled back for her calf, and other cows and calves followed her, "which caused a mess," Danyelle says. "We thought he'd just stay put," she says. "His momma would have found him after all this. We got so strung out, cows and calves everywhere. We finally got him with the group."

By the time they finish separating the animals, it's noon, and the cowboys step out of their chaps and chinks and hang them on the fences around the pens. They pile back into trucks, horse trailers unhitched now. They bounce back toward the main road and return to the barns they left that morning. Next to the barns, beyond a cattle guard built into the road, is the ranch foreman Jesse's house. The cowboys wait outside in the sun until Patty, Jesse's wife, calls them inside.

They walk into the cozy house, some taking their cowboy boots off first and piling their duck jackets on top outside the door. All leave their wool vests on. All take off their cowboy hats, setting them in a row on the back of the sofa, and then walk through the kitchen's buffet line. Patty's spread takes up the stove counter, the stove and all around the sink. They serve themselves: beef ribs; beer bread, in which beer is used instead of yeast; beans with bacon and brown sugar; cubed potatoes with cheese baked on top; green beans with onion and bacon; grape salad; quinoa salad; buttermilk pie; a gooey cheesecake with colored sprinkles; and sweet tea in large tumblers. They do not pile their plates with food. They serve themselves normal portions. They take a seat either at the big kitchen table by the front door or at a card table set out by the hallway. Patty asks, "Mr. Hemphill, what can I get you?" and "Jody, are you okay?" and "Ed, are you going to get seconds? I always get seconds and skip dessert." Everyone cleans their plates. The food is delicious.

Within about twenty minutes, as soon as everyone has eaten, they stand and leave at once. Back to the trucks. Back to the bouncy road. Back to the pens.

Danyelle is on the phone with the Coleman County Medical Center, a nineteen-bed hospital that has served

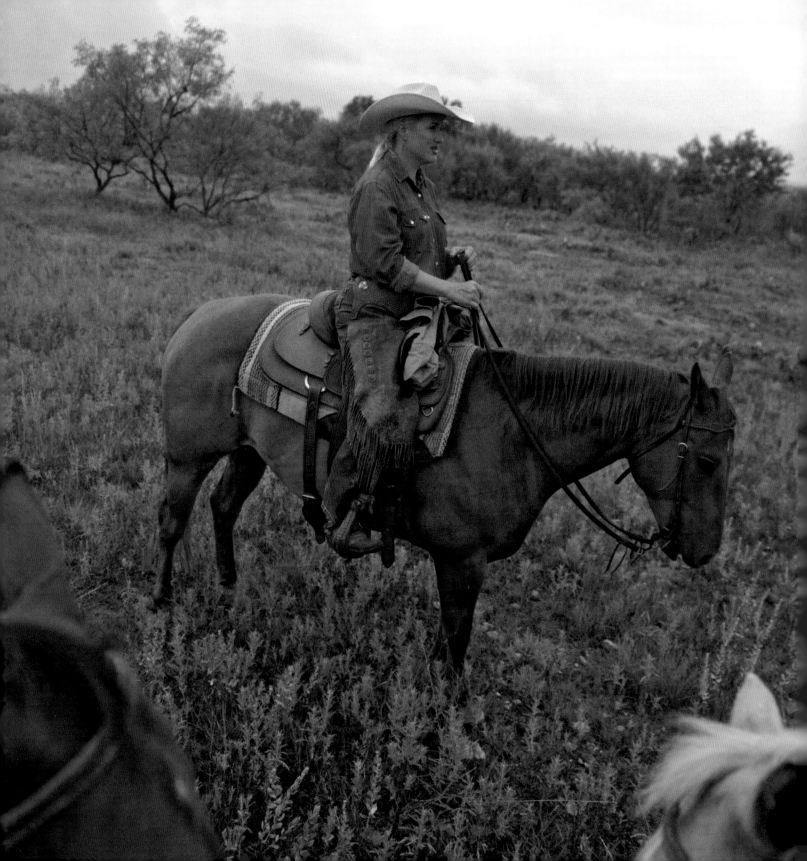

*Opposite*  Danyelle, on Goose, waits for cattle
to be pushed into her part of the pasture.

*Above*  Haigen, *front*, Hadley, *back left*, and
Madison, Jesse's granddaughter, sit on the back
of a truck.

Ed and Danyelle ride in a four-wheeler on their
way to pick up a truck and horse trailer.

*Opposite, top*  Danyelle unties her chinks before
processing cattle in the working pens.

*Opposite, bottom* Heath, *left*, Danyelle and Jesse,
the ranch foreman, talk before starting the
afternoon work.

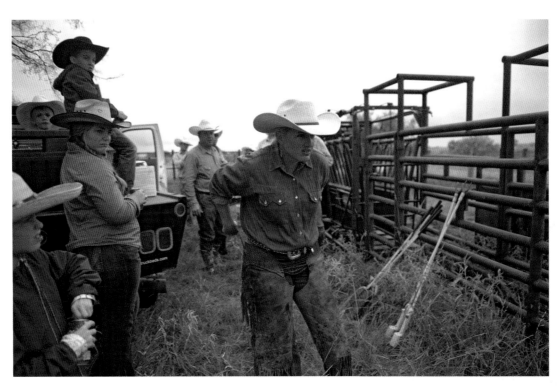

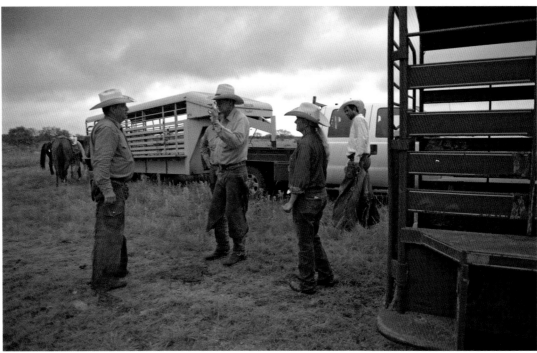

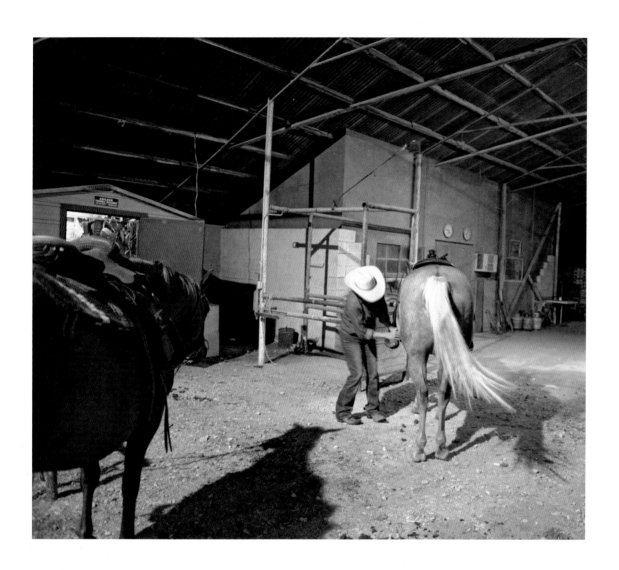

Danyelle saddles a horse in the barn
before sunrise.

*Opposite* Danyelle pets Leroy, her
daughter's horse.

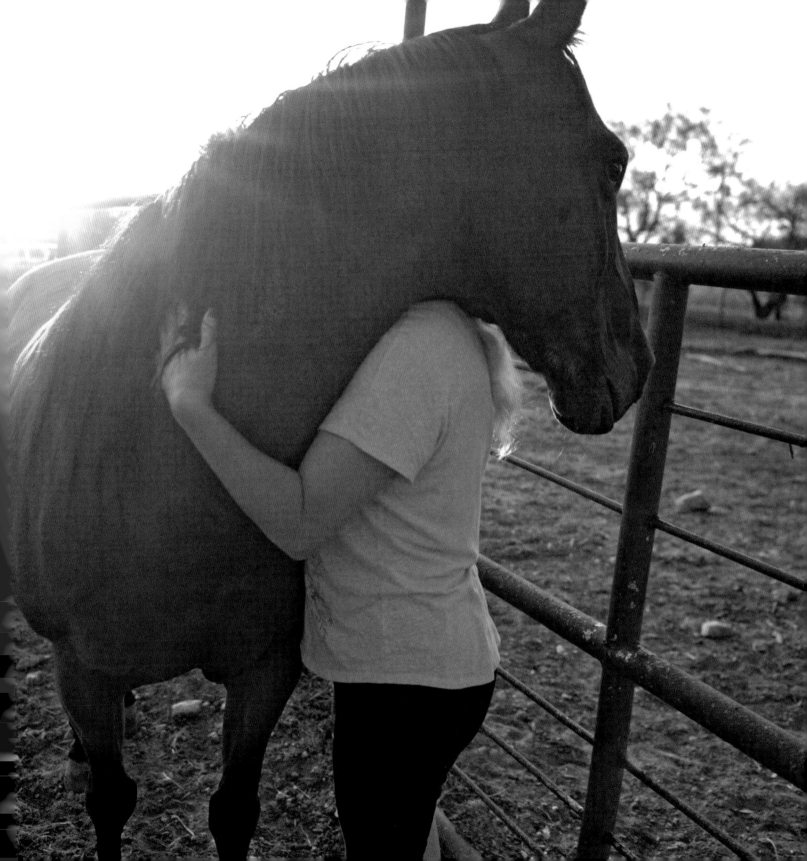

*Opposite, top*  Danyelle lets the family's cat out while her son, Ethan, eats breakfast.

*Opposite, bottom*  Ed, *left*, Danyelle, Heath and Joe Pat, *right*, help themselves to dinner at Patty's house.

*Above*  Danyelle waits to administer prophylactic shots and vitamins.

Everyone works together to push the cattle through the gates and into the pens.

*Opposite, top*  Danyelle visits Granny in hospice.

*Opposite, bottom*  Cowboys load horses into a trailer.

*Above*  Danyelle picks out a Christmas tree with Hadley and Ethan.

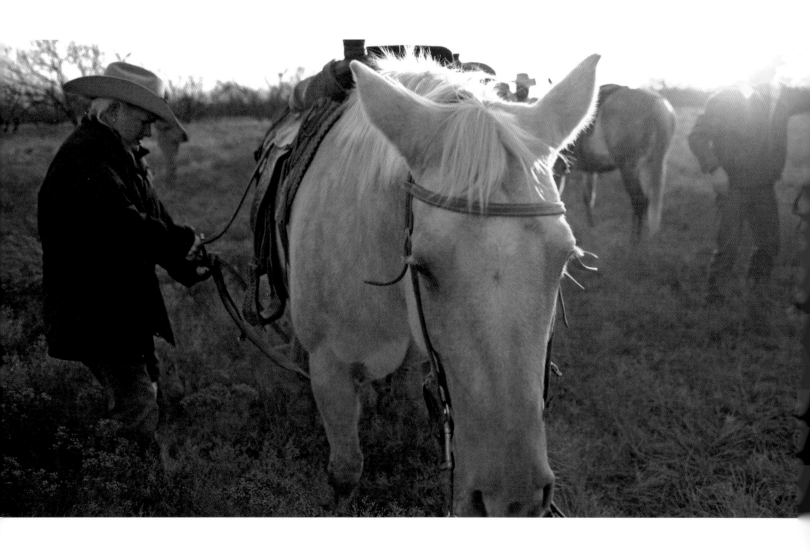

Danyelle adjusts the flank cinch on Jewel
before loading up and heading out.

Coleman County residents since 1923. The hospital is a small brick building in the middle of Coleman, across from the courthouse and library. It is the only hospital within thirty miles. Danyelle is on the hospital's board of directors.

"I don't want her to be in pain or overly anxious," she says into the phone before hanging up, "but just call me."

Danyelle's grandmother is in palliative care at the hospital. She's been there a few days after being moved from the nursing home where she has lived the last eighteen months. The hospital nurse says she's nonresponsive. Danyelle has just sorted out her grandmother's advance directive paperwork, signing a DNR order on her behalf, something she'd spoken to her ninety-three-year-old grandmother about several times while her grandmother was still in good enough health to do so. But Granny had said she didn't want to talk about it at the time—that she was fine, that she didn't want to think of that. The document has only now been finalized. Hadley and Ethan gave a fiddle and guitar concert at the nursing home a few weeks ago, and Granny was in good spirits then, clapping and talking, happy her great-grandchildren had taken after her own love of music.

"My grandma is my responsibility," Danyelle says after hanging up. Granny has other family nearby, but Danyelle handles most of her care. "I hope she holds until after Christmas. I know that's terrible to say, but I've had three bad Christmases in a row, and I'd like this one to be okay."

At the pens, the cowboys are pushing calves through the chute. Joe Pat holds a clipboard with a sheet of paper and his handwritten list noting each animal by ear tag number. He records each of them as they come through the chute, another measure to ensure the Hemphills have accounted and cared for all of their animals.

Danyelle keeps a notebook at home that she calls her "Ranch Key." In it, she takes notes on exactly when to put the bulls on heifers, when to vaccinate with seven-way and vitamins, when to worm, when to set out hay in the winter, the recipe for the chemicals they use to control prickly pear and mesquite, when to order what from the feed store and when to seed.

Not all ranch women are as deeply invested in the ranch's daily and seasonal decision-making as Danyelle. "So many women can ride along and be the gate opener," she says, "but Heath wants me in on all the decisions. It's a partnership with us. We tell each other everything. It's all out there. He doesn't want me to just know something happened, but how and why it happens."

Joe Pat calls out that the modified styrofoam cooler he uses to hold the liquid nitrogen and the cold brands is missing, and Danyelle heads back to the barns to retrieve it. It's a regular white cooler that he's cut slots in to allow the tops of the brands to stick out upright while the cooler lid is on.

Rustin and Ed feed calves down the chute, single file. Rustin stands behind each animal, lifting its tail. "This one's got balls," he says, or simply "bull" or "heifer. He pushes his hip up to the animal's backside, urging it to walk into a kind of swiveling table with a door that opens, called a calf spin chute. Of each of the female calves, Heath calls out "keep" or "ship." Lanham and Jesse work the brands—hot for all steers and the heifers the Hemphills will sell young, and cold for the heifers the Hemphills will keep. At the same time, Jody ear tags and vaccinates, and Danyelle cuts a notch in the tip of the females' ears and cuts the tip of the ear off the males so that forevermore, the shape of their ear will quickly communicate their sex to anyone. The table with the calf is righted, the chute opens and the calf jumps out, shaking its head, swinging its tail and running for the clustered calves in the corner.

Rustin stands between calves in the chute, pushing the next one with his hip while pulling up its tail. "Bull," he calls out, and the animal surges forward with such force it nearly goes all the way through the swing chute. Walt catches the calf's head and twists it, pinning the calf against the chute and holding his snout in the air. Rustin and Jesse swing the table down, and it stops parallel to the ground with a big, rusty-sounding clank.

Heath opens the small door by the bull's back leg, Rustin pulls the top leg out to help still the animal and Heath takes the pocketknife out of the bucket. "This knife has probably cut every bull for the last twenty years," he says. Heath keeps the quarter-size pelts he cuts from the calf's scrotums in his cotton waist pouch and counts them at the end of this run. Slice. A red-veined white testicle pops out, as fat as a cherry tomato and as long as a thumb. Pull. Push. Another testicle pops out. Grab. Push. Grab harder. Cut. "Joe Pat's got a certain way he wants it done," Heath says. "He showed me in the '90s, and I'm the one who does it. You can't cut them too much because they'll bleed too much. You can't cut them too little because they won't bleed enough. You need the blood to help clean the wound." He throws the testicles into the small bucket at his feet. They'll be fried for supper later. Then he tosses the pocketknife into the chlorhexidine bucket.

Another calf is on the spin chute. Jesse and Lanham are across the table and pull two firebrands out of the branding pot, which is a small steel barrel with the side cut out and a length of propane-fueled flame blowing through it. One iron is the letter *C*, and the other is the letter *V*. Danyelle clips the calves' ears with pruning snips that most people use for trimming roses. Joe Pat paints a green tattoo on the ear, the mark used to show the calf's been vaccinated against brucellosis. The front of his chinks and backs of his jeans are stained green with the ink. Jody injects the seven-way vaccine and a dose of vitamins, which boosts their immune system in the tough winter months. The table is righted with another metal bang, and the chute opens and the calf rushes out. All of this is managed in a few seconds, done without talking, everyone moving so in sync that nothing is left undone, no one gets pinched on the swing chute or hurt by the 275-pound calf. The calf shakes it off, kicking its back hooves in the air just out of the chute, as if recovering from a fall.

"It's quick," Jody says. Jody is tall, lean and hearty and has an easy, slow swing in his voice. His smile is calming and friendly, and like all the cowboys here, regardless of age and because I am the new one and here with Danyelle, he starts nearly every sentence with a "yes, ma'am" or "no, ma'am" or "ma'am."

The next calf is a heifer. "Heeeefer," Heath calls back, then "keep." These animals are beautiful, healthy, thick-coated things. Again the table falls, the calf's head is turned, the leg is pulled, but this time, Lanham shaves the hip with the clippers, sprays water and alcohol on the hide, wipes it down and sprays it again to "help the metal conduct and the brand take." Jesse takes two irons out of the liquid nitrogen cooler and applies them to the calf. From today's two pastures, Heath will pick about two hundred heifers he'll want to hold back for the herd.

"I'm looking for the ones that are thicker, fatter, better looking," Heath says. "We'll keep the bigger ones, but we don't want them too big. I'd rather my animals weigh 1,050 to 1,100 pounds and not 1,200, because they eat more feed. And you get about the same for the calf." He won't keep the calves with a lot of white on them, either. "They'll dock you if they have too much white on them," he says. "I keep the ones that are coal black. The thing that makes you money in this business is fertility. The bigger ones have more fertile mommas because they bred quicker, right? I'm trying to keep the frame down—shorter, thicker. Those are the best." He doesn't stop castrating, doesn't stop calling out "keep" or "ship" while talking. "Those calves over there," he points to several in a pen, "we won't hardly keep any because they have too much Hereford. The Hereford blood can make faces white and their coats curly and red. I'm not keeping any red ones for sure."

Joe Pat explains further: "You need so much feed to maintain a huge animal. So a 1,400-pound cow better mean an 800-pound weaned calf to make it worthwhile." It's unrealistic to expect a weaned calf to weigh 800 pounds at sale time, however, he says. "It's better to have a 1,100-pound cow and wean a 400-pound calf. Less feed. And the numbers work out right."

The difference between the oldest and youngest calves here is no more than sixty days. The youngest ones were born to mothers that didn't breed right away, and thus, they may be the least fertile mothers in the group. Cows with the best fertility breed early. The ranch ships its culled calves to market when the calves are about nine months old, by which time they will have been weaned and off their mothers for forty-five days. That forty-five-day weaning period assures buyers that the calf does not suffer any respiratory diseases. "We'll wean in early June," Heath says. Steers are shipped in early September.

A few heifers later, Heath says, "Let's keep her. A little brown, but she's made right."

Even in the twenty-first century, cattle theft is still a problem for ranchers. "Three-quarters of the time that cattle get stolen it's because they're not branded," Heath says. "Stealing cattle is a lot more prevalent in East Texas than here. If someone comes to me as district attorney and says their cattle were stolen, I say, 'Okay, what's your brand so we can go look for them?' And they tell me they don't have a brand or they don't brand their animals. I tell them it's a loss. How are we going to find their animals among all of the other animals if they're not branded?"

The hospital calls, and Danyelle and I get in a truck, drive to the horse barns, get in her SUV and drive to the hospital. Her grandmother's lab results show her kidneys are shutting down.

Danyelle walks into the hospital in her work clothes: jeans, boots, layers of shirts and sweaters and a jacket, wild rag, hat and spurs. She heads straight to Granny's room and pulls a chair next to her bedside. Granny lies face up and breathing thickly, covered up to her neck with blankets. Her eyes are barely open, as still as if she were sleeping. The only other sound in the room is the heater under the window blowing warm air. The nurse is Lanham's wife. She strokes Danyelle's back. "I'm trying to be in five places this week at once," Danyelle says. "We're in the middle of cattle working this week. I wish I could be here more."

Danyelle finds country gospel music on her cellphone and lets the music play, setting the phone on her grandmother's chest and sitting with her. Granny does not stir. "Just three years ago she had twelve piano students," Danyelle says. She leans over the bed, holds Granny's hand on top of the sheet, stares at her and keeps saying, "I love you." She combs back Granny's hair with her hand.

After half an hour or so, Danyelle stands up to leave. "You just rest, okay," she says. She leans low over her grandmother. "You be good," she whispers. "I'll be back tomorrow. I'll be back real soon." The nurse says, "We'll let you know if something changes."

We leave the hospital in a rush and pick up Ethan and Hadley from Coleman Elementary School. "I pick them up early on Wednesday, so they miss their last class, which is recess," Danyelle says "That forty-five minutes extra lets me have one stop—for gas, for a drink and not go crazy getting to their music class." We drive to Abilene for Ethan's guitar and Hadley's fiddle lessons, then to a local store called Garden World, where we wander through several Christmas-decorated rows of blue spruce and Douglas firs tied and suspended from the ceiling. "They're kind of scrawny," Danyelle says, spinning one. "Maybe something happened with the harvest." Danyelle chooses one, and the clerks load it into the back of her SUV. She drives to a saddle maker's shop to pick up the custom chinks Joe Pat and Alice had made for Hadley and Ethan's Christmas presents. He's stamped the tops with their initials and tooled the leather.

Back home, Danyelle builds a fire in the fireplace for Ethan to sleep in front of. "It's part of his process to separate from his sister," she says. Near midnight, she sets up the Christmas tree.

The next working day is much like the first. The cowboys look like they're sitting on tractors, one hand holding the reins, the other on their hip. They lean back, slouching in their saddles. Then they ride out, along their invisible line and out of sight. I trot back to the pens where Joe Pat is setting up and see a yellow, gray and brown coyote in the

grass on a rise looking at all of our commotion. He is long-bodied and beautiful in his wildness. His tail is nearly the length of his body, he is the color of the winter grass, and he turns his head, keeping his eyes on Jewel and me.

I tell Joe Pat I'm envious of how well everyone rides. "Your body's in better shape since you haven't been doing this all your life," he says. "The wrecks are inevitable. If you ride a horse long, eventually you're going to be in some sort of serious wreck." He is setting out the same pieces of equipment from yesterday onto the flat bed of the truck, moving things from here to there, backing the truck up closer to the chute.

"I got bucked off a horse twenty years ago and landed on a spot on my back, and that's the one that stays with me all day, every day," he says. "That's the one that makes it hard to get up and out of bed. An orthopedic I know said to me once—as long as there's football, horses and motorcycles, I'll always have job security."

What is the future for ranching, I ask him. "What'll happen is ranches will start buying up land from families who don't want to ranch any longer," he says, and that's already started to happen. "The average age of the rancher today is, what, sixty-five or something? A lot of kids don't want to come back. Sure, they want to come back to play—to hunt and fish and ride ATVs—but not to work. The economic benefits haven't been that great for them. The market's there, and it'll keep on. But there will be fewer families."

The riders return and separate the calves from the cows and then head to the next pasture. A couple of cowboys load into trucks and trailers with their horses; these teams will ride down the road to the far end of the pasture and then turn around and push the cattle to the pens. "It's a time saver," Danyelle says.

When they finish the second pasture, everyone heads to Patty's house for dinner.

Driving down the road between winter fields, Heath says, "What we need right now is about four inches of snow. That'd kick that wheat right into gear."

After dinner, Heath heads to his office, Danyelle takes over vaccinating and Jody takes over castrating, testing the sharpness of the pocketknife blade by shaving hairs on the back of his hand. Joe Pat mans the clipboard, and Lanham and Jesse resume their spots near the branding pot. Rustin and Ed are in the chute lifting tails and pushing calves into the swing chute. Danny keeps the line of cattle moving in the pen.

Danyelle answers her cellphone, a call from the hospital. "We're working cattle this week," she says. "I'll be in sometime this afternoon. No, I can't come earlier."

More calves come through, and with each one, Joe Pat calls out "keep her" or "ship her." Each of these animals is a black Angus, chosen as a breed by the Hemphills for their reputation as easy keeping cattle that don't need a lot of supplemental feed or extra care. Their bulls come from Wyoming stock and are bred for reproductive efficiency and a good disposition.

"These bulls," Joe Pat says, "make us cows we'd like to raise."

The Hemphills select bulls with two chief characteristics. First, that he's sound on his feet because he has to travel for feed, water and to mate in rugged country. And second, large testicles. "Large testicles is the whole package," Joe Pat says, "breeding voracity and a lot of sperm." Part of Joe Pat's selection process involves thinking of cattle in three dimensions: height, width and length. The ideal cow and ideal bull are deep-bodied, not long-bodied. Twenty years ago, there was a fad that came and went where ranchers bred cattle "with no gut on them," Joe Pat says. The Hemphills tried that fad and came close to ruining their stock. "We started breeding tall, long and lean cattle. The first thing to go when you breed like that is their reproductive efficiency."

The Hemphills switched to producing all-natural beef a couple of years ago, meaning they let their animals forage for grass and do not inject their animals with growth-stimulating hormones, a common practice in other sectors of the beef market. Raising all-natural beef is a premium,

top-of-the-market designation that pays off. The Hemphills' last set of calves, sold earlier in the summer, was bought "a second after we got them to auction," Heath says, with two different brokers on the phone outbidding each other. Without growth hormones, an animal at sale will be twenty-five to thirty-five pounds lighter but sell for five dollars more per one-hundred-weight than an animal that's been given hormones. "We market to companies who are looking for grass-fed, hormone-free animals," Danyelle says. "Our cattle are a specialty product, and this year, our stars will go to fine steakhouses."

The following is Danyelle's yearlong ranch schedule:

In the early spring, cows and heifers are pregnancy checked by blood sample. A few weeks later, around the end of school, the Hemphill Ranch family rides horseback through the pastures, taking a good look at the operation, mending fences and seeing what needs to be done. "We try to control the mesquite and prickly pear, which take away from the land quality," Danyelle says. "If you don't fight it daily, you're already behind."

Calves are separated from their mothers and weaned in May and early June, which brings "a lot of fussin' from both sides," Danyelle says.

The second week of July, the ranch puts together its once-a-year shipment and decides which animals it will keep, which it will cull and which of the very best specimens will go to a special pasture near Joe Pat and Alice's house.

The first week of August is "inventory management," done from a Tuesday through a Thursday and requiring the help of many hands to move the entire herd through pens for vaccinations and ear tags.

The heifers start calving in the middle of September; the older cows begin calving by the end of the month. Danyelle, Heath, Joe Pat and dayworkers check heifers and cows three times a day for problems or complications birthing.

In December, the calves are branded and the little bulls are castrated. At the end of the year, bulls are put in the pastures to "cover the cows and heifers" for two estrous cycles.

More than a year passes, and it is mid-July.

To be a ranching woman requires skills and attention in a dozen different directions. "There are so many of us and so much land to cover," Danyelle says. "I don't even know what to put when someone asks me to list my occupation." She reels out the list of her responsibilities: raise her kids; oversee ranch and feed operations; ride and train horses; manage a hunt operation and host and guide hunts; manage mesquite and brush control; wean; doctor animals; go see if that missing bull is in someone else's pasture; be a darn good personal assistant; run the household.

And then there is her family and the land that connects them. One afternoon, Danyelle and her children stop at a Texas State Historical Marker north of the ranch, along the road near Belle Plain. The marker commemorates the homeplace of Hemphill family ancestor Jasper McCoy. "He identified this country as good ranch country and settled this town," Danyelle says. Grasshoppers and tiger swallowtails mix chest high and bang into our backs and legs as we step into the tall grass. Danyelle and the kids lean over to read the plaque. "What I'm passionate about is carrying on western heritage," she says, her fingers on the plaque's letters, the twins' lips moving as they read it to themselves. "So few people can say they are on the land their great-great-great-great-grandfather owned." The twins look up. "He was a trail driver," she tells them, and then to me: "It's ours to pass on to the next generation."

The Hemphills came to Coleman County in about 1871 with the first wave of settlers of European descent, and Danyelle's family came in the second wave, in the 1880s. Her main "love and joy," she says, "is to connect the dots—how these people all touch each other in each other's tapestry. I'm interested in thinking about how we're all connected. It makes me feel like what we do makes a difference and that the threads we have with other people matter."

She met Heath when they were kids in the horse world where everyone, she says, knows everyone. "We were always friends, always had a good time team penning

together," she says. Many of the Hemphill Ranch cowboys and dayworkers are people she's known since they were kids. At her house, she shows me a framed photograph of her, Heath, Lanham, Heath's brother Brent and Jody posing together after a rodeo a year before she finished high school, before she won Miss Rodeo Texas. The teenagers are smiling, looking straight at the camera. "This lifestyle is all I ever wanted, these kids are the [only] kind of kids I've ever wanted," she says, "and Heath was always the standard of who I wanted, the kind of man I wanted my whole life."

Someday, the ranch will be in the hands of Ethan, Hadley and other young family members. Their education on ranch management is already well underway "As the kids gets older, we want to teach them the business side of it," Danyelle says. "They'll learn to mend fences, drive a tractor, they'll be asked to lay their eyes on some things as well as pay attention, care take and be a conservationist at the core level."

The next morning, after a breakfast of biscuits and deer sausage from Ethan's first deer ("It was a very big deer," he says), we arrive at the horse barns before light. The morning is summery, warm and sticky. Cowboys saddle horses without making small talk; everyone knows what needs to be done.

"Ethan. Ethan," Danyelle says into the back of her SUV. Ethan sits up, sleepy, eyes squinting, sheet wrinkles on his face and his hair out of order on one side of his head. "It's time to wake up. Time to get horseback. Your horse is waiting." Her daughter, Hadley, is awake and alert. Twenty minutes later, everyone has saddled and mounted. Ethan's feet don't reach his stirrups and he bounces at the trot, his knees gripped together to hold on. His feet stick nearly straight out on the sides. Hadley is longer-legged and fits better in her saddle. She walks Leroy through pastures, talking to him the whole while: "We won't get lost, Leroy. Did you see that? Just keep walking. We'll find our way back if they go on without us, Leroy, don't worry."

Both kids have elastic socks sewn into their hat bands to help keep them on their heads.

The Hemphills and the dayworkers will sort the herd into different groups today. One group will be replacement heifers—young female weaned calves that will replace older and less reproductive cows from the permanent herd. These animals' only job will be to breed. Another group will be cattle to cull—older cows that did not get pregnant and heifers that don't meet the Hemphills' standards. These animals will be shipped. "If they're not working, they're costing," Danyelle says.

There are thirteen people on horseback today, including all of Joe Pat's grandchildren. The group splits up; all of the kids follow Danyelle.

"I'm going that way to see if I find anything," she says. "Whoever's coming with me better be ready to trot." The group follows her, looking for cattle, riding to tops of ridges and back down again. At one point, Ethan ends up nearly sideways in his saddle. Danyelle rides up next to him and reaches across the top of his horse from her horse to pull the saddle, with Ethan still in it, over and upright. Ethan readjusts. We stop by a deer feeder and listen for the other cowboys to call.

"The reason to have a ranch is to keep up the tradition and heritage of ranching," Danyelle says while we're waiting. She is surrounded by the children in this family, the ones who will next own this land and its cattle. "Passing it on to the sixth generation is mind blowing. To say you've been doing this for six generations! The ranch has been resilient enough to keep going in hard times. We ride for the brand and stand for the brand," she says. "This ranch is a piece of what makes our country great."

We hear the cowboys on the far edge of the ridge. Woo-hoo. Danyelle calls back woo-hoo. "It's not for the weak, not for the faint of heart," she says, and she moves into a trot.

# ANN DAUGHERTY

*Southeast of Marathon, Born in 1960*

## AND

# PAT MARTIN

*In Marathon, Born in 1928*

Ann stands in one of her leased pastures next to a water trough. Behind her is Shely Peaks. "Shely's a family name," Ann says, "and there are two peaks."

After meeting in Marathon and before driving to her home southeast of town, Ann and I stop to visit one of her friends, Pat Martin, who has lived her entire life in the area. We pull off our boots at the door before we step into her house and sit with her in her living room, talking. Photographs of her family and impressions of her family's brand—a heart sitting atop a half circle, registered in 1906—are on the walls. "I have no idea how my granddad came up with the brand," Pat says.

She recalls how this area was during her childhood. "When there was a lot of cattle, the cowboys would mark them two times a year. They wouldn't have but a couple months' work each time; some of those boys didn't have a job all year. Cowboys made about thirty dollars a month. They had a bedroll. Food and a horse was provided. Mother cooked on a hard wood stove. They'd have their own saddle."

"This land has always been better for sheep and goats than cattle," Pat says. "Wool sheep's priority was to make wool, not make as much meat. There weren't any fences with herded sheep—someone was out there with them to protect them. A lot of them were supplied to the Northeast because a lot of people ate lamb up there. Daddy decided on wool sheep during the first world war because men had gone to war and no one was around to work and cattle is very labor-intensive. Wool prices were good during the war. During the war years when men were gone, you didn't have a labor force, and sheep and goats are a lot easier. They can take rain, cold or wind, but if you mix two of them, they don't fare so well. I'm not sure when the drought [she pronounces it drouth] really started, but it was going on in '46 and '47, maybe in '45. We just had goats. Daddy got corn from a program with the government that helped with feed. We had to apply for it, and there was a board in Alpine that approved you. When Benny [her husband] and I married in July '48, there was drought and things were so hard. In the '40s and '50s, drought lasted so long and never ended," Pat says.

"That was the time it never rained," Ann says.

Pat got married when she was nineteen years old and stayed married for sixty-two years, until her husband died.

"A man raised a family and taught his family how to work hard," Pat says. "Ranching's more than a lifestyle. Too many people have gotten away from standard values. Basics—when women were women and men were men. Families stayed together. They didn't take credit, and if they did, they paid it back. A handshake did it, and you didn't need a lawyer to make a document that didn't say anything. They worked hard. The [sheep] shearers came in the spring and fall. When they come in the spring, they'd make a date for the next year. It wasn't written; they would show up that next year on that date. They fed themselves. We provided them with a goat or meat. Twelve or fifteen men would come to shear. Some men could shear more than one hundred animals in a day. The leader was called the captain. The captain got paid by the rancher per head. Each time someone sheared an animal, they'd be handed a chip of aluminum and they'd keep it in their pocket. Daddy sold sheep in Del Rio, then Sanderson. When I was a kid, Daddy and Uncle poured a cement platform to keep wool and mohair clean and up off the floor."

"I took how I raised my kids for granted until I saw other kids," Ann says. "They didn't understand how to stay in there and work together and get the job done. My kids were raised with 'stay there and get it done, figure it out.' It took the whole family working together. That's how we all should be."

"My kids weren't used to going to the store and throwing money away," Pat says. "What kids know now is to go to the store and buy everything."

"The thing that worries me," Ann says, "is that a part of what we were able to do with our kids is because we stayed home. We were with them twenty-four hours a day. Everyone has to make their own path. If you're not at home at the dinner table with the family, if you don't have that home environment, we lose a great thing if we don't keep that."

"But I'd rather dig a ditch than do housework," Pat says. "And I don't remember teaching my kids any manners."

Ann homeschooled her kids, and Pat stayed home with hers but "would have rather been at the ranch."

"There's not a baby anything anywhere that won't amount to anything unless it has a good mother," Ann says.

"What living out here gives us is intangible," Ann says. "You can't buy everything. There's wealth and value out here, but it's not monetary."

Ann has three dogs: an Australian shepherd named Boss, an Akbash named Sir Mike and an Anatolian named Espa. She has been training them to follow her directional commands and help her with her goats and cattle.

*Left*  "A ranch calendar depends on where you live in Texas," Ann says. "You have to breed to calve in the early spring so they'll have a chance for rain and grass, then you wean them before the hard part of the winter comes. A monkey could ranch out here because the weather is so good and mild."

"We don't have to feed like other people, and we have grass that's tougher than other places," Ann says. "Usually, if there's any kind of moisture, something for them to eat all year, the cows are fine. If it's dry several years, you have to take care of your land. If you don't take care of the land and grass, pretty soon you won't have anything.

"The desert can't take abuse," Ann says. "The rancher is the original conservationist. The world revolves around grass. Agriculture is so very important because life revolves around water, food, shelter and clothing. If you don't have grass, you turn into a dust bowl quick. You have to take care of your land."

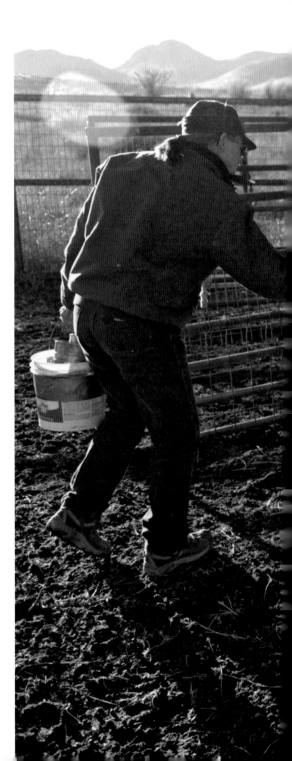

*Right* Ann moves her small goat herd—leftover animals from her son's and daughter's 4-H projects—around in their pens. "I'm thinking of getting sheep," Ann says.

*Above* "The desert environment is so fragile," Ann says as we drive through leased pasture she calls the Smith, from her home to her son's home, through land that was once a single property that all belonged to her paternal great-grandfather, A.S. Gage. Ann's grandmother was Dorothy Gage Holland Forker and one of A.S. Gage's two daughters. At Dorothy's death, she passed her inherited portion of the ranch to her four children, among them Ann's father, Gage Holland.

Ann owns only a part of the original ranch now, and this road connects land owned by several unrelated families. "If you disrupt the root system that's established," Ann says, "when it rains, you won't have a root system to take in the water, and the water won't soak in. It'll run off. It can recover, but it depends on how the land is damaged. That will determine how it heals. They've studied how land responds after a burn, and sometime the fire is beneficial to the land. When it burns, it cleans out stuff and the ash serves as fertilizer."

She notices that someone has crossed through the pastures and left gates open and that her cattle have walked into pastures that don't belong to her. "My father did all the fences, roads and windmills on all of this land," Ann says. She liked working alongside him. "When we were out here doing stuff, I never complained. He just gave me half a look and I'd do it."

In 1991, when her father died, his estate was divided among Ann, her brother and her sister. Her brother sold his portion of the ranch without offering it to Ann first. "I would have liked to have bought him out, try to pull all of this back together again," Ann says. "All this land—after it's been divided up as much as it has been—is not enough for three children to make a living on."

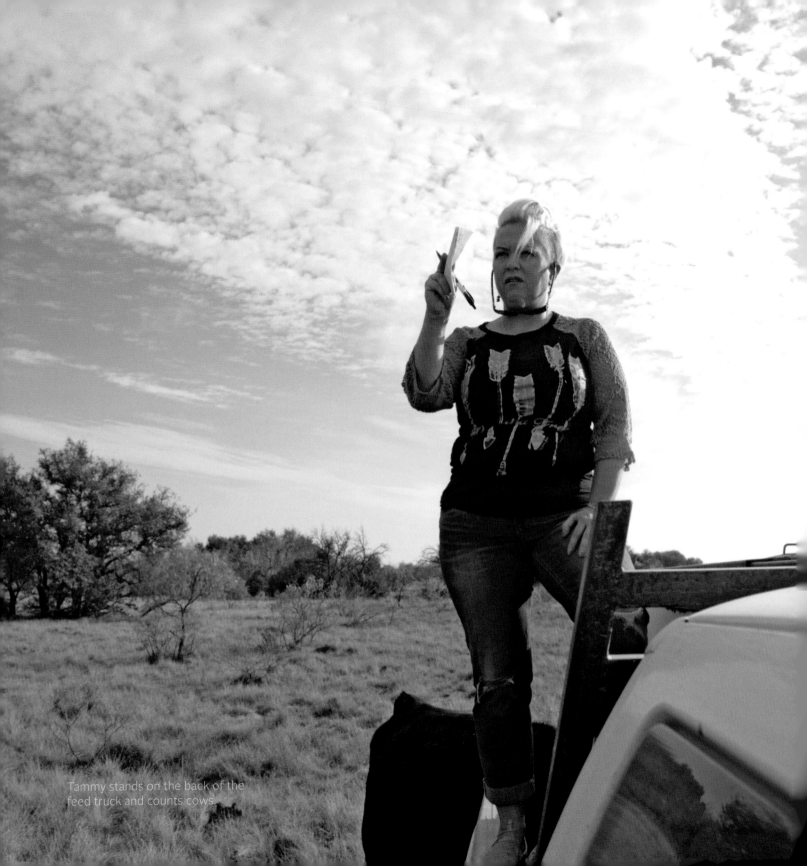

Tammy stands on the back of the feed truck and counts cows.

# TAMMY FISHER

*Southwest of Sonora, Born in 1974*

**W**hen I first meet Tammy Fisher, it is deep into winter and cold out and midnight dark. She stands squinting at me in brightly decorated, fuzzy and soft winter pajama pants and a sweatshirt. "You could be a mass murderer, but I'm hoping you're not," she'd texted the day before, then wrote that she'd leave the back door unlocked and the room on the left made up for me. The night I pull up, her small dog, Penny Lou, barks until Tammy gets out of bed. When Tammy hears me jiggling the door knob to get in, she decides to meet me at the back door.

Tammy's house originally belonged to her mother's cousin, who outlived her own two children and husband and who, when she died, bequeathed her entire estate to Tammy and her younger brother, David. The house is open and rambling, with shiny and rich burnt orange–colored clay Saltillo floor tiles, high ceilings and a wall of plate glass in the living room that overlooks a landscaped yard. Tammy remodeled the house when she moved in. She likes to decorate seasonally, and the nook between her kitchen and her laundry room is a huge winter wonderland diorama with figurines knee deep in glittery and puffy white sheets of snow. (I return in the middle of summer and see the nook decorated with American flags; in November, this nook is covered with the remains of silky spiderwebs with plastic bugs clinging above dishes filled with wrapped candy.) In the laundry room is a table where she uses beads and paint to decorate the steer skulls that she buys from a slaughterhouse. They are colorful and ornate. On the wall above the table hang old family photographs that go back several generations. The sepia-colored faces under brimmed hats squint at the camera. "Most of my dad's family stood next to cars, showing off they had a car. They were poor and never went into a studio to have their pictures made, that I know of. My mom's family had more money, and I have shots of them and they're always standing at a barn or in the front yard or at a studio."

The inherited estate also came with sections of land and a ranching business that Tammy now owns and runs. Her brother runs his half separately, though they coordinate wool shearing and some other ranch work activities in tandem. "A section or less is too little out here," Tammy says, "and you

can't make any money." Tammy kept the longtime caretaker and ranch hand, Eugene, who lives in one of the houses that's set where the flat land around the main house starts to rise. He visits family in Mexico several times a year. Aside from his monthly wage, Tammy provides Eugene with his housing and "maybe a goat to eat" for special occasions. "I couldn't do hardly any of this ranching without him," Tammy says. "He knows what needs doing out here better than I do."

The next morning, Tammy talks about the complications of inheriting land. "We've bought our own land from the government several times," Tammy says. "The death tax will kill large family lands. You'd nearly have to start giving the land away to heirs before they are born to avoid the taxes." Tammy had to sell more than ten thousand acres to cover the cost of her inheritance. "If you want to fragment the land, have a family member die," Tammy says. "The good thing is that a neighbor bought it, and she's going to keep it in agriculture. That's my family legacy, and I want to make sure it stays that way. We feed and clothe our country."

We step up into her pickup, with her custom Double T Ranch logo welded into the grill guard. Double T stands for her first and middle names. As we head toward town, hits from the 1980s play on her radio. She sets a makeup suitcase—bigger than a shoebox—that she calls "my face" onto the arm rest between the two front seats and, while she drives, picks through powders and brushes, liners and daubers. She looks at the visor mirror to line a lip or an eye and then looks out to the road, back and forth, driving with one hand and a knee, swerving on the caliche to avoid the larger hollows and ruts left by oil field trucks that use this road.

"It's goat country here," Tammy says. "We're south of the Concho Valley and right where it, and the Edwards Plateau, the Chihuahuan Desert, the Trans-Pecos and the Hill Country all kind of meet. We're at the end of the oak trees heading west."

Tammy moved to this ranch in 2011 after earning her law degree. "That was the year I first got into it on my own," Tammy says. It was also the year "the oil field dried up and went away and everyone left," Tammy says. The Sonora area likewise was in the middle of one of the worst droughts in memory. "I don't know that we've fully come out of it; this year is starting to look a little scary," Tammy says. "2011 stands alone as the worst drought year, but I think we're in a permanent state of drought." She decided to continue ranching as her aunt had, raising meat goats, sheep and Hereford cattle. Recently, she's invested in a couple of billies and a few nanny goats bred to prefer eating the locally invasive juniper over anything else. She hopes to sell their progeny as seed stock to other ranchers, as well as use them on her own land.

"Goats are browsers and perfectly compatible with sheep and cattle," Tammy says. "All of the animals get rotated through the pastures." Goats are big business in this part of dry and rugged Texas, where Muslims compose a percentage of goat consumers. "We used to sell halal goat and had a butcher here who would butcher halal, but we don't do that anymore. Now we sell our goats to a processor and don't process ourselves. Muslims on holidays show up looking for intact rams, and they'll slaughter them halal themselves," Tammy says. "With the cattle, sheep and goat, we're diversified in case one market is low."

Tammy is politically minded and regularly travels to Washington, D.C., with the American Sheep Industry Association as a member of its legislative council to speak to her congressional representative about ranching, trade and land issues. "Pretty much anything that affects us—what we want in the farm bill or what we need," Tammy says. "One of the biggest things is predator control and making sure there's a balance and that we're doing it the right way, the most humane way. The government controls what we can do, how we can do, when we can do. We might also talk to our rep about immigration and the estate tax—that's been our biggest one over the years."

Tammy's land is close to Mexico, and illegal immigrants crossing her property on foot are not uncommon. To

the north of her land, and away from Border Patrol checkpoints, the immigrants commonly reunite with their traffickers or are often picked up in vehicles. She'd also like a voice in her local city government, but her residence is at the ranch. "I live in the country like all the other ranchers who have been here forever," Tammy says. "Without a city address, we don't have much say in the city government because we don't even live in the city limits. We're the only city in this county. But we ranchers don't have a voice. It's bad," Tammy says.

We stop for her mail at a bank of mailboxes where the county road meets the caliche road. She pulls out her phone to show me a file she's labeled My Bucket List—a long list of things she'd like to do and be. She updates it often. The current one includes hunting axis, an invasive species. ("They were first brought into the Hill Country by people who run those exotic hunts, and some escaped.") Also on the list: hunting mountain lion and blackbuck; traveling to Egypt, Australia, Maine, Connecticut and Ohio; seeing the Supai village in the Grand Canyon; attending the Summer and Winter Olympics; attending all three Triple Crown races; watching the Rose Bowl and Macy's Thanksgiving Parade; seeing fireworks from a helicopter; taking a mission trip; becoming the president of the Texas Sheep and Goat Raisers Association; and opening the Old Jail Museum in Sonora.

We drive into town and straight to her law office, which is a converted Victorian house she bought near the railroad tracks. The shingle outside the office reads "Tammy T. Fisher, Attorney at Law & Mediation Services, PLLC"; she painted it herself. "I do ranching in the morning, lawyering in the middle of the day and ranching again at the end of the day," Tammy says. Most of her law practice involves sorting out divorce and custody issues, plus estate planning and probating wills.

Tammy prints out some paperwork, and we drop it at the courthouse on the way out of town.

Several miles down the road, we pull onto a smaller road, the entrance to her land. "I come from a traditional family," Tammy says. "Mom cooks, Dad works. Mom was a substitute teacher. Every Sunday of my life, Grandma cooked dinner for us, and we'd eat there. We usually had three generations around the table, once a week, eating dinner together. When I was growing up, it was my great-grandparents, grandparents, my parents, me and my brother. Plus, all the little orphan old ladies whose families lived too far away—they'd be there too. Green beans, two desserts, pot roast or leg of lamb. Dad worked at the mohair wool warehouse."

We pass several signs her grandfather put up announcing his Polled Hereford cattle, a breed with no horns. "Everything I have is as Hereford as I can get it, and if it's not Hereford, I turn it black as quickly as I can, no matter what I start with. Baldies are the ideal," Tammy says. A black baldy is a Hereford crossed with a solid black breed, such as Angus. The resulting cattle are black with a Hereford's white face. "They're easy because they have Hereford blood. Herefords weigh a lot and bring a lot of money," she says. "I like putting in the docile nature of the Herefords. But everyone wants them black, and black brings more. The Angus Association has worked really hard on their marketing and won the public over with believing that black Angus beef is the best beef," Tammy says.

We get out of her truck and climb into the feed truck, a banged-up vehicle Tammy and her brother use to feed cattle and to drive through the pasture to check on the animals, the fences and the land. The pickup has a feeder—a large metal box set in the bed—that is made to receive and hold the pelleted cow feed commonly called cubes in this part of Texas.

We stop at a windmill, where Tammy pulls the brake so the blades no longer spin and the pump no longer draws water for the tank. With the arrival of freezing weather, Tammy wants to make sure the windmill is inoperable and still. We leave the fence line and drive across the brushy landscape, dipping and diving over cactus, mesquite, juniper and rock.

"Once the mesquites put out, it won't freeze anymore," Tammy says. "I should say if mesquite puts out on top of the branch, it won't freeze. If they put out on the bottom only, it will freeze again. Mesquites are the smartest of the plants here. They're supposed to be smarter than Mother Nature. Oh, and," Tammy says, "if it thunders in February, that date in April will be the last freeze."

Deep in her land, laid out in the middle of the road and in the whipping wind, is a lamb, barely alive. Its umbilical cord is dried and black and curls down from its belly. We stop, and Tammy takes it to her chest, wrapping her jacket ends around it, then lays it on the floorboard of the truck, rubbing its ear. The lamb opens and closes its mouth, tries to open its eyes and is otherwise still and deflated. "Its momma probably had twins and had to decide which one to save. I'm sure she's here somewhere," Tammy says, and we sit in the truck for a few minutes, rubbing our hands together, wiggling our toes in our boots to warm up. As we start again down the road, we see a ewe with two lambs under some juniper, close to where the lamb had lain. "She had triplets," Tammy says. "She couldn't have taken care of three." We continue through the pasture, locking down another windmill and checking on another pump, the newborn lamb at Tammy's feet as she drives.

In town, Tammy buys a thick black nipple and powdered formula from the feed store. The salesman gives her a Mexican Sprite bottle ("the nipple fits perfect on these bottles"), and Tammy sits on the ground in the parking lot, her truck breaking the wind, trying to bottle feed the lamb. "If she doesn't eat, she'll die," Tammy says. "Come on baby, eat. This is a bottle baby. We lose more than we save. If she survives, she'll always come back to the house and won't ever be accepted into the herd. She'll lead the herd back to the house. She'll be a bottle baby her whole life."

We stop for Mexican food with the lamb in Tammy's truck, set in a small box in the back seat. The animal's warmed up now, and its mouth is wet with the formula. Back at her house, Tammy lays the lamb on a blanket on the floor just inside the door in the entryway. Sometime in the night, the lamb dies.

Months pass, and it's spring.

"Ranching is a mix of geology, ecology, biology, vet stuff, fence builder, contractor, entomologist, welder, lawyer, mechanic, mediator, the boss, the employee, repairman, handyman," Tammy says. "So much we do. Everything. Brush control, what time of the year is best for grass. Random. So random. I changed nine flat tires last summer. Five were on trailers filled with cattle. It sucked so bad. I don't think this happens to other people."

One morning, Tammy and two hands—Eugene from her own ranch and Jaime from her brother David's ranch—ride four-wheelers into one of Tammy's pastures to gather sheep and drive them into a pen. "Last year, 2016, was one of the worst years. Coyotes killed about fifty lambs, which is my profit margin. I got a coyote out here last year. They just started showing up. They're eating me alive. The government restricts the ways you can kill coyote. You can't use poison. You have to kill a certain way."

The four-wheeler engines surge and roar noisily, discordant with the openness of this ranch, the great solitude, the clusters of mesquite, broom weed and juniper, the pasture grass, the prickly pear and dirt, the bare white rock where ancient limestone has shifted and surged over millennia to break ground. "We're done with horses and we do all four-wheelers," Tammy says. "We have dogs. Horses are more dangerous than four-wheeling, and they eat a lot of grass. You have to put shoes on them all the time, and you wouldn't know it, but it's a lot of maintenance. I'm small, and I don't like getting on and off a horse."

Tammy, Eugene and Jaime coordinate and travel to different parts of the pasture, splitting up to chase sheep out of hiding places and toward the dry creek bottom that winds through the land and ends up at a working pen. Eugene and Jaime ride standing up, racing the motor, whooping as the machines under them bounce and bound over the scrub. The sheep bound before them, hanging their tongues out.

Tammy and I pull up side by side, and the men ride on behind the herd, pushing them down the dry creek bed. "I'm going to check one more time to make sure," she says and heads in the opposite direction.

I follow the creek bed and the noise until I again see Eugene and Jaime. An eight-year-old ewe has fallen, and Jaime binds her feet together and loads her onto my four-wheeler. Up close, I see her wool is several inches thick. From the outside, it feels like an impenetrable, soft crust that is dense and does not want to part. When I part the wool, though, my fingers disappear into clean, tight, wavy, soft wool. The fibers are covered with a viscous lanolin that stays on my hands and leaves them smelling slightly fecund. I carry her carefully on the back of my four-wheeler, and we make our way to the pens. When we arrive, Tammy and the hands are already there. Eugene removes her from the four-wheeler and unbinds her feet. She springs up in fine fettle and rejoins her herd.

Eugene and Jaime trailer the ewes from the pen to a shearing shed. The shearing shed is an open-walled, wooden-raftered, rectangular structure with a cement slab down the middle and dirt floor areas on either side. At one end of the shed is a large sorting table next to a press baler that is loaned out by the local wool co-op that will ultimately broker the sale of the wool. The baler allows the operator to pack sorted wool tightly into four-foot-tall wool bale bags that he sews shut when they can't hold anymore. Each bag weighs about four hundred pounds.

Down the middle of the shed, eight men set up their shearing stations. Each man stands with his electric clippers in front of a pulley system that holds the clipper's long electric cord out of the way with counter weights. Some shearers keep a rag in their back pocket and use it to wipe off sweat; others tie a bandana around their necks. Some work without shirts; others tuck their shirts into their blue jeans. Some arch backward to stretch; others twist their upper bodies around and reach their arms up. All sharpen their shearing blades with small whetstones. One

man has his name tooled into his leather belt: Medina. Several men are generations into this trade, and one man has been shearing for fifty years. "He sheared for my great-grandfather," Tammy says.

At the far end of the barn, the shearing crew's boss looks over the operation. Busy season runs from February to the end of May, and in these months, he drives this crew from ranch to ranch, collecting a negotiated rate per animal that includes a cut for himself.

Besides the shearers, the crew includes a helper who carefully gathers the sheared fleece from the cement floor and carries it to the sorting table, where he hands it to a man standing at its head who gracefully throws the fleece, unfurling it from one end as someone might toss a billowy tablecloth, leaving it flat on the table. Two men on either side of it pick out the sticks, burrs and muddy edges before folding it and adding it to the bag the man running the press baler packs with clean, best-quality wool. Some of this wool will be sold to satisfy a contract Tammy's great-grandfather negotiated with the U.S. government to provide wool for military uniforms. Wool from the belly has short fibers and is kept separately, in a different bag. The bits of muddy wool are gathered in a third sack together with the odd bits of wool blowing along the shearing barn floor and the wool that falls off the sorting table.

Tammy, her father and her brother walk around, from time to time taking up a thumb-sized sample of wool, pulling it apart against the light, checking the length of the fibers and nodding to one another, content with the quality of this year's harvest. "It looks good," Tammy mouths, "it's tight."

There is too much noise in this barn to communicate other than by nods and gestures. The shears buzz, a compressor blares, the sheep bleat and the wool press thumps. The helper looks for a nod from a shearer that indicates he has finished taking the fleece off one animal and is ready to select his next one. The shearer points to the animal, and the helper steps into the surging and bellowing herd of sheep and grabs hold of the ewe by its back legs. He then

Tammy organizes ear tags in a set of the ranch's cattle pens.

walks backward while she hops on her two front legs to keep up. "Some guys like to shear only old ones," Tammy says. "Others will only shear young ones. Everybody thinks they know which animal will be easiest."

Both men get the heavy, lively animal to the ground on its side, and the shearer ties one front and one back leg together, catches the ewe's free back leg between his legs, sets a knee on her and slightly pulls the animal straight to reduce its fidgeting. Then he gets to work, removing the wool fleece in a single sheet. He unties her when he's done, and the animal jumps up, leggy, big-headed, yellowish with lanolin and half her former size. She immediately runs to join the others. The shearer clicks his counter; the white numbers in the black window read seventy-one. A very expert shearer will do one hundred animals in a day.

Tammy walks among the shorn animals on either side of the shearing barn with a piece of light blue chalk, marking the animals they'll ship to slaughter. "We'll cull really hard this year," Tammy says. She opens their mouths and looks at their teeth, as animals with worn teeth can't feed themselves very well. She reaches between their legs to feel their udders, since animals that don't breed are culled—if they have a bag, they have had a lamb. She twists at their faces to check for wool blindness; if an animal genetically has too much wool growing around its eyes, it cannot see well enough to walk, eat or get to water. She draws a long blue cull-mark line along the spine of an animal with three-inch wool grown completely over its face.

Of the hundreds of animals that have passed through the barn this day, I have seen only two tails on two babies. "We cut the tails before the tails become coyote magnets," Tammy says. "Tails are the easiest way for a predator to catch them. Also, it makes them have flies and grow worms and disease. Bad stuff come with tails. Nothing good about a tail out here in the West."

Most of the sheep here are all white and are "fine wool," meaning their wool will be woven into fabric. A few have black legs.

"We have stud stocks for mommas, and we use babies for meat," Tammy says. Tammy and David have Suffolk and Hampshire sheep and Rambouillet (pronounced ram-buh-lee) cross sheep. "They live a long time," Tammy says. Each slaughtered animal produces about fifty-five pounds of sellable meat and a ten-pound shorn pelt sold at the slaughterhouse to a pelt buyer. The meat includes rack of lamb, eye of lamb, loins, riblets, brains and viscera. "We sell a lot oversees to the Muslim world," Tammy says. "We don't shear the babies," Tammy says. "They go to auction like this."

After the last of the white-faced sheep are shorn, the helper sweeps the barn. The shearers take advantage of the short break to sharpen their blades. Large black-faced Suffolk and Hampshire sheep are the next group. They have heavier, coarser and shorter wool that sells for less and is used for felt fabric in hats, pool tables and stuffing. The black-faced bucks are unsettled, and several run from one side of the barn to the other, cutting through the shearing stations. Someone hollers "haaaah," and everyone looks up and moves out of the way. "You've got to keep an eye out," Tammy says. "They're more wild." They are meaty animals, and the Fishers cross them with the Rambouillets. "They're our baby daddies," Tammy says. The ranch markets the lambs for meat.

The next time I pull up, eight months later, Tammy's wiping down the inside of a new red pickup. "The last one hit 100,000 miles and I traded it in," she says. The truck is loaded with a backup camera, Bluetooth, leather, remote entry, dark window tint, lift kit and double suspension. "I could care less about the other fancy stuff," Tammy says. "I got it for the suspension." The truck has the same Double T custom logo on the brush guard as her previous truck. She turns the page on the notebook she uses as a schedule before returning it under the clot of bound rubber bands that hold it in place on the armrest.

It is deer season, and all over Sonora, there are men dressed in camouflage pumping gas, walking in the stores and riding in city-clean pickup trucks. Hunting is a vital part

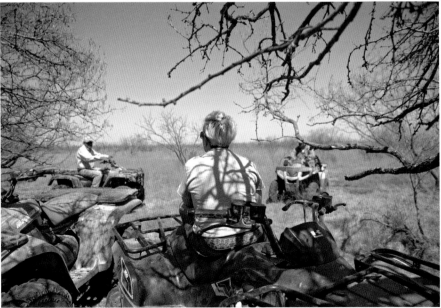

*Above* Tammy and Eugene count the gathered sheep as they run into the pens.

*Left* Tammy, Eugene and Jaime sit on their four-wheelers and talk in the shade before continuing to gather sheep.

*Opposite, top* Tammy and Jaime separate a cow from its calf in a pen.

*Opposite, bottom* Tammy scratches Dukee, Eugene's border collie, before she, Eugene and Jaime gather sheep on four-wheelers.

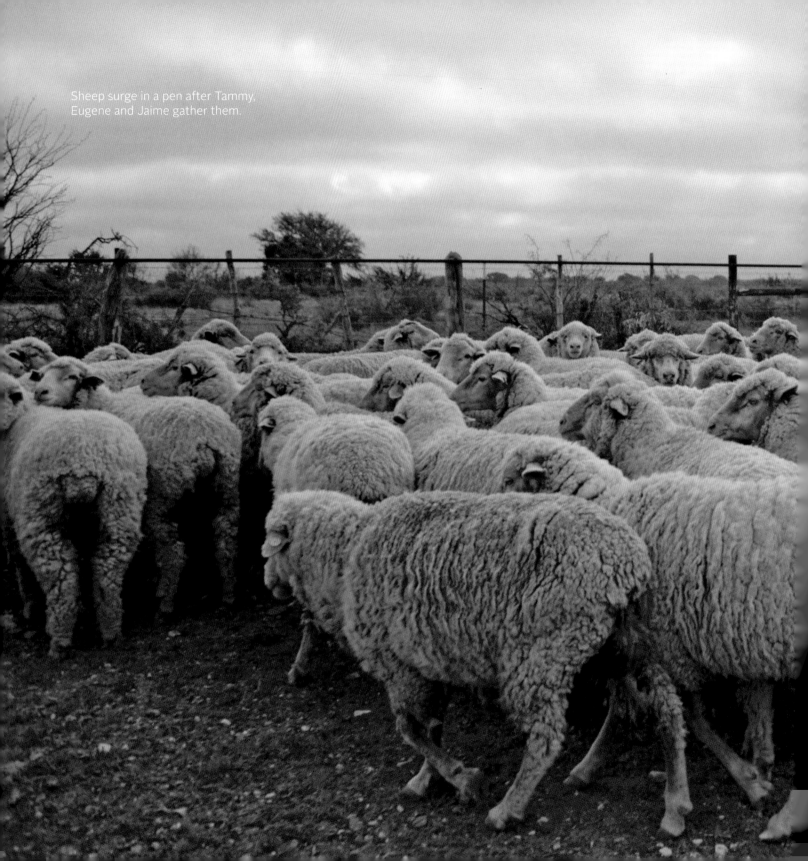

Sheep surge in a pen after Tammy,
Eugene and Jaime gather them.

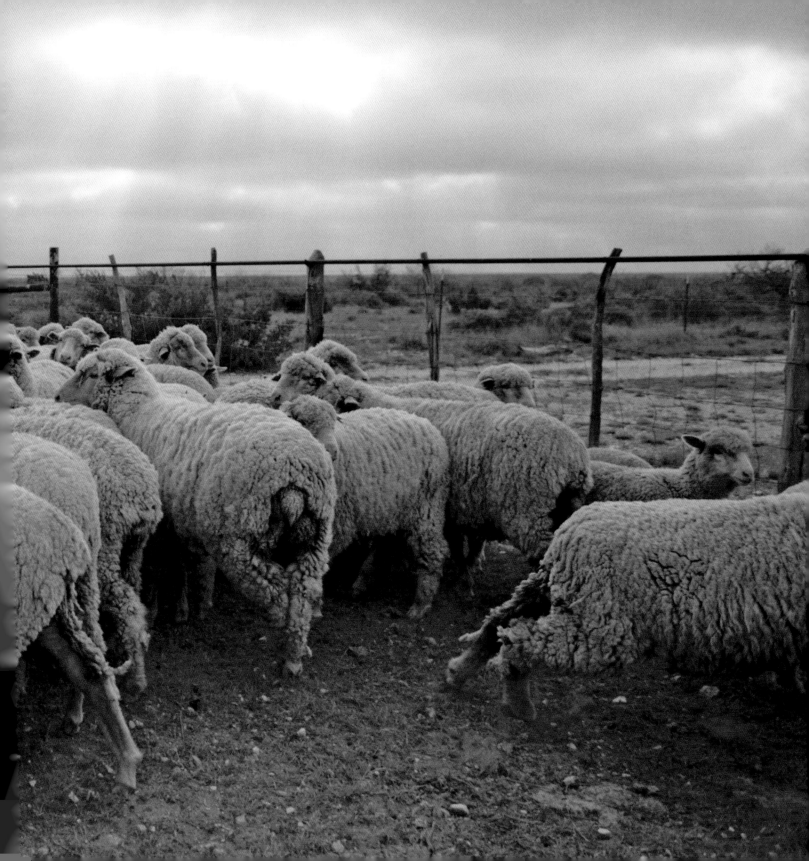

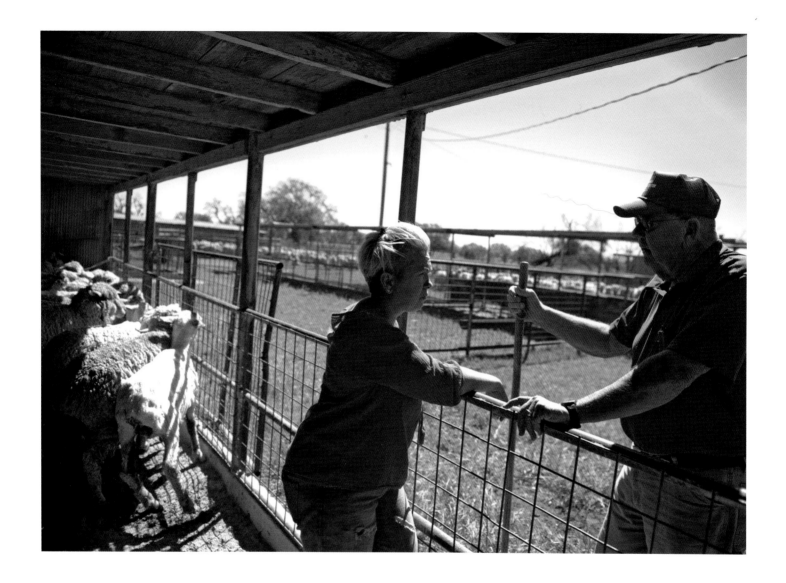

*Opposite, top*  Tammy stands in one of the ranch's hunting cabins during a dinner with her family and neighbors.

*Opposite, bottom*  Tammy at a church luncheon.

*Above*  Tammy talks with her father on sheep shearing day.

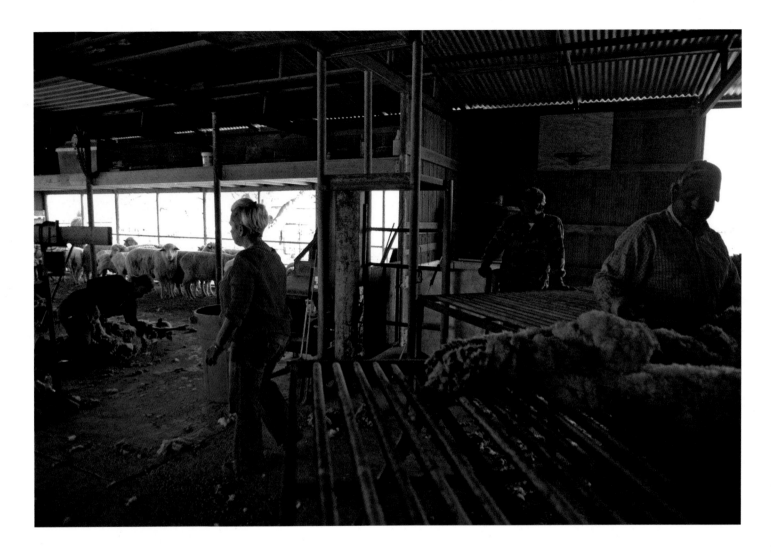

Tammy walks through the shearing barn while workers
sort fleece (*right*) and shear animals (*left*). Other sheep
wait on the edges of the barn.

*Opposite*  A ewe is laid on its side before it is shorn.

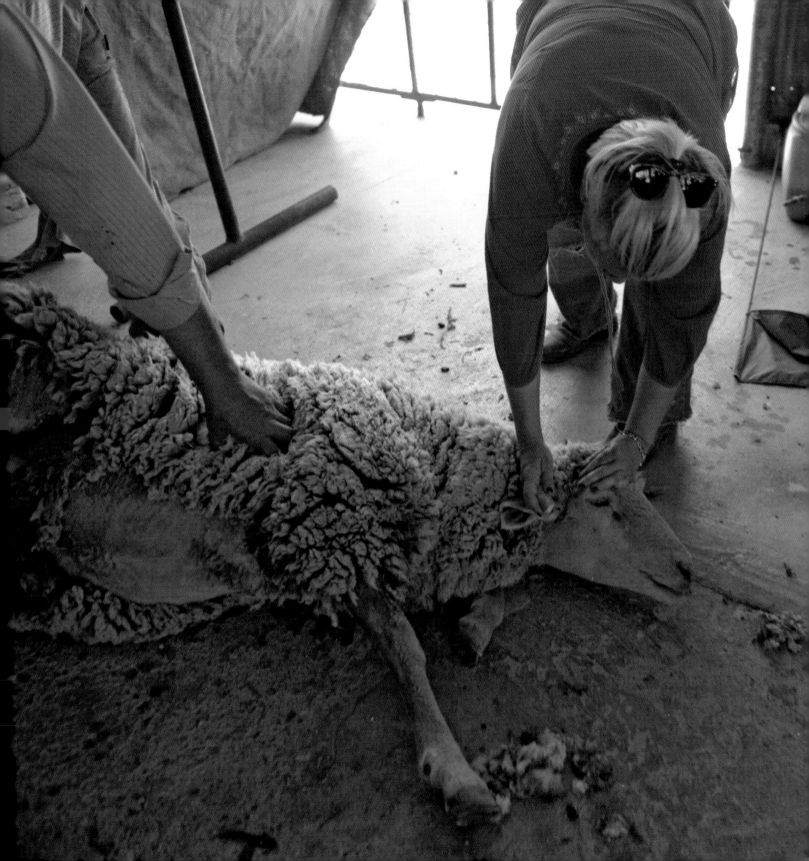

*Opposite, top* Tammy explains the failing pump on one of her windmills to the well serviceman she called out to her ranch.

*Opposite, bottom* Tammy shops in a store in town.

*Above* Tammy rubs the ear of an abandoned newborn lamb to warm it up.

Tammy walks through the wholesale wool
warehouse where her father used to work. Behind
her are four-hundred-pound bundles of recently
shorn wool. In addition to wool, the warehouse
trades in mohair. It's been in operation since the
1930s.

*Opposite,* Tammy looks through binoculars during
the deer survey on her ranch.

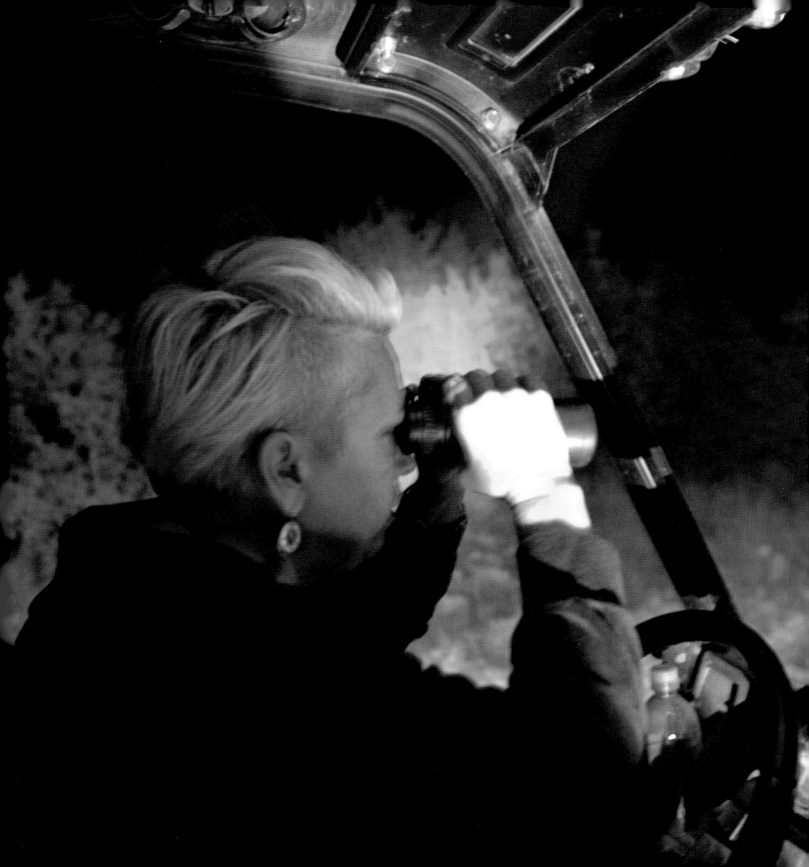

The hunters' camp on Tammy's ranch,
illuminated by handheld spotlight.

of the local economy. Signs saying "Hunters Welcome!" are set out in front of stores, hung above restaurant doors and taped to the "Now Entering" town signs from the interstate to the Texas border.

Like many other ranchers, Tammy leases out the rights to hunt deer and turkey on her land. "In these parts, leases make up about half of a ranch's annual revenue," Tammy says. Her leaseholder is a man from East Texas named Jim who has held the lease for several years. "He's an oil man," Tammy says. "He tried to retire and that lasted about a minute. Now I don't know what he does. But he's got planes."

The lease has worked out well for her. "Leasing to him is an ideal situation," Tammy says. She uses the revenue to cover costs elsewhere on the ranch, and Jim brings family and friends to stay at Tammy's hunting cabin for the ten weekends of hunting season. Tammy moved the cabin from another spot on her ranch. It is the oldest building on her land, and it sits on the original homestead's foundation—a house her great-great-grandfather built in 1900 that was long gone by the 1940s. Its location on the other side of one of her pastures means his presence on her land is hardly felt. As part of his lease, Jim sets out deer corn and hunting blinds on the edge of clearings. "He's worked really hard to get our herd to where it's good," Tammy says. "He's done a really good job of culling deer."

Tammy's ranch is part of the Managed Land Deer Program, a Texas Parks and Wildlife project that aims to encourage sound management of wildlife and habitats on private property. The state's deer population is a part of that stewardship; landowners who are enrolled are allowed an extended hunting season and harvest limits.

"I manage the deer on my land like a herd," Tammy says, "and based on the spotlight survey, the biologist recommends the number of bucks and the number of does, and I can talk to her and we can figure out how many we can hunt."

Tammy works with a wildlife biologist and Jim to create a multiyear strategy for her deer population, which includes a spotlight survey. "When you cull a deer, you don't want

the genetics at all," Tammy says. Together, they determine which and how many animals to keep; which genetic traits warrant elimination, like undesirable spike or basket antlers; which females are good breeders and need to be left alone; and which bucks are getting old and need to be culled. "We don't put up with any hunter killing an animal and them not eating it," Tammy says. "They have to eat it if they kill it or donate it to a food bank or something. If they don't respect the animals by eating them, we don't want them."

Tammy looks at the clock on her kitchen wall and then out her side glass door. Her plan is to start the survey just as the sun sets. "We've had fog the last few nights," Tammy says, "so I want to get out before it rolls back in. We count every deer the whole time. We try to ID each animal, and the wildlife biologist can extrapolate how many deer our ranch has. It's the best way we have to figure out how many animals we have."

We walk out to the carport where a utility vehicle is parked. "I make hunters go on one of the surveys with me. I do one and they do one. We do the exact same line every time. I cut my line down this year by two miles so the hunters don't know where the line is. I'll take them and show them tonight," Tammy says. She rummages under the dash, working to plug in the spotlight. "They'll probably turn up with beer."

Jim and his friend arrive, settle into the back seat and take the clipboard holding the Parks and Wildlife survey form from Tammy, where they'll note each buck, each doe, the number of points on the bucks and the number of babies with the does. Eugene sets a rocking chair in the utility vehicle's shallow bed and holds onto the roof, a handheld spotlight in his hand. Each of us carrying a spotlight, we start the nine-mile loop. "Hang on, Eugene," Tammy says.

It takes more than two hours to drive the loop. The moonless night is very black, and the utility vehicle's headlights only throw light a little ways ahead; cold mist blows. Tammy, the two hunters and Eugene look through binoculars and shine spotlights into the fields, the brush and

the trees on both sides of the way. Skunk, fox, raccoon and jackrabbit eyes reflect blue in the strong light. We see deer deep in the clearing, eating new shoots in the seeded pastures and on the top of rises, others standing still in family groups behind trees set off from the road.

Everyone speaks quietly and infrequently.

"There."

"I see him. We counted him already."

"We didn't. Is he the same?"

"Yes. We saw him back there. He's just come around."

"Eight points."

"Could turn into a trophy. He's wide and heavy and big enough."

Once, we get out of the vehicle and walk into a clearing to look for the ten-point buck Jim and Tammy both swear they saw but no one else did; then we get back in the vehicle and bounce farther down the road.

At Tammy's house after the survey, she looks over the survey results while the hunters grill steaks to medium rare in the backyard. "Our ratio is off," she says. "We've got about double the does to bucks. We need to listen to the biologist this year, who tells us every year we need to kill does. We doubt her and wonder if we're killing too many. Now we can see for ourselves we need to kill more."

The next day, Tammy is talking cattle and not sheep or deer. "If you don't have a bull who's bred up a pasture, you're out of business," Tammy says. "Any little thing—a thorn—can affect a bull's ability, and if anything happens to his testicles, he's not much good." The vet fertility tests all of Tammy's bulls, first the herd sires in November and then, in January, the fifteen-month-old bulls bound for the sale. "He checks to see how many sperms per whatever," Tammy says. "They're registered so we know and whoever buys them knows they'll produce."

She drives, bouncing through the pasture with the feed truck siren turned on. Soon, Hereford cows start running from all directions toward the truck. Cows on the other side of the fence in the adjacent pasture have also started gathering and running up the fence line, following the siren and the truck. "Sometimes you'll come to a pasture and all of the cows will get up and start heading toward you. Then all of a sudden, a single cow will walk up from behind someplace with all of the babies. She's the babysitter," Tammy says.

On the way to the pens, she laments her everlasting need for brush control. "The only time we ever kinda caught up was when my aunt and granddad hired two full-time guys to run bulldozers all day every day for two years," Tammy says.

Tammy, Eugene and Jaime are moving cows and calves to a pen so the calves can be identified with their mothers and ear tagged. "It's important to keep up with who birthed who," Tammy says, "and who sired who." Every year, Tammy and her father assign animals a number sequence, so anyone looking at the tag and knowing the system can easily tell which animals are the same age. Additionally, each animal is given a number; calves are initially given the same number as their mother.

Tammy and the cattle slowly make their way to pens built by her grandfather. They've been out of use the last few years, ever since a huge live oak broke and fell into the enclosure. But Eugene and Jaime have been slowly clearing the wood, cutting branches, making logs out of the twenty-foot boughs and hauling them away.

"I don't know who decided to put a gate right there in the middle," Tammy says. "You have to put gates in the corner. It's really hard to pen things with the gate in the middle. Cattle won't go through." Once through the gate, the animals will be trailered to another set of pens in another section of land. "You need about forty to fifty acres per animal unit out here," Tammy says. "When there's drought, you need about eighty acres a head."

Once they're offloaded, Eugene, Jaime and Tammy separate the calves from the cows and let the babies "soak" in a pen in the shade of a big live oak. "We'll come back in a couple of hours and see who pairs with who," Tammy says. "The baby will find its mother real quick."

Tammy, Eugene and Jaime each check a handwritten list made by Tammy's father that details which cow is bred and which cow has a calf. After lunch ("We're not skipping lunch," Tammy says, "we're eating lunch."), they look at the list and compare it to the numbers on the cows' ear tags. One at a time, they shoo a cow into the small pen next to the babies' pen, open the babies' pen and see which calf runs out to its mother. When one does, most head straight to the udder and latch on, slightly splaying their legs as they suck. Eugene and Jaime separate the two again by shooing, shushing, waving a long flag, jumping and opening and closing gates until the mother is on one side of the pen and the baby's on the other and the air is dust-filled and an earnest bellowing is coming from both animals. They quickly pin the baby, tag its ear and let the pair onto the waiting trailer.

"They're both jittery," Tammy says. "It's genetic."

Every five-cow-and-five-calf cycle, Eugene hauls the pairs back to their pasture and then returns to fill the trailer again as more animals are sorted. Empty, the trailer rattles, and you can hear it before you see it. His round trip takes about forty-five minutes. It's a hot day, and the work is loud and slow. Most of our time is spent in the main pen with the cows where the only shade is under a six-foot-tall, three-branch scrawny mesquite tree with a thorny nopal right next to it. The ground here is rock. And there is dust. "If you're right on the edge of her sight," Tammy says, "you'll spook her. As soon as you pass their hip, you're in front of them. The hip is the steering wheel of the cow." Once all the cows and calves have been matched, Tammy determines that one cow lost its baby, one is still pregnant, one never was pregnant and the rest had healthy calves. She notes it all on her sheet.

Toward the end of the day, as Eugene and Jaime haul the last batch of cattle to their pasture, we drive to the courthouse so Tammy can turn in a court document. "I've missed my filing deadline, but hopefully the other lawyer won't take me down for it and the judge lets it go," Tammy says. She opens up the day planner held to her armrest with the rubber bands and scratches "courthouse" off her list. She leaves me in the truck while she runs in.

When she returns, we sit in the air-conditioned deliciousness of her truck. "What we did today, workers could have done," Tammy says, "but I'm there to make sure it's done right. I try to do too many things at once; I know that about me. I'm making a list of what I have to do. I can only get done what I can get done."

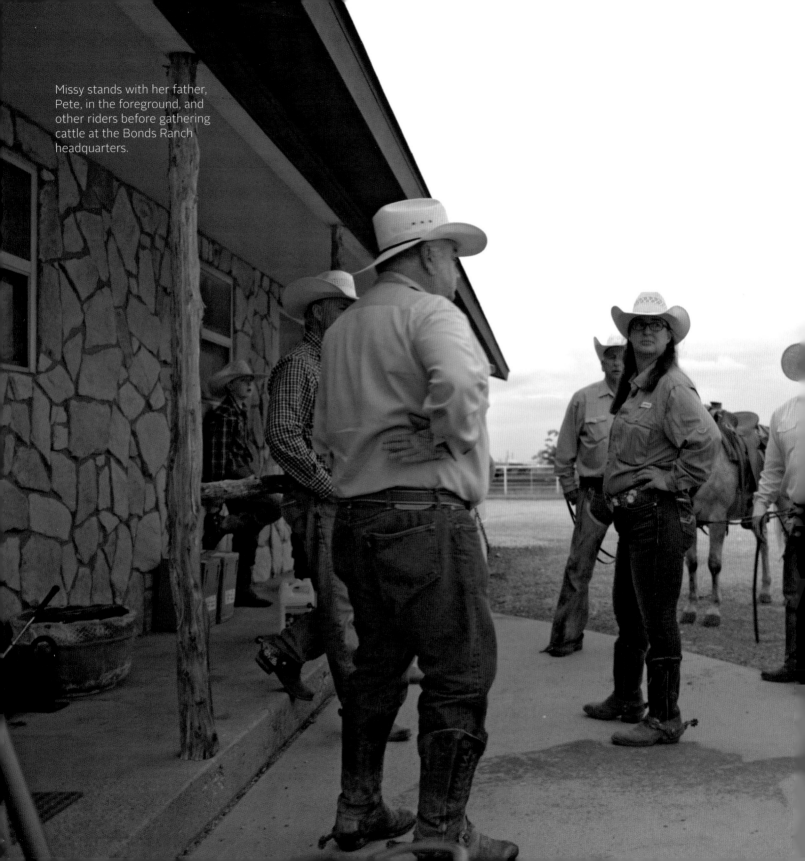

Missy stands with her father, Pete, in the foreground, and other riders before gathering cattle at the Bonds Ranch headquarters.

# MISSY BONDS

## *North of Fort Worth, Born in 1978*

**M**issy Bonds drives her white truck from her house on Bonds Ranch Road through the suburbs and into Fort Worth. It's an early, foggy winter morning. Superior Livestock Auction is holding its bimonthly national video and satellite cattle auction this day, something it has done out of the same ground-floor room in the Livestock Exchange building in the Fort Worth Stockyards since 1987. Several dozen people fill the room. They watch groups of cattle for sale—called lots—on the video feed and bid to purchase them. The cattle in the video have been filmed walking through pastures, standing against fences or in pens, sunlit and fat. A banner streaming at the bottom of the monitor has information on each lot, such as delivery date, the current bid per hundred-weight and the animals' average weight. For example, the banner may read: "Baldy, Nov 20, $119, 500#, $120 SOLD." About 19,000 head will be sold today, a fraction of the 100,000 head sold at a summer sale.

Missy started coming to these sales with her father, Pete, when she was a little girl. "As I got older, if I went to the bar the night before, he'd bring me in here. To make sure I stayed awake, he'd have me keep up with the bidding. There's no way you can fall asleep if you're following the auctioneer."

The auctioneer sits with several ring men at a raised wooden desk at the front of the room, up against a mural of cattle grazing on rolling green pasture, which completely covers the back wall. The door to the back rooms is part of a painted windmill.

Besides the auctioneer's call, it's a quiet room, and when someone's not bidding, they may be in and out of their seats, walking across the room to visit quickly with someone. The men are dressed in pressed jeans and long-sleeved western shirts, cowboy boots and hats; the women are mostly in prairie skirts or dark, pressed jeans with flouncy-sleeved blouses and fancy cowboy boots meant for showing off. Everyone—the auctioneer; the bidders; the record keepers; the ring men staffing the bank of telephones, taking bids from people watching the auction on the Cowboy Channel; the ranchers and cattle traders—snacks on glazed donuts and black coffee in the morning and later on sliced brisket and pinto beans served in the building's vestibule just outside the auction's door.

Missy stands out in a baseball cap, brown T-shirt, jeans and well-worn chukka boots. She's come to buy lots of steer and heifer calves to put on wheat pastures leased by the Bonds Ranch. At a round table she's claimed under a monitor, she takes out a laptop and opens a screen with the Chicago Mercantile Exchange and another with her "break-evens," a spreadsheet that lists cost benefit data of every head Bonds Ranch has bought or sold since 2008. There are columns and rows for price per one-hundred-weight, guaranteed death loss, lot weight, freight, location of the animals in relation to the location of pasture, numbers of animals, age, breed, cost for feed, profit—all the algorithms that make her business work. "That's what I watch every day," she says.

She looks at the video of steers on the screen as the auctioneer punctuates his call with incremental bids. "I'd lose $100 a head at that price. I'm sorry, but I won't buy that," she says. "I can tell you within $2 or $3 per one-hundred-weight how much I can sell these cattle for." She clicks through her spreadsheet. "By running my break-evens, I know what my cost of gain's going to be; I know fairly well what input costs are; I've calculated out my freight costs. I look at the market and I hedge those cattle the day of purchase. I have an idea of the deviation from what the board is showing of what my cattle should bring. Some cattle that are better quality will bring more. Some cattle have more, let's say, Brahman and will bring less than what the board is showing. And I normally know what that deviation is, the basis, the difference between the cash and the futures price. Some will bring more than what the futures are saying, some will bring less at the same weight. When I buy something, I know fairly well what it's going to sell for. I know what my probability will be by using futures. I lock in my futures prices. We manage risk by using futures. Our only biggest risk at that point would be basis, or the difference between cash and futures prices at the time of sale."

Because Superior markets and sells lots from all over the United States, buyers factor in the price of the cattle and the cost to transport them, so the distance between the originating location and where they're going matters. "If they have to spend less on freight," Missy says, "they have more to spend on cattle and still make the same profit." As a result, "cattle sold out of Nevada usually get sold to California," Missy says.

These next six weeks, she and her father will buy three or four "lot loads"—cattle are not counted by head but by weight, and a truck load is forty-six to fifty thousand pounds of animal—of heifers and steers from auctions throughout Texas, from sale barns and from family ranches. "We buy from certain people; we want to keep up our relationships. We like their cattle so we keep buying from them," she says.

The Bondses run several operations. First, a cow-calf operation, meaning they have a bull to cover every twenty Bonds Ranch herd cows in the pasture, and when the resulting calves are about six months old and weaned, Missy either sells the offspring then or waits another forty-five days before selling them. They also run a stocker/

yearling operation, meaning they buy lightweight (400- to 500-pound) calves and grow them for approximately six months on either grass or small grains. These cattle will be sold weighing around 750 to 900 pounds. Finally, they run a feeder operation where they buy cattle and place them into feed yards where they are fed high corn rations and grow until they are sold to a packing plant for processing. These cattle can be purchased at any weight but will all be grown to weigh approximately 1,300 pounds. "I look at the markets, and that dictates what we need to do," Missy says. "Now, it's dictating that we need to reduce the number of cows we're running. That might change. But now, the market dictates it's more profitable not to breed but to sell."

Missy holds up her hand to attract the attention of the auctioneer, and he calls on her by name. She nods at the numbers she likes. She's locked her sight on him and bids in 50¢ increments by slicing at her neck with her hand. "They usually go up in dollar increments, but I like to bid 50¢ at a time," Missy says. "Now, Missy," the auctioneer says to see if she'll raise her price after someone bids after her. She is bidding on a lot from Mount Pleasant, Texas: 350 pounds, $172 per one-hundred-weight. "I know the family who is selling," she says. "That's very important. We're long-term customers. I know that they're good cattle, so I'm willing to pay a little more." When someone bids $174, she shakes her head slowly no at the auctioneer. "All of a sudden, that higher price eats all of the profit," Missy says.

"The seller has the right to not sell at the price got at the auction. That man there," and she points to the back of a man's cowboy hat–covered head in front of us, "has a neighbor who has brought his cattle here the last few auctions. He doesn't get what he wants, and once his animals sell, he decides not to go through with the sale."

When Missy was eight years old, she told her father she wanted to be a rancher. He told her to get a degree in business, and she did, earning a BS in agricultural economics with a minor in finance and an MS in animal science from Texas Tech University in Lubbock. She also has a certificate from TCU's Ranch Management program. "It's the equivalent of a master's in nine months. We write the equivalent of two theses on top of other projects. It helps you run the ranch as a business. Of all that studying, TCU's Ranch Management was the best. It taught me to apply what I was learning and what I knew from growing up around it all." Missy's father, Pete, graduated from the same program in 1973. "Daddy always said that the thing he hates worst is that ranchers think it's a great life but a piss-poor business. But if you treat it like a business and not try to be smarter than what the market has dictated, you can make a great living for yourself." Though Missy can be hands-on—especially when loads of cattle are delivered to leases—it's the business side of running the Bonds Ranch that she likes. "I don't need to be outside working; we can hire cowboys to do that, and we have a few really great cowboys," she says. "I'm not outside working, I'm in my office crunching the numbers. And that's what you have to do to be able to be profitable, and if you're not profitable, you're not going to be here for the next generation. We look at this like a business, not just as a way of life. It is a way of life, but it can't be a way of life if you can't make money at it."

On every deal, Missy figures in a 25 percent return on her equity and won't ever do a deal for less. "Most everyone looks at the price per head," Missy says. "I'm looking at return on equity. I would love to have a home run every time, but sometimes we don't. We've had deals that have turned out like we hadn't planned. When we bought the cattle, the numbers worked, but somewhere along the way, the basis got out of line—like maybe drought hit and the cattle didn't gain, things you don't foresee."

She explains further how she runs her numbers. In order for a bank to loan money to purchase a cow, the buyer has to put up 30 percent of the value of the animal, also called 30 percent equity. "That's your skin in the game," Missy says. "If I'm borrowing money and running 100 head and I make 50 percent return on equity on a turn of cattle, next year, I can run 150 cattle because I've now made 50 percent of my

initial investment back and I can reinvest it. That 50 percent is called return on equity. With your big corporations, a 10 percent annualized return on equity is a good return. We have done some deals where we make 200 percent return on equity. With those deals, you have to look outside of the box. Cattle are widgets. The product—the widget that we make—is cattle. So we look at our widget-cattle as any big corporation would look at their business. The way we do it is not regular," Missy says. "Not enough people in our industry look at it this way."

Throughout the auction, she keeps an eye on the Chicago Mercantile Board, a window that's open in the corner of her laptop screen. It's an exchange that shows how much feeder cattle are trading for. She also uses it to check the futures market of cattle. She'll have sold most of her animals before she even buys them. "This is like the stock exchange for cattle," she says. "As soon as I've bought cattle, I've hedged them," she says.

She gives an example of dealing in futures. "The Chicago Mercantile Exchange May Feeder Board is $135 at the time I buy my cattle in November, and I believe I can sell my cattle for $1 over the board, so I use $136 sell price to run my break-evens. Then I will take a short position in the May Feeder Cattle Futures Market at $135 when the cattle are purchased. I will contract the cattle to the feed yard stating that I will sell them my cattle with a $1 positive basis. Basis is the difference between the cash price and the futures price at a given time. I will also give the feed yard the right to tell me at what price on the futures market to make our base price. This can happen at anytime between the time the contract is made and the time the cattle ship. So say I have my short position at $135 and I contract the cattle for $1 basis. At the time the feed yard prices the cattle, the board is now at $137. So when I remove my position, I lose $2, but I have still sold the cattle at $138— the $137 base price plus the $1 positive basis. In turn, I have still sold my cattle for $136 like I had expected. And I'm happy with that because I've made my expected profit.

And I can do it again next year. Sometimes it goes in the wrong direction and we lose."

Missy has bid on several lots today but hasn't won any. "Sometimes we can get some bought, sometimes I just sit here," she says. "These are likely cross bred," she says of the next lot. "I don't like this batch. The cows look good, but the steers are potbellied and short. Their legs are small. They don't have much growth to them."

Missy took over buying cattle at the auction and hedging them for the Bonds Ranch several years ago after her father spent a month in the hospital with pneumonia. "We almost lost him," she says. "I told him if he ever did that again, I'd kill him." Today, her father is looking at cattle in a sale barn in Canadian, Texas.

The Bonds Ranch buys most of its cattle from sale barns, though Missy also goes to the Superior auction because she can buy full lot loads of cattle. "You know the history, breed types, what vaccinations they have, you know if they're weaned or not and if they might have extra special bells and whistles that might make them bring more money," Missy says. "There's higher risk at a sale barn. You're putting together the cattle from different owners. Then you bring them back home and they don't have the immune system to fight off all the introduction of all the other cattle. There's higher input costs in running cattle from sale barns. A truckload with one hundred head might have ninety different owners out of forty different sale barns."

The cattle Missy and her father buy today and in the next few weeks will be moved to land the Bonds Ranch has leased from different farmers and landowners throughout Texas. On each of them, the cattle will forage on wheat for the next four or five months. "400- and 500-pound calves grow to 800 pounds on wheat pasture," Missy says. "Steers'll grow about 2 pounds per day. Heifers about 1.8 pounds." In order for the farmer who owns the leased land to insure his wheat crop for the following year, there can be no cattle on it after March 1, so Missy will move cattle off that land before then and deliver them to the feed yards that have bought

them. Farmers also want the cattle off their land by then so they can harvest the wheat seed, called harvest wheat. Other farmers opt to keep cattle on the land until it has fully played out, allowing cattle to graze the end-of-season wheat sometime between April 15 and mid-May. By May 15, the Bonds ship those cattle out. "We buy heifers to turn out, not to breed," she says.

A man walks up to Missy's round table and touches the brim of his hat. Another lot is on the screen and other people in the room are bidding, but Missy is not. He leans over to take her hand. She gives it to him and smiles. She may or may not recognize him. "If more people figure cattle like you do, Missy, we'd all settle down and start making money." He lets go of her hand, touches the brim of his hat again and moves on.

Another lot appears on screen. "I don't like them," she says, "they're light boned."

Then another lot. "I like these calves," she says. "Their frame is really big and their bones are big. There's not much Brahman influence. Not too fat. Pretty uniform. I think these aren't for breeding but for selling down the road."

As the auctioneer calls out the rising price, Missy plugs numbers into her spreadsheet and figures the loss she'll take if she buys the steers now. A man in the room is bidding on the animals against someone on the phone. "These people are buying because they're expecting the cattle prices to go up," she says. "There's no reason for me to bid on anything because they're way too high," she says.

A man in a blue-checked shirt at the table next to hers turns completely around in his seat and leans toward her, asking if she'd be interested in buying a load of steers from him. He gives her the numbers in a quick offer, and she shakes her head no without considering her laptop.

In 2015, the price of cattle was very high, and now, it's shockingly low. "You had the perfect storm in 2015 with the low supply of three proteins—pork, chicken and beef—and the continued increase in exports," Missy explains. "Our meat exports all over the world to places like the European Union, Japan, Korea, Mexico and Canada; Mexico and Canada are number one and number two for exports. Egypt buys many tons of kidneys and livers and tongues. A lot of stuff we export is stuff we don't eat. Mostly offal." She says that in 2011, mad cow disease caused a shortage of meat. Once exports opened again, the combination of low supply and high demand caused the price of cattle to rise past $2 a pound by 2013. "The value of a tongue alone increased $8 a head because of the export value," Missy says. In 2014, seeing the high price of beef, a lot of people held onto their heifers and bred them. This, in turn, caused a glut of beef in the market. The demand has remained steady, but the supply is overloaded and the price subsequently dropped. Cattle producers lost $200 to $500 a head in 2016, says Missy.

"Hey," Missy says quietly into her cellphone with her hand over her mouth, "our cattle are up." A video of black steers walking over green grass is playing on the monitors. The ticker tape reads: "Lot 9719A, Bonds, Gollard, Texas, 575 pounds, 87 count." She's talking with her father.

Three lots of Bonds Ranch cattle will sell: A, B and C.

First, the A group: "They're at 25…26…27," she says, keeping her eyes on the video feed and listening to the auctioneer in the room and her father on the phone line all at once. The lot sells for $128 per one-hundred-weight.

Then, the auctioneer says what's on the tape under the next video: "Weaned heifer calves, Lot 9719B." 16…17…18…

Missy's lot B sells for $119 per one-hundred-weight and runs about 560 pounds per animal.

The final Bonds Ranch lot: "Weaned steer calves, Lot 9719C. 575 pounds, 49 count." "26…we're at 30," Missy whispers, giggling a little into the phone. "Sold at 30."

Missy is red-cheeked and happy with her numbers. "That's higher than what I could pay for them," Missy says.

A few weeks later, before driving up together to see one of her leases northeast of Wichita Falls, Missy and I meet again, but this time at the Bonds Ranch headquarters. Purchased in 1933 by Missy's grandfather, the ranch originally ran four

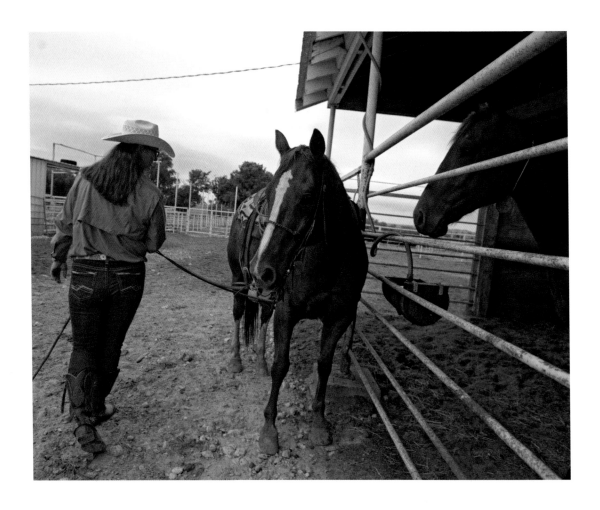

Missy leads her horse through a pen.

*Opposite*  A newly delivered load of cattle waits
in pens to be sorted, tagged and set out on wheat
pasture.

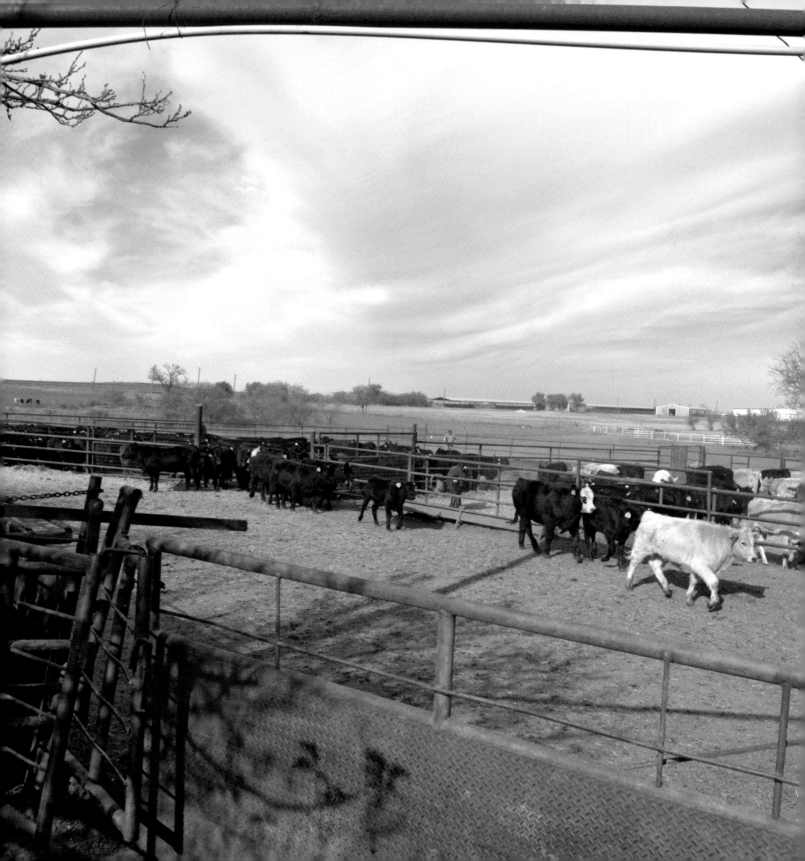

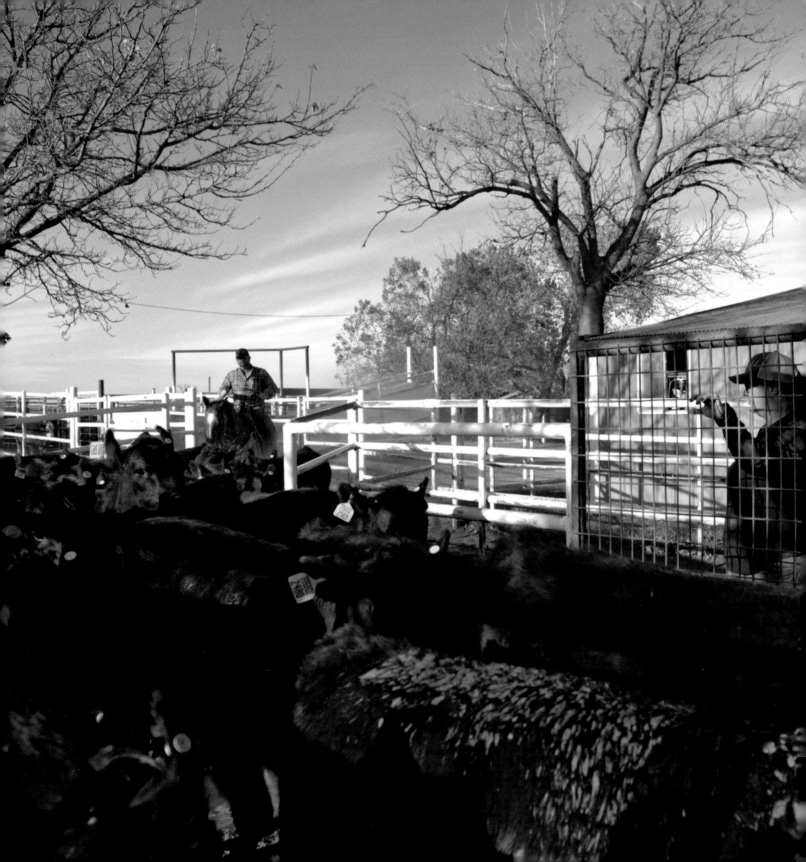

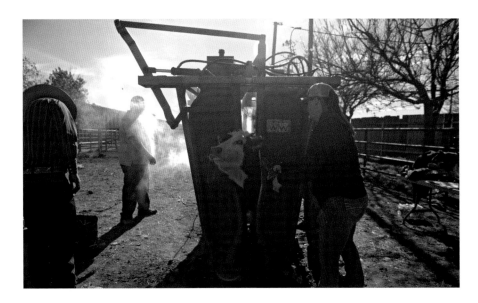

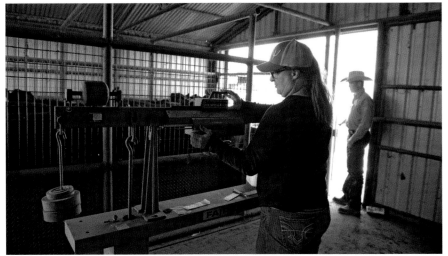

*Left*  Missy looks on as the landowner moves cattle through pens after being ear tagged.

*Top*  Missy ear tags every animal after it's delivered.

*Bottom*  Missy weighs cattle in a weight room after they are delivered to land the Bonds Ranch leases. They are also sorted and ear tagged and then let loose to forage on wheat for four or five months.

*Opposite, top*  The Superior Livestock auction in Fort Worth uses video monitors to show lots from all over the country. Missy has attended auctions here with her father since she was a child.

*Opposite, bottom*  Missy and other riders sort cattle at the Bonds Ranch headquarters.

*Top*  Pete, *left*, Missy and her mother, Jo, grill meat as part of the cooking competition at the Texas Ranch Roundup.

*Bottom*  Missy talks to the Bonds Ranch manager for the Saginaw location, Colby Hunt, after competing in arena events in the Texas Ranch Roundup.

*Top*  Missy walks through the coliseum before her team events at the Texas Ranch Roundup.

*Bottom*  Missy saddles her horse before sunrise.

*Opposite*  Missy closes a pen gate at the Bonds Ranch headquarters north of Fort Worth.

hundred Herefords on five thousand acres in what was then Hicks, Texas, a few miles north of Fort Worth. The Bondses raised and sold cattle on their own land until fairly recently. The focus shifted to putting cattle on leased property in the 1980s when Pete, Missy's father, started looking at ranching in terms of return on investment and sold off a significant part of the ranch to subdivision developers. "We now have three housing developments on the ranch," Missy says.

Promotional materials for those subdivisions are marketed toward buyers who want to live "away from it all, but close enough to enjoy the city," with oasis-like backyards and low-maintenance saltwater pools. Today, a 1,600-square-foot 3/2 home off Bonds Ranch Road sells for $208,000; another home, a 4/2 in the Emerald Park neighborhood, is $275,000.

The Bonds Ranch headquarters is tightly surrounded by houses and landscaped lawns. Missy and her sisters, and their father before that, grew up here. Their parents, a few horses and some cattle still live on what's left of the property. Colby, the ranch manager, lives in the ranch manager's house, which is set between the headquarters and the main road. The ranch office is in an outbuilding with a flagstone patio across from the stables. Colby built the patio furniture with old horseshoes, lengths of angle iron and an acetylene torch. The rocking chairs have built-in drink holders, and the table is the right height to invite resting feet. The houses and outbuildings don't sit square with either the main road or the caliche road that runs through the ranch, giving the feeling that the buildings were on this land long before roads. Looking in any direction, though, you can see rooftops. The subdivisions are so close to the pasture that when Missy, her father and the neighbor cowboys ride out to gather a couple dozen cows and calves and move them to the pens, houses up and down the rolling hills are all you can see behind them. "We're surrounded by the urban world now," Missy says. "I knew it was going to happen, but I don't like it."

"City ranching is no fun," Missy's mother, Jo, says. "The Fourth of July is the worst. The firecrackers scare the dogs and the cattle. And we have to go around with a water can making sure there are no fires. We find people in our pasture. There are 'no trespassing' signs everywhere, but people just think they can come out and do whatever."

The Bonds Ranch runs cattle on leased land in twenty-six Texas counties and eleven states. It is a tight symbiotic relationship: the landowner spends his or her own money to plant and fertilize that wheat pasture, the Bondses pay the landowner rent for their animals to live on and eat the landowner's wheat pasture and the landowner gets paid based on how much weight the cattle gain. "We take care of the land like it were our own," Missy says. "We leave it better than when we got there." The Bonds Ranch shares the cost of ranch improvements with the landowner "if we know we'll have a long relationship"—long being at least five years.

"In the cattle business, you have two different businesses," Missy says, "real estate and cattle. You can own the ranch and not own the cattle on it, or you can not own the ranch and own the cattle on it. You can have one without having the other."

Missy actively looks for landowners who want to lease their land. "Our goal is to find younger people with drive and start out small with them," she says. "When their neighbors see how we handle cattle and do our business, how we handle people who work with us, a lot of time when they hadn't thought of running cattle, they see how we do it and ask to have cattle on their land too. We don't overgraze. That's the biggest danger of leasing land. Some people overgraze, and that's not good. We help maintain fences, make sure the windmills are working properly. We pay on time and the check won't bounce."

"Overgrazing is a real problem industry wide," Missy says. Land that could carry one hundred head of cattle in years of good rain will get overgrazed quickly in years when less rain falls and less wheat grows or if you put too many cattle on it. "You have to change, accommodate, adjust," she says. The land in this part of Texas is verdant, and a single cow needs access to only eight acres in a season to survive.

In far South Texas and West Texas, animals often require about eighty acres.

We are driving before sunrise from Fort Worth to ranch land northeast of Wichita Falls in Missy's SUV. She makes this trip every two weeks "when we're in cattle"—the Bondses' cattle-buying season is from October to mid-December. As we exit off the interstate onto a two-lane blacktop road, the sun is just making light, and we drive east. Missy drives as fast as she drove on the interstate, passing ranch land on both sides. She slows slightly, looking at a distinctive herd of black-and-white cattle in a field. "That's a Belted Galloway!" she says. "They're more of a beautiful breed. I don't mind a good Hereford, but Herefords don't have as good immune system. They don't have the size. They're short and squat."

The Bonds Ranch trades in several breeds. In North Texas, they mostly trade in Angus and Brangus, which is an Angus crossed with a Brahman. Their bulls are Angus/Brangus/Charolais crosses. In Canadian, their cows are red or black Angus and their bulls are red Angus. In South Texas, they have Herefords crossed with Brahmas and red Angus bulls, or Brahma cows and Charolais bulls. "It all depends on the location and climate of these ranches," Missy says. "The further south and east, the more Brahma influence we need because of the heat and humidity and pastures."

When we pull in front of some ranch buildings, Missy rolls down her window, and Dillon, the hand for this property, leans in. He is red-headed and red-cheeked with cold. He says good morning and laughingly calls Missy "Mistress" as she hands him a sausage biscuit from a bag. He puts it in the pocket of his canvas duck jacket and then pulls out an insole with attached wires from his chukka boots—the same kind Missy wears—and a handheld control box also attached to the wires but kept in the pocket of his jeans. "Heated," he says, showing it off. "From Cabelas." I ask him if it's going to be a long day. "I'm used to working from dark to dark," he says.

"Dillon's a good hand," she says. "He feeds and takes care of the cattle, fixes prolapses and foot abscesses, pinkeye, knows when to increase or back off the feed, doctors outside and can tell the sick from the not sick ones. A lot of people who want to have the job want the title of it more than they're good at it. It's being on horseback, fixing fences, fixing water pumps, gaps in the fence. There's been a time or two when a calf's got his head stuck in a bucket. A lot of people don't want to be outside doctoring cattle when it's twenty degrees and snowing or breaking up ice on the water tanks. A bad caretaker is someone who won't do any of that. We tell him what minerals and what vaccines we want him to use." He also counts the animals, checking that none has been stolen. "When people steal cattle, they bring moveable pens to load them up," Missy says.

Missy bought three loads of steers—226 head, 267 head and 101 head—at an auction a few weeks ago and had them delivered to this lease. The first load arrived yesterday, the second last night and she's expecting the third by tomorrow. Today, one of the loads will be processed, which means they'll be walked through a chute, ear tagged, vaccinated and hot-branded with the Bonds Ranch turkey track–shaped brand on their left hip. They'll be kept in a single large metal pipe–fenced pen until the entire group has been processed, and then a cowboy ranch hand on horseback will cut small groups from the general herd and push them into the weight room to be weighed. Some cattle come in heavier than expected. "We'll separate out the bigger ones," Missy says. "That's what you get with ranch cattle—a bunch of different sizes."

"Are we going to call these steers cross bred?" Dillon asks. "The black ones we did yesterday are English." English means there's no Brahman influence, that they're Angus and Hereford breeds only with maybe some Charolais. Cross bred indicates Brahman blood. Missy nods yes; these are cross bred.

A crew of four people has gathered and sets up to process. The steers that were transported here yesterday from Show Low, Arizona, mill around in their pen. They moo, stomp, huddle together, kick up dust and try to mount one another in a mixed show of dominance, nervousness and playfulness.

Missy sets up a fold-out table next to the hydraulic squeeze chute that all roads from any of the pens lead to.

"It takes about five people to make this work and have it go easily," Missy says. "It won't surprise me if one has come in as a bull; the rep might have missed it."

She opens a heavily padded aluminum case and pulls out her laptop, where she'll record the animal's original ranch, his tag number and today's treatments in a spreadsheet. One of her ranch hands stands at the head end of the chute next to an old refrigerator on its side that serves as a table top for bags of light blue ear tags and boxes of smelly insecticide. Two ranch hands stand inside the pens holding battery-operated electric prodding rods and shoo the animals single-file down the narrow alley that leads to the chute. Dillon stands on this side, near a drop-down door at the back of the chute where the steer's hip will be, holding an electrified branding iron. And Missy, between the chute and her table, stands next to Dillon with a dosing gun she hangs on a bent piece of baling wire. She sets out a pair of heavy-duty branch loppers to use if any of the steers still have horns.

Someone's opened all four doors on a pickup truck and turned the volume all the way up on the radio, set to a '90s pop station. As Boyz II Men sing "I'll Make Love to You," steers bellow and slam into one another as they're driven quickly down the narrow alley. Men holler at animals to move into the chute and holler again when they've gone too far. The chute's hydraulics exhale as Dillon opens and closes the metal walls against the animals and pulls the head gate around their necks.

"What's up with the slow jams?" Missy says and stops the entire assembly line to change the satellite station to Old Top 20, starting a playlist of Guns n Roses, Pearl Jam and Nirvana.

There are 264 steers and 18 heifers to process this day. For several hours the music plays, Missy and the men run animals through the chute and Dillon brands. "Why are you afraid?" he asks when my shaky hand takes the brand to a hide. "They're not pets. If you want a pet, get a dog."

Missy vaccinates the animals under the skin at their neck and hands me the dosing gun to run while she enters data into her laptop. Put the shot in the neck near the armpit, she advises, not in the shoulder. "The shoulder's a prime cut, and you might cause an abscess in a good cut of meat."

Missy holds up the flow to lop off short bits of horn on some animals, making a wet, compressive sound and sending a very thin stream of blood arching out, like water flowing from a hallway water fountain. The steer holds its foghorn bellow extra long when this happens. The steers jump out of the chute and hit a patch of cement that was poured there to fill the hole caused by five-hundred-pound animals jumping out of the chute and onto the same spot season after season. They run to the other animals and stand jostling one another, sometimes with their huge blue tongues hanging out of the corners of their mouths.

"Don't get run over," Missy says and gestures me away from the head of the chute.

After all of the animals are processed, they will be moved from the holding pen to the weight room, a two-walled enclosure with a roof and two gated sides. One side opens to the pasture and the other to the pens.

The weight room's floor is the scale, with gates on each end. Dillon closes the far gate. Once the steers move into the room, they are driven tighter together, more animals pushing in ahead of a cowboy on a horse and an Australian cattle dog running zigzag at their ankles. The second gate is closed behind to hold them in. There is so much noise from animals bellowing in a closed room that Missy directs the opening and closing of gates and moving of animals with hand signals and short sentences. "Come on," she says, her hand in the air waving animals toward her, the cowboy watching to see when he's pushed enough steers inside. "Stop," she says and holds her palm to the cowboy. In response, he turns his horse around and stops any more steers.

The steers look blue in the dark shadows, and it is hard to see individuals. There is a single beam of sunlight that spills in. Missy counts the number of animals, writes down

the number and the weight and directs Dillon to open the gate to let the animals out. They run toward the thousands of acres of green and yellow pasture where they'll graze for months, fattening on wheat in the winter and early spring. They'll be gathered again in March or May, sent to a feed yard and shipped from there to slaughter.

The survival of ranching is tied to exportation, Missy says, and she wants to grow their business toward that trend. "If China opens up, I'm hoping we'll meet their export requirements," she says. A tracking program that she's instituted follows each Bonds Ranch animal from its origin point all the way to slaughter. Having that information ready and at hand will help the ranch jump into the China market someday. "We'll have a system in place to get in that market," she says.

Over the course of ten days, Missy and her crew run 2,200 head, the same thing over and over. "Ear tag, process, just like this," Missy says. If it weren't for the ear tag tracking program, which she prefers to oversee herself, she wouldn't be here as much. But she likes the work. "I could sit in a chair and work the cows. I could. But I like to pull my own weight," she says. "There's something good about actually working."

After all of the animals have been weighed and let out into the pasture, as the other hands are loading their horses onto trailers or smoking cigarettes, Missy asks Dillon about other possible land leases in the area. She goes down the list of how many animals are on each property they've leased. She'll look for cattle in the coming weeks at sales and auctions to maximize the leases and put as many cattle on the land as will hold.

She speaks to him in shorthand for some time: "The first week of December we have 102 heifers coming in. English. Graze outs, unless something happens and these cattle are huge, but that won't likely happen. December 12 we have 1,450 cross bred steers coming in. After December 12 we'll have a mixed load. Graze outs. English. Four or five loads are harvest cattle only from Falls County. I won't do nothing

to them. They'll be turned out. It's a split load—steers and heifers. Cross bred. English."

Dillon mostly nods his head in agreement, his hands tucked into his zipped-up jacket, his feet toasty warm.

Missy enters the farmer's simple house, near the pens. There's a low worn couch and a shotgun against the wall. Several pairs of leather work boots and several pairs of tennis shoes are just inside the door. There's a double-burner cook top but not a stove. A hook on the wall holds jackets. Missy sits at a table and pulls out her laptop. She sets a valise with notebooks and slips of paper coming out of the top in the seat next to her, and the farmer sits on her other side. He hunches toward the screen as she points to it with her finger and her pen. He doesn't say a word. Farmers plant and fertilize the wheat that the Bonds cattle eat. They usually help the crew on shipping day, says Missy. "They want things to go as smoothly as possible."

A shipment of cattle came in nearly two months early, and this farmer "found some grass to put them on, to hold them," she says later. "He'll turn them out onto the wheat pasture when the wheat's ready. They were able to plant and get it in the ground early. It's great weather for growing wheat. From the day you plant to when you can turn cattle out on it is forty-five days. If he has ideas of what he wants to do, he'll let us know. We do have a protocol of things we want. We see our cattle as a thing to buy and sell. We look at the numbers. If they make sense, we'll do it. If not, we won't."

Ten months pass before I see Missy again, and in that time, she has bought and sold thousands of head of cattle. The price per one-hundred-weight is slightly up from what it was before, and the ranch is doing well. They've been asked to be one of ten Texas ranches to participate in the 2016 Texas Ranch Roundup, an annual, invitation-only ranch rodeo held in August in Wichita Falls. Ranch rodeos are different than professional rodeos. Ranch rodeo contestants are working cowboys, and they compete for bragging rights in events like calf doctoring, team branding, team penning

and ranch cooking. "Cinnamon rolls, supper rolls, T-bone steaks and corn is what they're asking for this year," Missy says. Everything is to be cooked over an open flame.

"We lobbied for a few years to participate. Finally, one of the ranch families bowed out, and we were invited in," Missy says. The same families compete year after year, and the ranches that compete must be Working Ranch Cowboy Association members—historic working ranches with a certain number of employees.

In Wichita Falls, Missy shops in the vendors' hall with her sisters and mother before the rodeo begins. Missy is the oldest of three sisters. Her youngest sister returned home to help with the ranch about three years ago, and Missy's middle sister is married with four children ("They are the cutest damn things") and lives and ranches in Colorado. Missy pays for and picks up items she'd already ordered: brightly colored boots with whimsically stitched uppers from Mexico that she'd had custom-made for her young nieces and beautiful leather handmade purses for her sisters, mother and oldest niece from a woman she's ordered from over the years. The purse designs have Navajo wool rug or Mexican textile stitched into them, worked and stamped leather, dangling tassels, braided leather handles and silver fittings. The women figure out quickly between them which bag goes with whom.

Before the team penning event, Missy hands me a ticket, and I find my seat among Bonds Ranch folks who work in the main office. Missy, her ranch manager, Colby, and two other Bonds Ranch men are competing in this event. Missy enters into the arena on a horse, her long hair untied down her back.

"We don't fit the mold," Missy tells me after the rodeo. "Most teams here are single tracks of land with big pastures and a homeplace. Bonds leases all over the place. Most operations run the same animals over and over, but because we have our yearly plan, we can change rapidly. We're not tied to a certain land like these other ranches are. We value our homeplace, we do, but we had to change our mindset about the land. We had to distance ourselves from the sentimentality of the land."

# JEAN ANNE EVANS FORT

*In Alpine and North of Fort Davis, Born in 1954*

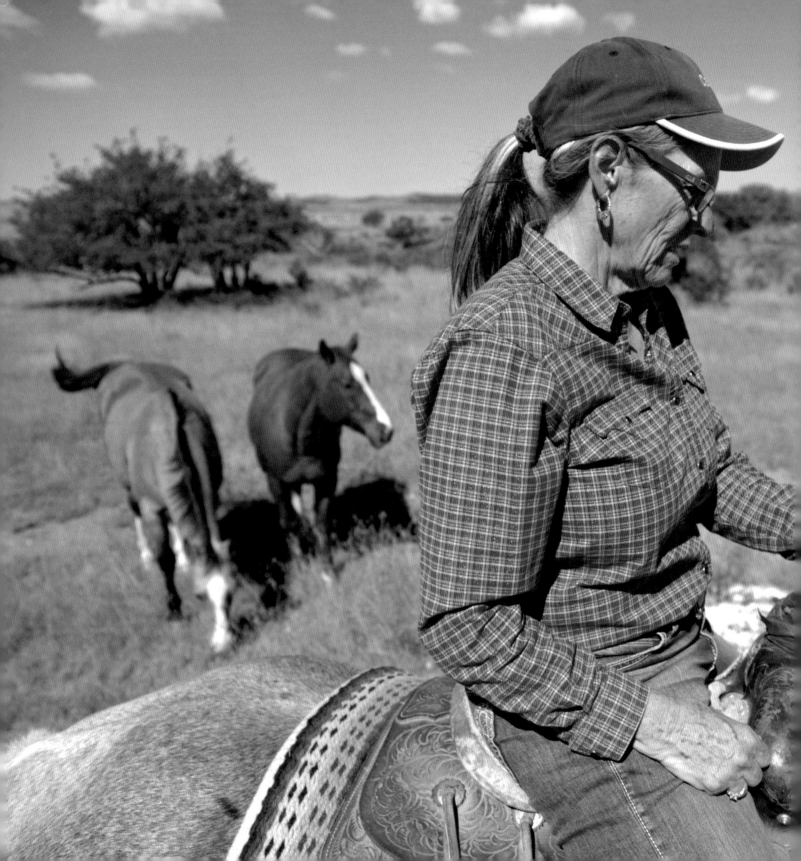

Jean Anne rides Scout, her red roan mare, through her pasture on ranchland that belonged to her great-grandfather, then her grandmother, then her father and was divided between her and her brother, Curtis, after their father died in 1992.

Every bit of her land was scorched in the Rock House Fire, the third-largest grassland fire in Texas history that started on April 9, 2011, burned for thirty-seven days and consumed more than 314,000 acres in two counties. High winds caused electric lines to spark at a vacant house near Marfa, catching the prairie on fire. "It was a huge fire," Jean Anne says. "The wind was blowing fifty or sixty miles an hour and came through one pasture and jumped Highway 118 at our place. It had already jumped the highway at Fort Davis."

The ranch's cattle had to be moved to safety, and Jean Anne drove the truck through her pasture, honking. "I got the cows to start following me. I looked up and saw Bill driving through the pasture with the horses. We had to drive the two miles across. There was a calf that was one or two days old that couldn't travel as fast and got really tired. Bill roped it and put it in the front seat of the pickup. People were driving by and saw we needed help and were stopping. Some lady I'd never seen before helped us get the cows under the bridge because they didn't want to go.

"As soon as I got them under the bridge—the way we always do it, there's a passage that connects the pastures under the bridge—I got on one of the horses Bill brought and started driving cows, pushing them up the fence, and you can hear trees cracking and burning. The fire was across the whole flat. It also went up the mountain and burned my aunt's house down. The way the wind was blowing it looked like it was going to Curtis's house. We were up against the fence line and just going higher and higher. I was hoping the rocks might slow it down. The cattle split on us; Bill went with one bunch to a spot that was protected from the wind, but he left the cows there after the smoke got so bad, he couldn't breathe. The cattle were doing okay. He went on to the arena. We were going to meet up on top of the mountain, and he never came.

"You could see the fire coming. Curtis, my nephew, and a friend of his had gotten on their horses and pushed their cattle up to me, and here they came. It kept getting darker, and we got to the corner of the fence that joins our neighbor. He'd been running yearlings and they had ate the pasture down, so I said a prayer and pushed our cattle through the gate. My nephew was riding a gray mare, and I could see him through the smoke. The cellphones weren't working well, but Drew [her son in Midland] could call in, and he relayed messages between us. I gave my mare her head and kicked her and let her make her way. You have to trust your horse. They can see better than you. She had to jump some, but she got us down, and we followed my nephew off the mountain. Bill said that when we got down and into the flat to come running because my brother was blading a road and had made a firebreak. When I came through, the flames were taller than me on my horse. Curtis was driving the 'dozer blading in circles and flames were going into the 'dozer.

"The group of cows that Bill left—we didn't know what had happened to them. It's midnight and we're driving, and we get out at the water trough and they're there. He pulls that baby calf out of the front seat. The cows are just bawling. His momma was looking for him."

Curtis bladed roads as firebreaks for about two weeks. "If the wind's not blowing too bad, it'll stop a fire," Jean Anne says. Neither Jean Anne nor Curtis lost any animals in the fire but ended up selling all but seven heifers afterward "because there was nothing for the cows to eat. We just kept seed stock and made it back up again," she says.

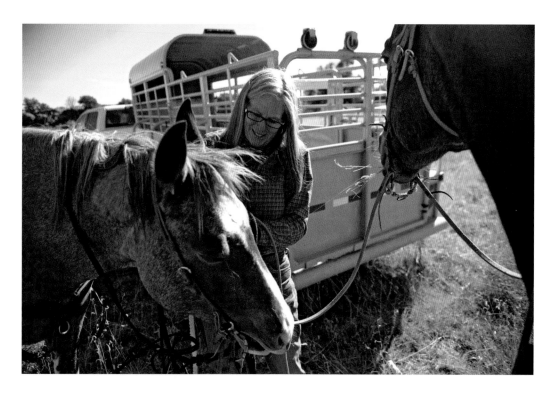

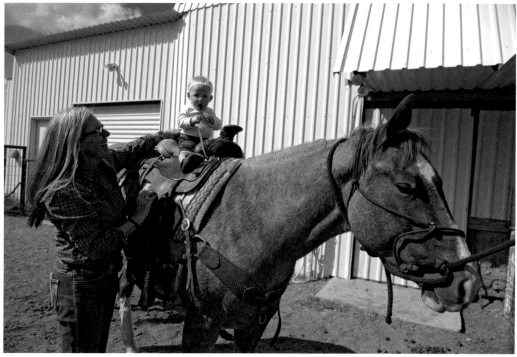

*Opposite, top*  Jean Anne readies her red roan, Scout, and her buckskin gelding, Newt, for a ride.

She grew up in Fort Davis and Marfa, graduating from Marfa High School. She earned bachelor's and master's degrees in elementary education from Sul Ross State University. She was a librarian for a few months and then spent twenty years as a reading specialist for pre-K through fourth grade in the local public schools. "The ranch doesn't make enough to support a family," Jean Anne says.

In 1982, she married Bill, and when the kids were young, they bought the house in which she, Bill, their youngest daughter Mimi and their granddaughter Harlie still reside. Their other two children are Drew, who owns a trucking company in Sweetwater and has two young sons, and Holly, who researches land titles and oil leases for an oil company and occasionally does daywork on ranches near her Fairfield home.

"Bill saw a future with me here on the ranch," she says. "I think God sent him to take care of me. He's been such a generous man with me."

*Opposite, bottom*  Jean Anne holds her granddaughter, Harlie, on Scout.

Jean Anne was horseback when she was nine months old. "My mom went with my dad on horseback every day, and they didn't have a babysitter," Jean Anne says. "They led me on a horse as soon as I could sit up and hold on," she says.

She has a photograph of her at fifteen months old, asleep while sharing a saddle with her mother. A *Life* magazine photographer covering the 1955 filming of *Giant* in Marfa took the image. Several scenes of the movie were filmed on her maternal grandfather's land, with his cattle and horses. She keeps a scrapbook of the magazines and newspapers where the photograph was reproduced. "When Mercedes McCambridge got bucked off, my dad was her double," Jean Anne says. "He had to ride seventeen bucking horses out in the pasture to get that scene right. I've got the pictures of him with the wig and dress on and everything." On the set, her mom helped move the cows. Jean Anne says the set designers planted plywood cattle silhouettes in the background because live cattle wouldn't stand still for the filming.

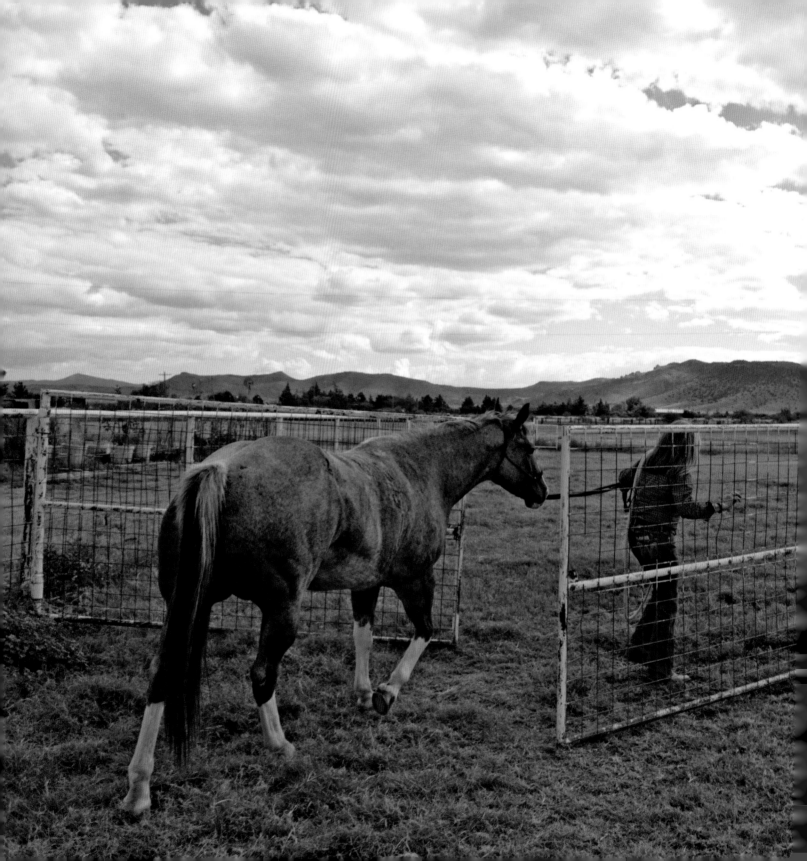

*Opposite*  Jean Anne moves Scout into one of the pens behind her house.

*Above*  Jean Anne selects bridles in the ranch's tack room. She's kept two of her mother's N. Porter saddles and a matching saddle that her father brought from Arizona when she was five years old. "All my kids rode it," Jean Anne says. She's also kept one of her father's N. Porter saddles, which Harlie will use when she starts riding.

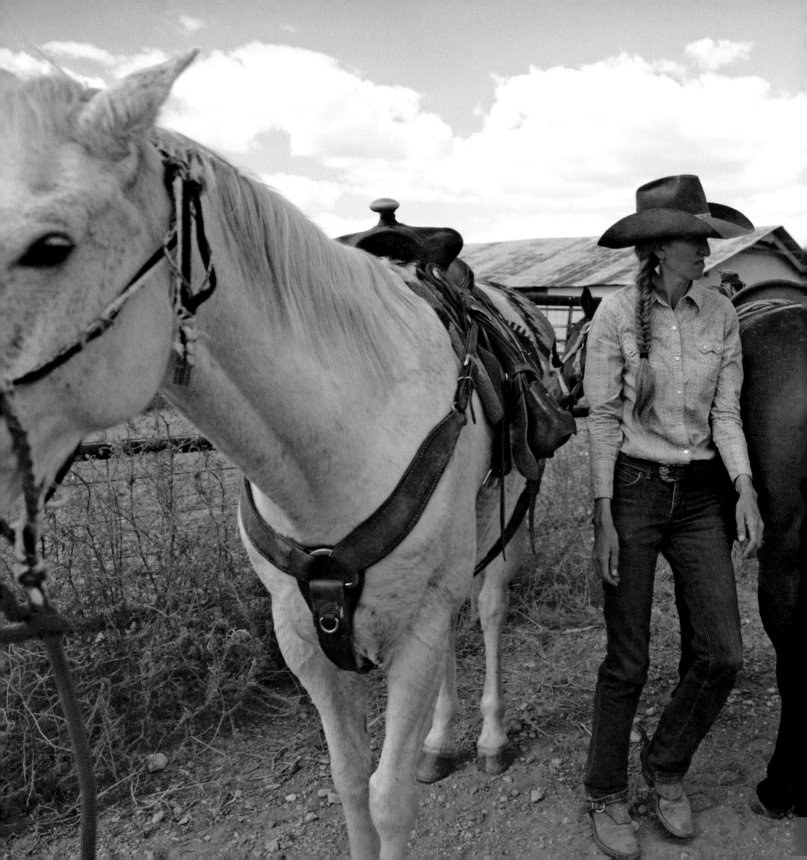

CHAPTER 10

# RACHEL MELLARD

*Southwest of Plata, Born in 1988*

Rachel; her husband, Damon; and their four sons—Thomas, nine, Aiden, seven, Travis, five, and Jacob, three—live on a ranch where Damon is the ranch manager, looking after the owner's cattle. The owner has leased the Mellards a portion of the land to run their own herd, an arrangement they've had for ten years.

Rachel and Damon's children, who have ridden since they could sit up and hold on to their saddles, regularly gather cattle alongside their parents. They are fluid on their horses.

"We're not trying to have another one," Rachel says. "But that's up to God. I don't know what I'd do if we had a girl. Boys are so easy."

Travis, *left*, and Thomas drive the family's four-wheeler.

*Opposite* Rachel takes a saddle to the barn while Aiden, *right*, starts unsaddling his horse, Hickory. The family rides all mares, except for Travis, who rides a gelding. "If I can't pack a child on a horse, we don't keep it," Rachel says.

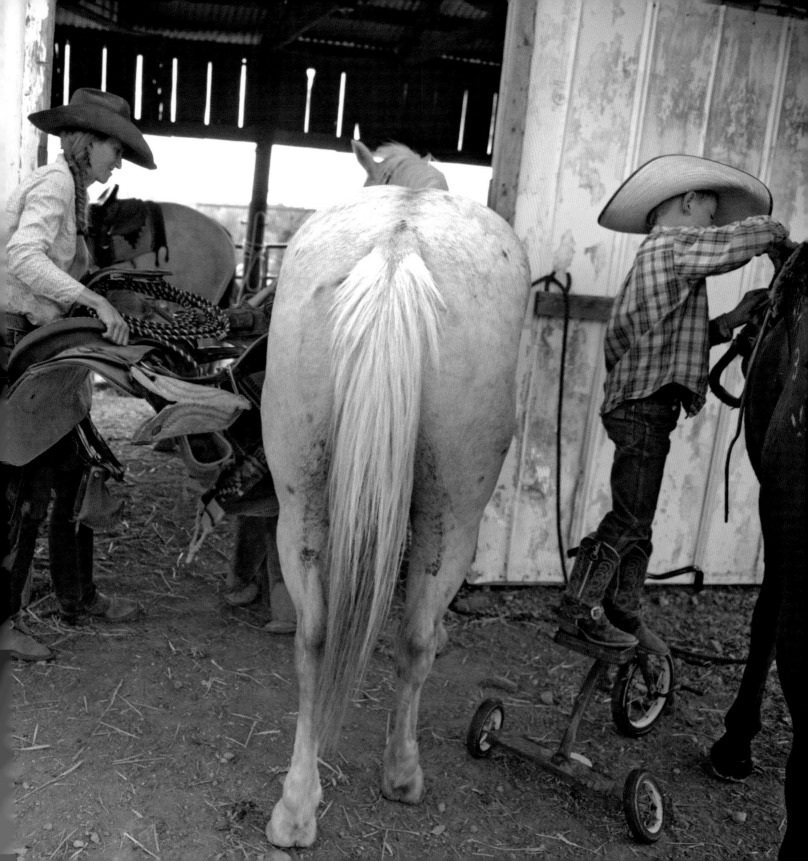

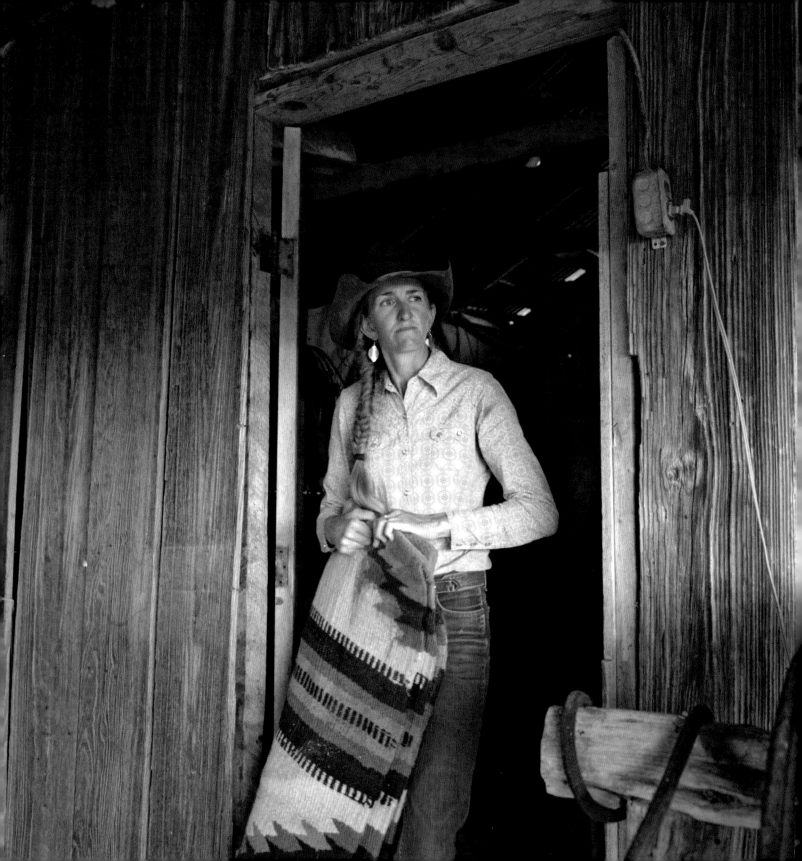

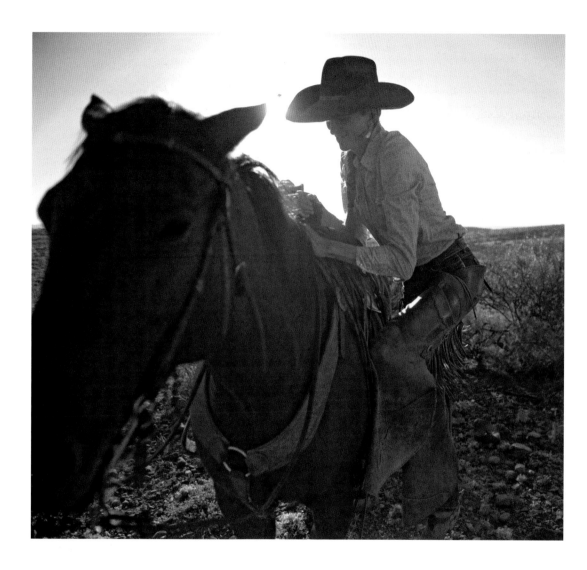

*Left* Rachel stands in the tack room holding a saddle blanket. She married Damon, who is ten years older than her, the October after she graduated from high school in New Mexico, where she was raised. "We met when I was young," Rachel says, "and he waited until I finished school."

*Above* Rachel mounts her horse at the start of a workday.

Rachel and three of her sons climb a rise and look for cattle on a day the family gathers, palpates and then culls their herd. Workdays start before light and are physical. Rachel and her family will cover every portion of this pasture looking for cows—which are often scattered and somewhat camouflaged in the terrain—until they find all of them. On days like today, the Mellards can cover many miles. The country they lease is measured in sections; one section is a square mile, or 640 acres. "If there's no rain, we can put six cows on a section," Rachel says, "and ten if there's good rain. Generally, we try to run about eight." She and Damon divide up the land into search areas—one heading in one direction and the other in another—to ensure it's been fully covered.

Until he's more sure on his horse by himself, Rachel leads the horse of her youngest son, Jacob, with a lead rope.

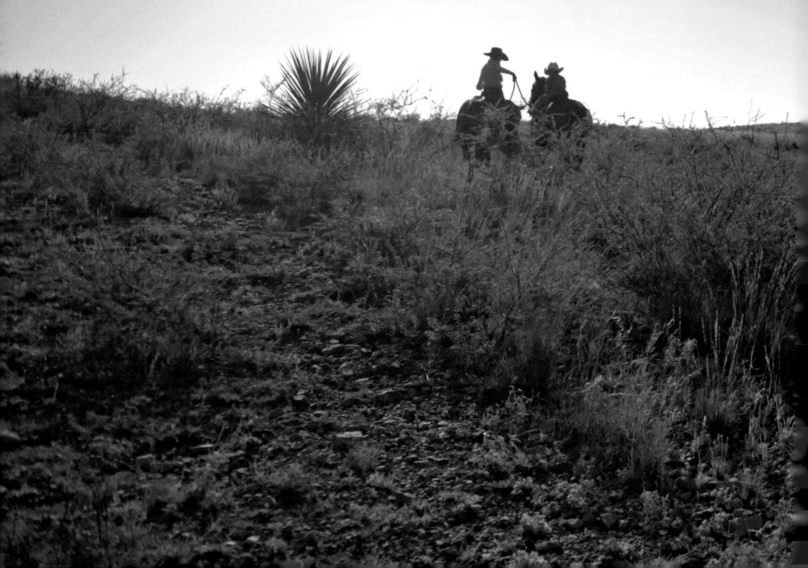

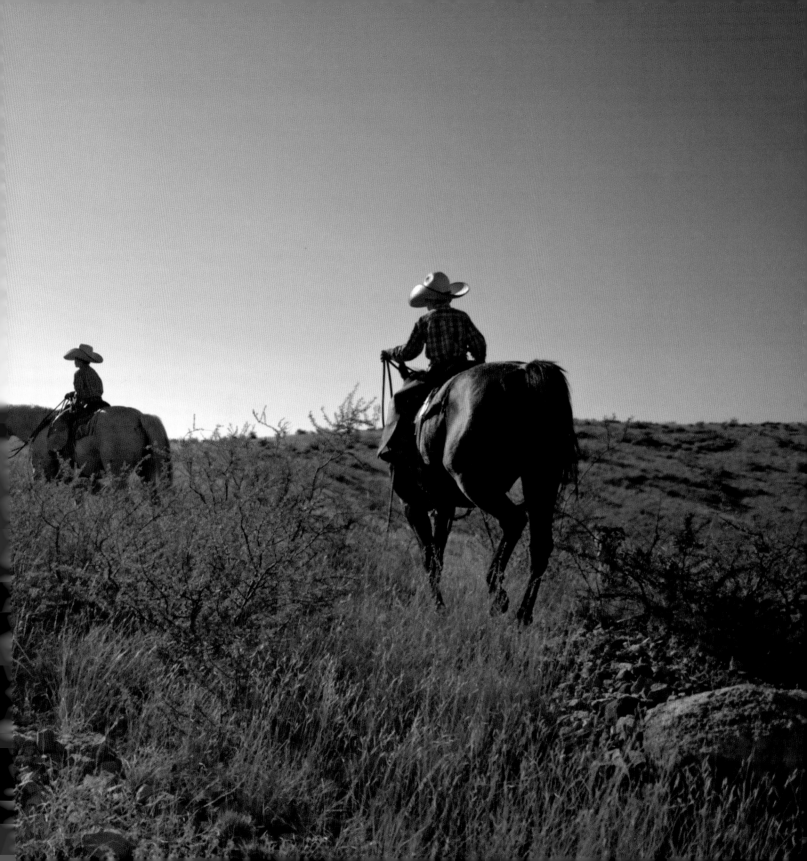

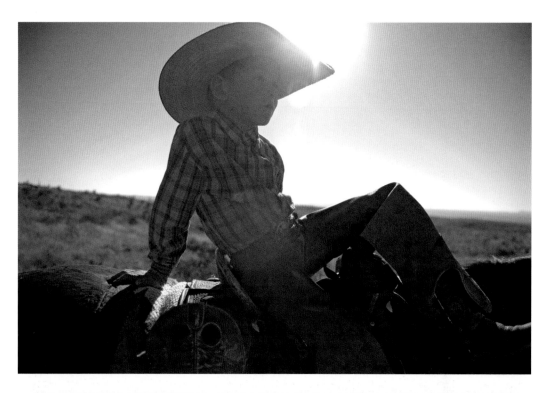

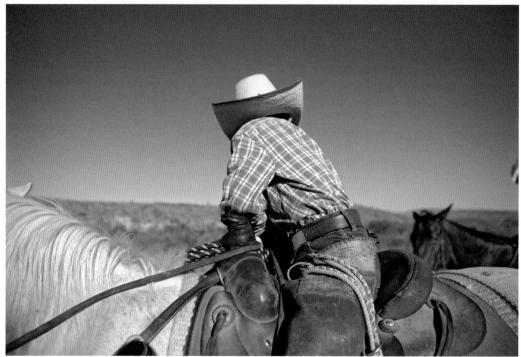

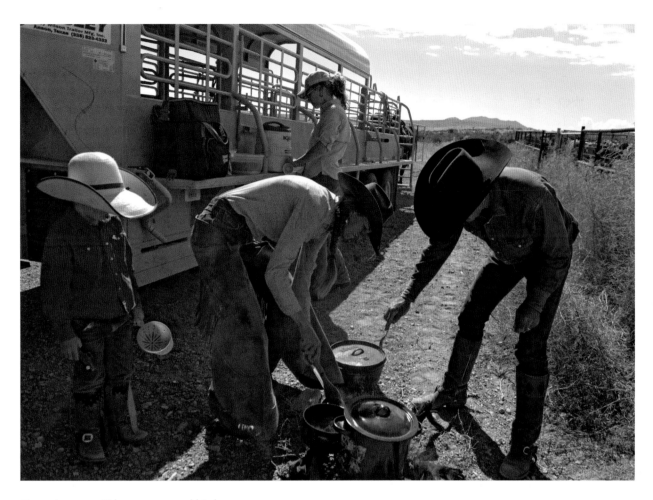

*Opposite, top*  Aiden, seven, and his horse.

"She spins like a dime," he says of his mare, Hickory. "'Hickory dickory doc,'" he starts, "'the mouse ran up the clock. The clock struck one, the mouse ran down, hickory dickory doc.' The man we got her from taught me that song," he says.

His youngest brother, Jacob, rides a mare named Jackie. "We all rode Jackie," Aiden says. "She's the one who taught us how to ride."

"Aiden's like me," Rachel says. "He's quiet until he gets to know you."

*Opposite, bottom*  Thomas, nine, sits on his horse.

*Above*  After gathering the entire herd, the family breaks for dinner. Rachel woke up early to assemble enchiladas made from the meat of a cow the family slaughtered earlier in the year. They typically slaughter two a year. Since the family doesn't finish their cows on corn, the beef tastes wild, unlike grocery store beef. Rachel also pre-cooked beans, Mexican rice and coconut and chocolate chip cookies. "The kids aren't like regular kids," Rachel says. "They like different kinds of food. Aiden's favorite food is squash casserole and beans."

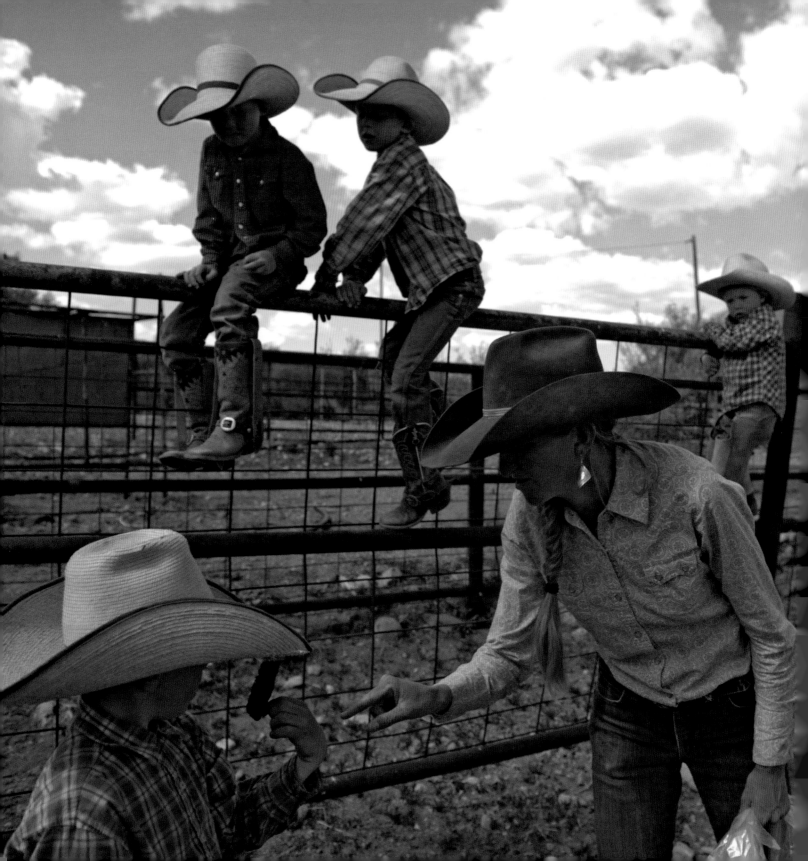

*Left*  Rachel looks at an empty wasp nest with Thomas during a break from sorting cows. Her other sons climb on the pen.

*Above*  Rachel homeschools her sons each day using a Christian-based curriculum—with the Bible and an American Indian prayer book as readers—in a room in their home that they modified into a classroom. "I have to hand it to Rachel," Damon says. "She's trained the boys in common sense stuff, but now they're getting their book learning with her too." Before class, the boys say a prayer and then recite the Pledge of Allegiance together. During class, they raise their hands and wait for Rachel to call on them, fill in worksheets and practice sheets that accompany Rachel's scheduled lessons and take turns reading. Since their ages range from three to nine, there are several levels of teaching going on at once. While Thomas reads out loud, three-year-old Travis interrupts. "Momma, what goes in a vase?" he asks as he cuts paper and glues it into a workbook. "Pretty flowers. Leaves," Aiden, his oder brother, says. "Momma," Aiden says, "I'm always the last to read and it's never very fun." He puts his head on his folded arms on his desk and sulks. Rachel tells him to wait and listen to his older brother read first.

*Top* Travis plays a toy guitar in the family's living room.

*Bottom* Rachel and her sons untie trailered horses at the start of a workday.

*Opposite* After gathering cattle all day, Rachel and Travis wash down the horses.

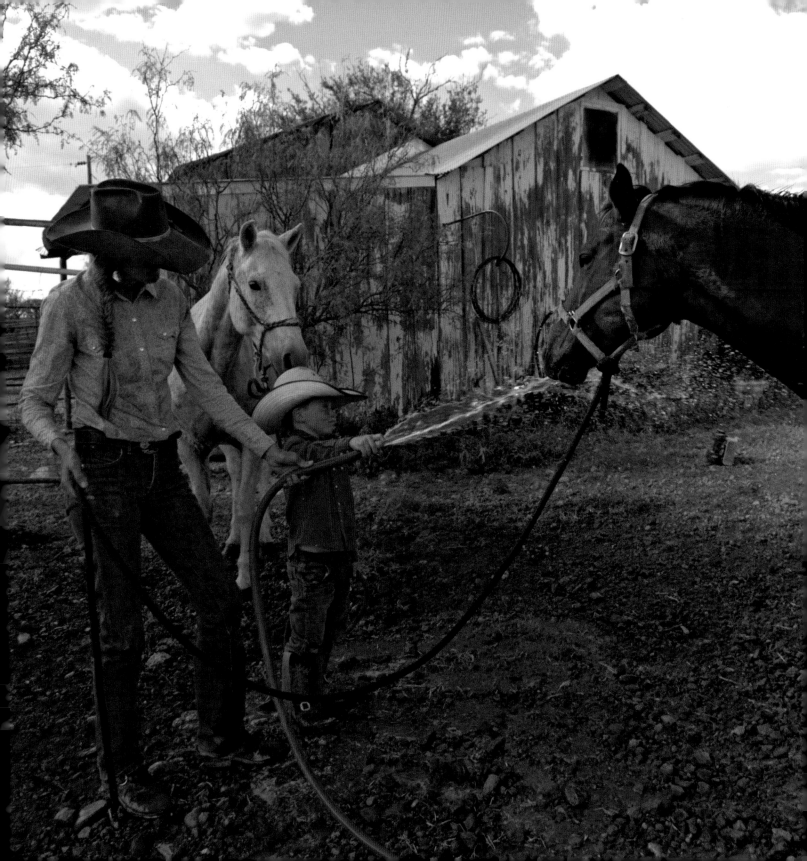

Rachel palpates one of her cows. "We're improving our herd," Rachel says. "We want frame and growth. Our main objective is that they weigh good. We want them to weigh big and have structure to grow. The man we sell our cattle to, he wants them to be healthy and grow. We want big beefy calves, and we want a bigger calf production. Our first-year heifers have a hard time because they're not only raising a baby, they're growing and maturing themselves."

"Ninety percent of our herd are four- to five-year-olds. Most of the Corriente cows we have are about a year old. We sent the cull to San Angelo and sold them to the sale barn. We sold the calves to a man who bought calves from us the last three years. Before, we sold to a man who would pick through them and give us less if he thought the calf's bone structure was weak.

"You can watch a cow as she ages," Rachel says. "The kind of grass cattle eat wears on them. If they eat hard tabosa grass, it wears their teeth down and they can't chew good. Then you cull. You have to be sure to look at what her calf and her body looks like to see if you need to cull her.

"This year, we kept four bulls," Rachel says. "Two breeder bulls and two smaller bulls for the first-time heifers so they don't hurt the first-time heifers when they breed. The calves came out dark brown or black. The bulls are big-framed, big bone structure and muscling.

"We run Corrientes," Rachel says. "Our lease is rough. The cows get out and make a living for themselves. They don't wait around the water trough for you to bring feed. They are smaller and don't eat as much.

"With young heifers, if we feel like she's a good producer, we'll keep her," Rachel says. "But if the heifer doesn't get pregnant, we ship them."

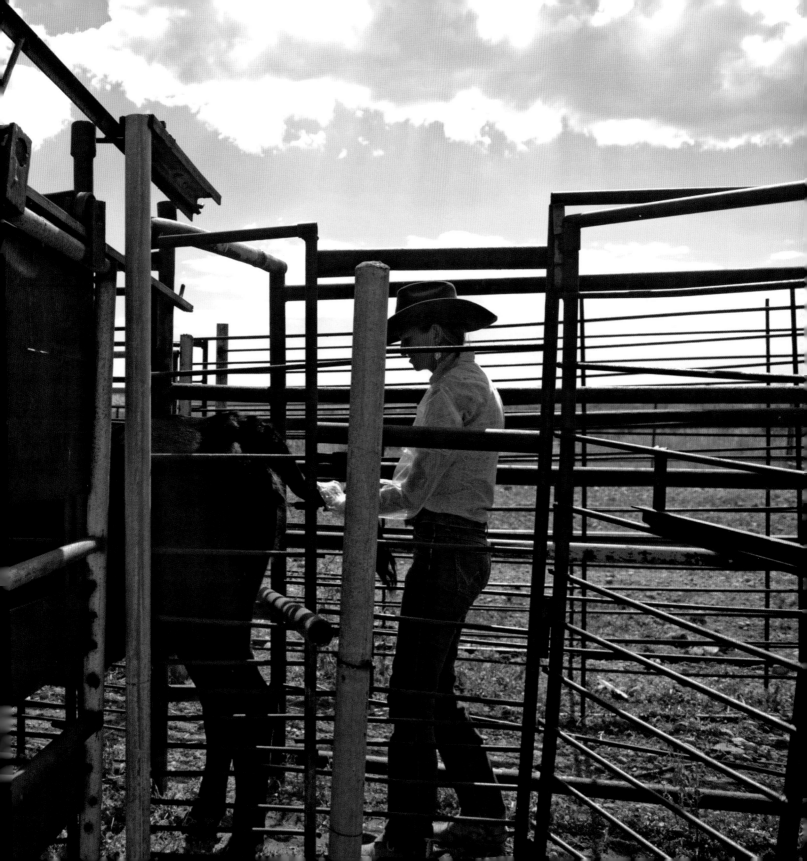

In addition to their cattle, horses and dogs, the family keeps a chicken coop, beehives for honey and a garden.

*Opposite*  Rachel training a horse. "I want to build roots here," Rachel says. "Living off ranching is a complete, solid living. There are two kinds of outfits. First, a lot of people are cattle traders. They buy and sell as long as the market moves. Then there are people who do ranching. You build your herd for three or four years and the only thing you trade are your calves. You hold your cow for five or six years. We're ranchers, not traders. We want to make our herd better and better."

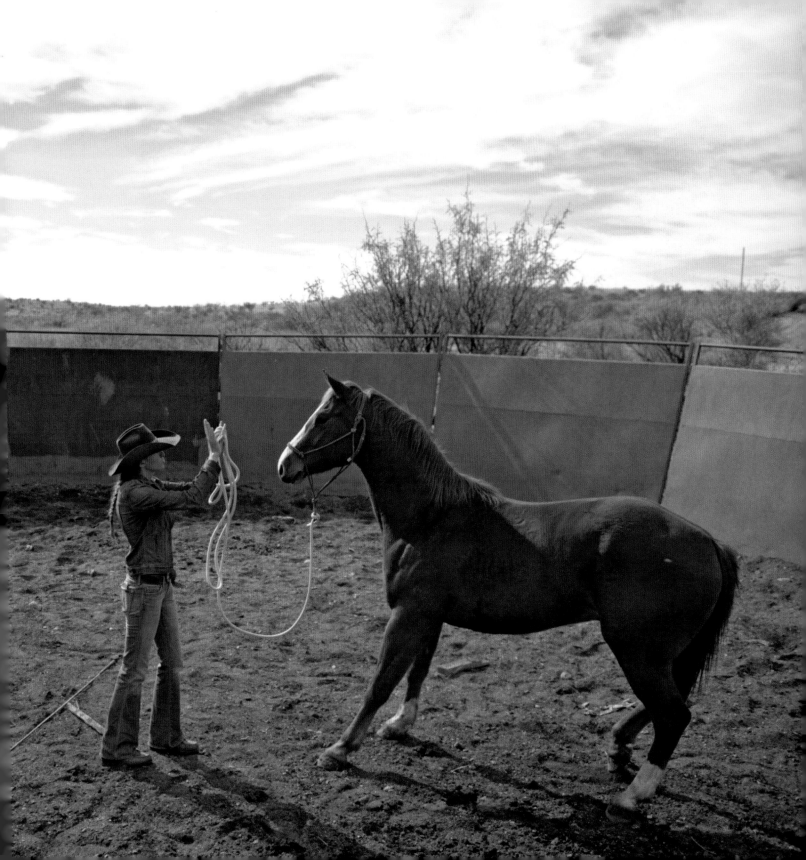

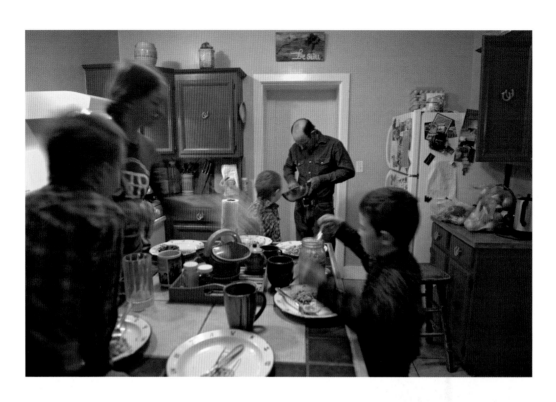

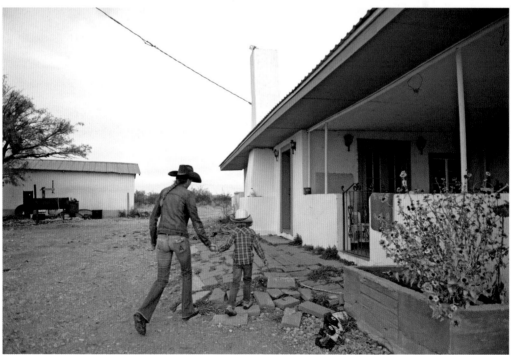

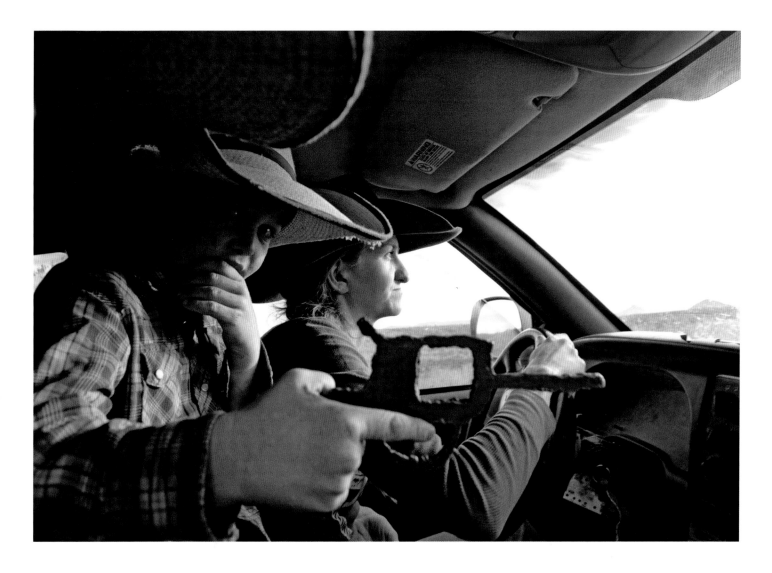

*Opposite, top* The family eats home-cooked, made-from-scratch meals every day, including biscuits, gravy, home-harvested honey and mesquite bean jam.

    Before they eat, everyone around the table says a prayer. Damon starts: "Lord, thank you for the nourishment of our bodies. For this way of life. For Rachel to be able to stay home and teach the boys." The eldest, Thomas, adds: "Thank you, Lord, for taking care of Daddy and Jacob on the 'dozer." Then Rachel says: "Thank you for this way of life, Lord. And for your good night's rest. Thank you for bringing our friend who came out to see us [me]." Jacob says: "And thank you for" and ends his prayer in sweet mumbly baby talk.

*Opposite, bottom* Rachel walks with Travis into the house.

*Above* Travis and a play gun cut out of a piece of scrap metal.

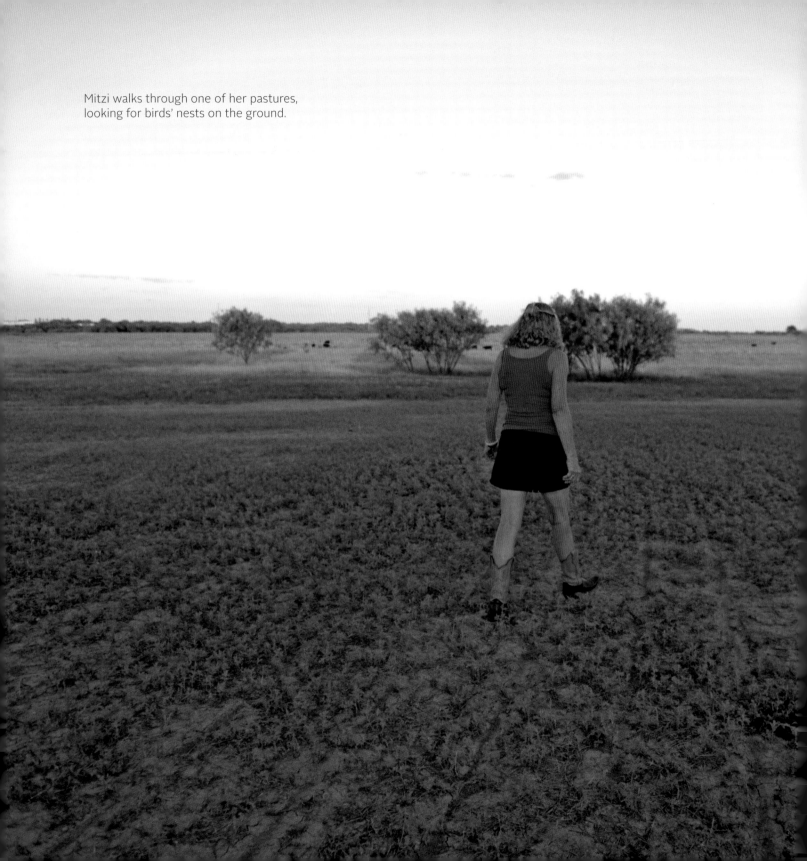

Mitzi walks through one of her pastures,
looking for birds' nests on the ground.

# MITZI KING MAYS

*In Coleman, Born in 1952*

Mitzi King Mays lives at the end of the road, and we pull into her drive at the same time. The only bumper sticker on her SUV reads "Eat Beef. The West Wasn't Won on Salad." We walk together into the house. Still dressed in her office clothes, she fills two glasses with ice and water. I sit at her kitchen bar and she leans against it while she tells me about her part-time work at a financial advisor's branch office in the next town over. It's secretarial-type work, she says, answering phones, addressing envelopes, making deposits and communicating with the main office.

The part-time job is a welcome change in her regular routine, where human company is scarce. "When you just ranch and drive tractors and cut trees and talk to cattle and dogs—I sometimes feel like I need to do a little mental work," she says. "Office work's good for me, lets me work my mind. In ranching, my mind's going all the time, but how much does it take to cut a tree and poison it? See what I mean? Mental work."

She's held other jobs in the past. She paid for school herself and earned an RN degree years ago, back when she lived with her husband and their four kids. Though she's kept up her license, it's been a while since she worked as a nurse. "Last time I practiced nursing," she says, "I worked for home health. Nursing is all about paperwork anymore."

We finish our glasses of icy water. Mitzi's big dog steps two paws on my feet and leans on my knee and thigh. "That's Jigger," Mitzi says. "His father was named Whiskey."

Personal hardships have marked Mitzi's life. Two of her three sons are twins, and one of the twins is in prison on charges that stem from a drug habit. "Thirteen years of crystal meth," Mitzi says. He'll soon transfer to a halfway house in Central Texas. The other twin, she says, "is smart and in sales and about to get married to a girl he met in Dallas." Her daughter is married and also in sales. This year, one of her daughter's children, a special needs baby son, died in a drowning accident. Mitzi's youngest son, King, has both auditory and visual dyslexia and lives in a group home on a ranch with other special needs adults, where he tends to the community's livestock. "When King was a kid and I'd tell him something, he'd repeat it back to me backward," Mitzi says.

Mitzi's early years were spent in Mills County, near Goldthwaite, on a ranch with ten thousand acres. "When I get to heaven," Mitzi says, "I'd like to ask my daddy why he sold that place. But it's okay. He did what was best for our family." She moved with her parents and her brother, Rocky, to this house in eighth grade. Her brother was six years older; he died one month after their father in 2000. "Rocky leased land for cattle out in West Texas," she says, "and was married several times."

She married, put herself through school and had four children. After the kids grew up, she left her husband and came back to the house and this land to live with her mother. She is nearly two decades separated from her husband, who still lives in the original peaked-roof ranch house in the middle of one of her pastures. She would like to take over that house and live there herself, but given her emotionally complicated life, moving him out is low on her priority list. Her mother has dementia and now lives in a nursing home. Mitzi goes by each day with snacks, sometimes fried pickles with buttermilk dressing she's picked up from the drugstore café in town, or soap or anything else her mother might want or need. Once she's there, she says she often hears her mother complain to the nurses that she never visits.

Mitzi folds the napkins on the kitchen bar, rinses our glasses in the sink and opens a drawer. "What am I hunting for?" she asks herself, then closes the drawer and returns to leaning on the kitchen bar. This talk of her life's challenges makes her think of a story that might sum up its ups and downs. "I once found some collie puppies and gave them all away but one female," she says. "I brought her home and the kids were going to name her. She got rattlesnake bit and died. Isn't that the way it goes? You get dumped on a dead-end road, get picked up and saved and the next day, you get rattlesnake bit and die."

The land and all of the pastures Mitzi now owns and runs belonged to her father. "When my dad died, I had to ask myself, 'Do I let the land go?'" she says. She decided to stick it out by herself, to continue running cattle on it as her family always had. King is the only one of her children who wants to live here and steward the land and its animals. "The others have their own lives," she says. "They don't want to come back here."

Raising her kids in the country with no close neighbors, they relied on one another for play, comfort and work. "Country kids talk to each other. They find things to do. You get to know them based on the things they invent. Getting to know my kids was important because Mother never did that with me. She wanted me to be something I was not. It was important for me to get to know them." Achieving that closeness takes a commitment of time, and time wasn't always easy to find. "It was tough. I was working and going to school. I took jobs like mopping a

car dealership on the weekends so I could be home with the kids."

I wait in the kitchen rubbing Jigger's ears while Mitzi changes into shorts, a tank top and cowboy boots. Under her carport, we get into "the mule"—a Kawasaki all-wheel-drive vehicle, like a souped-up golf cart built for rugged terrain. We drive through her backyard and down to the pasture where her pregnant Angus cows and heifers graze.

Mitzi no longer has a registered Angus herd, which requires DNA testing and considerable paperwork. "It's just too hard to keep up," she says. When an animal is cross bred or it's unregistered, it is sold as commercial cattle. Mitzi saw only mixed success with a Wagyu bull she leased for her Angus cows. Though he was left in the pasture through two estrus cycles, or about three months, some of her cows "still didn't breed up," she says. Her solution was an Angus heifer bull she purchased to pasture breed the remaining open cows. All but two eventually bred, and those two she culled from the herd and shipped to slaughter.

She hopes her half-Wagyu calves will sell well. "They should," she says. In the late-summer afternoon orange light, we sit in the vehicle in the middle of the pasture, mostly in silence, just looking at her animals. "We all do this," Mitzi says, "all us cow people."

We spend some time walking around the pasture, looking at the ground for the egg-filled bird nests she saw the week before, then drive to the far fence line where cows have started clustering. "I gather my cattle by calling them," she says. "They are very gentle."

We ride back up to her house in the mule and cook steaks sprinkled with salt and pepper on a grill in her backyard.

In the morning, we eat oatmeal and drink coffee. "I've got to eat first thing; my stomach is empty," Mitzi says. "Oatmeal, cream and butter. The butter's the most important thing." She's been awake since well before first light, sitting on her couch in pajama pants and a T-shirt, reading the Bible and waiting for the day to wake up.

After breakfast, we drive through town to a pasture that Mitzi calls "the Duggins"—referring to the family who once owned the land—where she hitches a brush shredder to the back of her tractor and pulls it through hip-high grass and shoulder-high willowy, young mesquite trees. "Daddy bought this land with me in mind," Mitzi says. "He was always trying to take care of me and knew I loved the land. He bought it from a woman who had inherited it and who had no interest in keeping it. Honestly, he probably bought it thinking 'this is my way to con my daughter into coming here and to bring her and my grandchildren closer.' And it worked."

She's clearing the fence line of brush in order to mend the fence and move cattle here later in the season. Grasshoppers jump through the air amid blue, black and red dragonflies floating around. The cut grass smells bitter and mixes with the fecund smell of the dirt stirred from under the shredder and tractor tires. The shredder makes whizzing and grinding sounds, spitting out what it mills in all directions. Every bit of the air around us is moving. When Mitzi steps off the tractor to move a dried mesquite limb out of the tractor's path, the tall tips of grass brush at her hips and waist; the growth nearly covers the tractor's front wheels.

After clearing a swath, we get back in the truck, open and close gates, drive past cows and from the main road turn off into another one of her pastures. This land belonged to her maternal grandparents, and she calls it "the Stone," referring to their last name. "It's a big giant place with a windmill," Mitzi says. "Pastures have names, and they're always related to what that place represents to the owner." We go deep into her land. She looks at the fence as we drive by, at the condition of the gates we open and close, at the animals we pass, at the ground. We drive to an oak tree–shaded rock pool where she picks a leaf from a bush and hands it to me to suck. "When I was a kid, my daddy told me to put this in my mouth when I was thirsty and it'd make my mouth water," she says, and we stand in the shade with a leaf in our mouths, cooling off in the deep Texas summer. "When

I was a kid, I loved being in the country. I'd saddle my horse and take off, ride to the creek, swim across the water. I loved my horse," she says. "My best friend in the whole world was my second horse, and when I got in trouble as a kid, I wasn't allowed to ride. That was my punishment." A few years ago, a horse threw Mitzi, and that was the last time she's been on one. "I thought—I don't need this," she says.

We stop to fill an old paper coffee cup with the red, prickly, peanut-sized fruit from a pencil cactus. Mitzi picks at the plant with a pair of pliers she keeps in her truck. "You grill these," she says. "They're sweet and tart and go well with a cold glass of white wine." We squint in the bright summer light and fill the cup, careful in our greed to collect that we do not touch the neighboring thorn-covered branches.

Months pass, and in late fall, Mitzi calls. "I'm calving heifers right now," she says. "I lost one—a calf, not a heifer—to a buzzard. They picked its eyes out. It was a white-faced Angus. So now I go around in my mule and if I see a buzzard within twenty yards, I shoot at it. Of course, you can't kill buzzards—and I don't hit them—but I shoot toward them. I think it was migrating flock. A strange killing."

Mitzi's calving season is between September 15 and November 15. She uses the "calving wheel" her father was given as a promotional giveaway at a feed store long ago that she says "tells me exactly when to put the bull on them." The wheel is pinned to her desk in her office, as her father had done for years. She never takes it down. She's been keeping her eye on her three late-calving heifers. "The heifers don't know what they're doing. They're teenage moms," Mitzi says.

I drive down the next day, and when I see her, she hugs me. "You know us country folk—we love our people," Mitzi says.

King is home when I visit. The three of us sit in a truck parked in a pasture. "That heifer's not making a bag," Mitzi says slowly, mostly to herself. She's leaning forward over the steering wheel looking through a pair of binoculars as King and I watch cows eat at a giant hay bale or nudge through dropped hay on the ground. Some calves reach under their mothers' bellies, pushing their heads up against round, taut udders, slapping at them with the tops of their snouts, grabbing hold of and pulling at stiff teats with their lips and tongues while the cows eat and act like they don't notice. Other calves stand in groups off to the side and away from the adults. Some calves run a few steps and kick up their back legs, jumping and playing. The animals are black and stark against the pale gold-colored early winter ground, and in the afternoon light, the whole pasture looks warm and quiet. "Nope. Not bagging up," she says and sits back in the truck seat.

"Bagging up is one of the things you look for," Mitzi says. "You also look at the vulva. It starts turning big, turning out. It's not hard to tell with heifers when they're about to birth. They're usually dripping pretty heavy with mucus before they go into labor. I call the mucus icicles." She looks through the binoculars again at the herd. "I do a lot of this too," Mitzi says, "just sitting and watching, seeing what they're doing. I enjoy it."

The next day, we bounce down the caliche road that runs alongside the pasture in the mule instead of cutting through the pasture to check on the animals again. Jigger knows where and how to ride in the back seat and spends the ride with his body facing into the sun and his mouth open against the wind.

A red-tailed hawk crosses over the road and sets down in a short bare tree. "I think they live over there," Mitzi says and gestures with her chin toward a small oak grove. "It's good they're here." We pass a thickly furred dead fox on the side of the road. "My father would say that a dead fox was a bad omen," Mitzi says. "It means times were going to be lean."

Mitzi parks the mule next to the pens. King and Mitzi gather the calves in a pen by luring their mothers to them with handfuls of "cow cake"—pellets of commercially made feed shaped into two-inch round plugs that cows find tasty. They throw the cake onto the ground and call, "Mommas… wooo-whoo…suck-suck…Mommas…woo-whooo…suck-suck." At the first call, the cows lift their heads; by the third,

they are running toward the pens. Teaching the cows and heifers to come when they're called allows Mitzi to gather the cattle from her truck or on foot. When she needs to give shots or set ear tags—two of the tasks she'll do today—or any other interaction with the herd, she can call them to her. If she's driving, she'll holler out the window and they run behind her truck.

At the pens, the cows and heifers pick up cow cake with their lips, eating noisily. The calves follow their mothers. Mitzi and King distill the group by shooing cows, closing and opening gates, waving arms in the air, chasing behind calves, standing open-legged, pushing and gathering the calves into smaller and smaller pens until it's just the calves, in the smallest pen, with Mitzi and King.

Jigger yelps and barks from where he's tied in the back seat of the mule. "Stop it, Jigger!" Mitzi and King both yell, adding to the noise of cows and calves bleating and bellowing and Jigger's barking. "Chasing calves is his favorite thing," Mitzi says. "I won't let him out. It's like he's chasing a jackrabbit."

Mitzi's phone rings, and she sees the call is from her daughter and lets it go to voicemail. She promises herself that she'll call back when work's done. Soon, her phone rings again, and it's her son. "I can tell he's nervous because he calls so much," Mitzi says, talking over the automated operator who is saying into her ear: "An inmate… correctional facility…do you accept a collect call…"

"He usually calls once a week or so, but he's called three times this week. He's nervous about his move," Mitzi says. Then into her phone: "Yes. Hello, son." She hands the phone to King. He listens to his brother's answers between questions: "What are you doing? How are you feeling? What up, brother? We're working some calves. Tagging them and giving them their first shots. They're very soft. I'm missing you. I got in last night. Wednesday I'm working the sale barn. Just follow God's steps. Don't go that other way. Don't let Satan come to you. I don't want you going the other way. I want Him to make you have nice steps. God's steps, not that other guy's."

Mitzi takes the phone back from King: "Oh. Okay, son. Yes. Okay, then. Love you."

She puts the phone in her back pocket next to an indelible marker and a tool used to set ear tags, gathers the bags of pink and blue plastic tags and walks back into the pen where the small calves are pressed together in the corner.

"Yeah, he's nervous," Mitzi says. "I haven't seen him in a long time. He told me not to come visit him when he was in rehab. He's going to rehab prison, aka a halfway house. I was afraid he'd be sent to Dallas, afraid because his brother and sister are there, i.e. pressure. He needs his own town, his own space, figure it out himself. Needs to make his own way. I've pulled my son out of drug dens. I've told him I was doing it to save his life. I'll do whatever it takes. All the drug kids were afraid of me. I'd walk in there and pull him out. But if it's a problem now, I'll let the legal system handle it. I'm done handling it."

Then King: "He has to do what God wants him to do. He can't do what Satan wants him to do. He can't listen to Satan. I want him back. I just don't want him to do what he did. He'd do meth. It's a block, and they cook it and give themselves a shot. He's going good now where he's at. He reads his Bible when he gets into a bad spot."

Mitzi sets her sunglasses on her head and her corrective glasses against her face and stands still as King tackles a calf to the ground, sets his knee on its body and holds it down. Mitzi puts her own knee on it, and King quickly moves to the animal's back half, pulling straight a back leg and setting his foot against the animal's belly and ribs, slightly stretching it long and immobilizing it. Mitzi puts a blue ear tag with a number and date code on the little bulls and a pink ear tag with a number and date code on the little heifers with the pliers made for the job. She also gives them a single shot containing eight shielding and fortifying prophylaxis, including one that protects against blackleg and another against tetanus.

"This calf's got lots of Wagyu," Mitzi says. "It's itty bitty." Mitzi works around King and the squirming animals. She stands up, bends over, jumps away, sits on the ground and

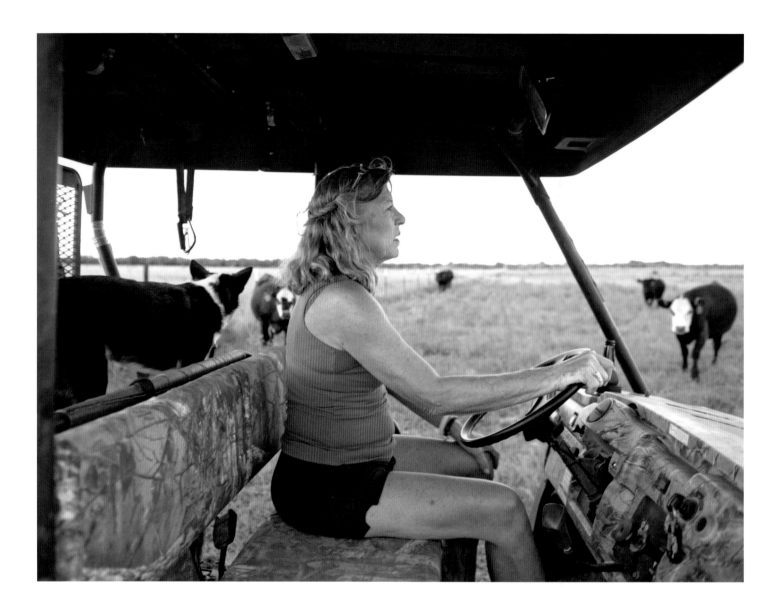

Mitzi checks on her pregnant cows, which won't give birth for another several months.

*Opposite, top*  Mitzi wraps wire around one of the legs of her windmill.

*Opposite, bottom*  A constant job on the ranch is the abatement of brush, shrubs and mesquite to make way for grass. What Mitzi can't tackle with poison or a weed eater, she cuts down with a chain saw.

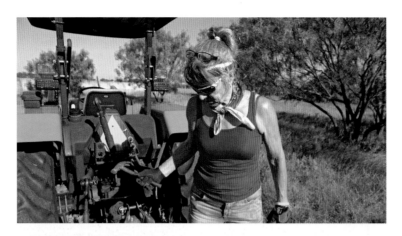

*Opposite, top*  Her tractor is one of Mitzi's most versatile pieces of equipment on the ranch, allowing her to drag a brush hog, clear fence lines and move huge bales of hay.

*Opposite, middle*  Mitzi, with a can of root poison, pulls a splinter from her glove.

*Opposite, bottom*  Her dog, Jigger, rides in the bed of her truck or in the back seat of her four-wheeler.

*Above*  Mitzi was raised in this house and only recently moved back into it. In addition to ranching, she's a trained, non-practicing nurse and has a part-time receptionist job in an office.

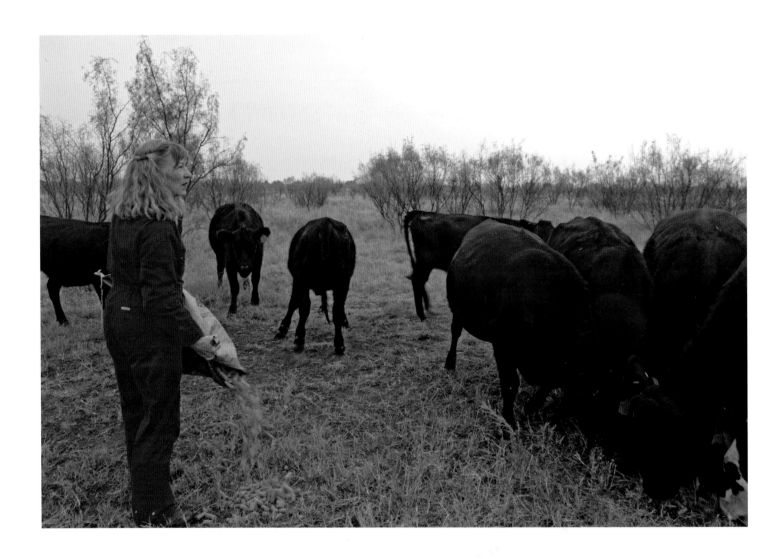

With so little forage in the winter, Mitzi sets out cow cake for her herd, which needs the supplemental feed. In the spring, when so much of the land sprouts, she'll no longer have to give them bagged feed.

*Opposite, top*  A calf flattens himself out to hide in the dry winter grass. The calf is less than twenty-four hours old and was hidden here by his mother while she ate with the older calves and cows. When she returns, he'll drink her milk.

*Opposite, bottom*  Mitzi prepares injections and ear tags for a pen of young calves.

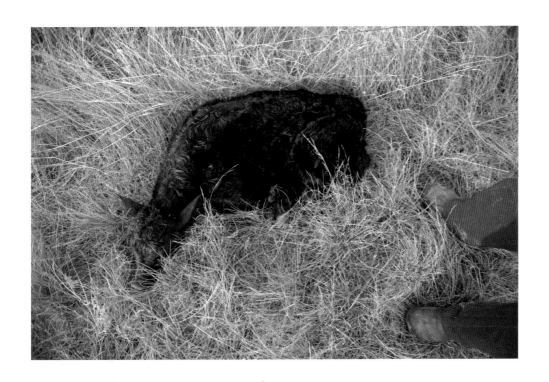

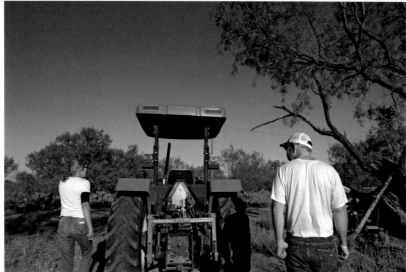

*Top* Mitzi and her son King spray insecticide and dewormer onto the backs of cattle they've herded into a holding pen.

*Bottom* Mitzi and King walk to the tractor.

*Right* Mitzi stands on the back of her pickup truck with her dog, Jigger, looking out over her herd.

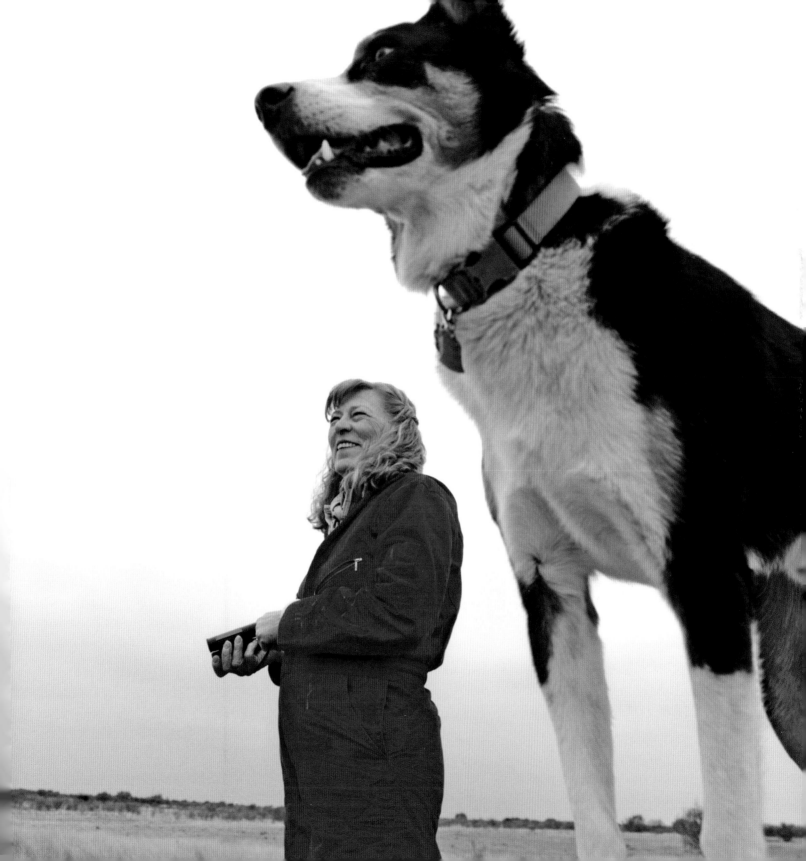

then gets up and sits in a different spot. She kneels next to their heads. She waits until King subdues the animals. A little calf drags him backward on the ground while he holds it around the neck; another runs and kicks and jumps so virulently that King only finally pins it when he falls on top of it and lays it on its side. "You're my magic man, my muscle man," Mitzi says to King.

After they work with the calves, Mitzi and King move the entire herd into a big pen and spray them down with a purple insecticide mixed with water that helps protect them from bothersome flies and parasitic worms.

We break for dinner and head to an old mercantile and drugstore in the middle of town. The store has a café set in the back, tables next to shelves of over-the-counter medicines, scented candles, coffee mugs, T-shirts and the like. We order a basket of homemade fried pickles—they batter and fry them fresh at the end of the soda fountain bar—plus a burger for King and another with mustard and pickles for Mitzi and me to share. We all drink unsweet tea mixed with lemonade and visit with locals the next table over.

A woman: "You back, King? Good to see you."

King: "Good to see you. Yeah. Working calves."

Another woman: "You look good, King. I hear you're working the auction."

King: "Yeah. On Wednesday."

Mitzi: "He's got his schedule full this time."

A man: "The auction? That's good, son."

Mitzi: "He's getting ready. We're going for batteries for his Hot Shot [cattle prod] after eating something."

That evening, Mitzi goes into town to visit her mother, and King drives us to check the heifers. In the last minutes of light, one stands away from the herd, swishing her tail. She turns her head to look toward her back right hip, lifts her right leg and then her left and stretches to touch her snout to her belly, stretches to smell the ground. Mitzi had described this behavior earlier: "A cow that's about to drop a calf will lay down, stand up, separate itself from the others, smell the ground, lots of mucus, lots of bellowing."

After supper, we return with Mitzi to check on her. In the headlights that cut through the pitch dark, we see the cow standing with her minutes-old calf next to her. They face away from us. "They're good," Mitzi says. "Looks like she cleaned out fine." We sit in the dark truck, looking at the animals in the dark.

The next morning, early, Mitzi and I drive into the pasture and see the little black curly-haired calf far out by the fence line, away from the rest of the herd. By the time we reach him, he is flat and as level as he can be with the ground. "He's alive and he looks good," Mitzi says. "That calf says, 'My momma told me to stay here and be quiet and that's what I'm going to do! She's gone to eat and she'll be back.' She keeps him here to be safe." The calf is small and dry, and when I reach down to touch him, he flattens even more into the ground. His long hair is soft in the way dog hair is soft. He is firm with muscle, and he is still. "He's curly," Mitzi says. "Got lots of Wagyu in him."

Mitzi's not sure what she'll do with this first batch of half-Wagyu calves or if she'll ever lease another Wagyu bull to set on her herd again. As long as an animal is one-quarter Wagyu, it's purchased at the Wagyu price, which is higher than the Angus price. The least she'll do is keep the calves for the next eight months, letting them grow and fatten, before selling them for slaughter, as she always does with calves she doesn't keep as bulls or replacement heifers. She may "hold some of the boys back" and breed them to another pasture of cows. She also may sell some of the bulls to other ranches so they can breed up their cows and heifers with part-Wagyu bulls and start growing their own Wagyu herd.

We drive through town to the land where she'd cleared brush from the fence line in the summer, pulling a long, empty hay trailer behind the truck. "Brad's baler's still here," Mitzi says after we go through the gate off the main road. We approach neat rows of enormous round bales of Coastal Bermuda hay, each weighing 1,200 to 1,400 pounds. "It's been three weeks since he cut, and he still's not come to get it," Mitzi says. If it had rained a little more, she would have

gotten one more hay cutting from this pasture, she says. She stops the truck and switches over to a tractor. She carefully maneuvers it until she can squarely spear a bale, and then she carries the impaled bale to the trailer. This she repeats until she has seven bales on the trailer, packed end to end.

She'll feed hay and cow cake to her livestock through the coming winter, when there's not enough forage in the pastures. "I buy the cow cake by the ton," Mitzi says. "Each bag is fifty pounds and costs about $8.50. They let me buy it by the ton at the feed store and pick it up a few bags at a time as I need it. Cow cake recipe is all pretty much the same."

Mitzi has a productive hay field. This year, she used a machine her "daddy had in the shed," called a Pasture Dream, to plant legumes in the middle of the coastal field. "I found it and I kept thinking, I needed a pasture seeder and I kept looking at this piece of machinery," Mitzi says. "I did research online and found the name of it and found out what it was, and then I went to work on getting it fixed." The machine was seized with rust, and Mitzi kept it in her carport for months, spraying it with oil every day. "I finally got it to turn and got it to working," Mitzi says. She plants legumes—radish and clover—in the coastal because doing so puts nitrogen back into the soil and improves the quality and growth of the grass. She'd looked at the machine for years without knowing its use. "It has four rippers and a teeny tiny little seed box for things like radishes and non-bearing clover, then a bigger box for bigger seeds like wheat and barley and peas and fertilizer," Mitzi says. "It drops all the seeds at the same time. So I ran that. These plants all feed this soil. The coastal likes to be ripped, cattle like to eat the radish tops and it allows the coastal to come up in the spring," Mitzi says. "It would be great to have hay in the spring, but it hasn't rained yet. We depend on thunder clouds to come by and wet the seeds."

She and King offload the round bales in the front yard at Mitzi's house, setting them down next to the row that is already there. She hooks up a different machine and trailer used to gather a single bale, which she'll deliver to the pasture with the cows, calves and two heifers. "That's my life," Mitzi says, "hooking and unhooking trailers."

"You need another tractor," King says.

She pulls at the blue Nitrile glove she sometimes wears on her right hand to help abate her itchy and painful eczema. "Yeah," Mitzi says, "I need a lot of things. A couple hundred thousand dollars' worth of things."

A morning soon after is overcast and gray and feels more like winter. Mitzi and King pour bags of feed into long metal troughs for the cows that nudge each other away as they find their place along it to eat. Their calves, still only drinking mothers' milk, play outside the pen tended by a babysitter cow. Mitzi and King look among the swirling black bodies for the calf they know has a dislocated shoulder. "I don't have eyes on him yet," Mitzi says. She stands up in her truck bed and looks out. "There," she says. A black calf with a loose front left leg runs, bucks and snorts with two other black calves as they make their way toward the pen and the rest of the herd. They look like kids in a schoolyard running in from recess, happy and alive and young.

"I can't do anything about it," Mitzi says of the calf's injury. She's dressed in a red coverall and looks at her animals with her hands in her pockets. "Sometimes when they're born, they dislocate it. Now he's like a three-legged calf. I thought it was his leg, and I got all the stuff together to set it," Mitzi says. "I'll sell him in six months. He'll just be a crippled calf."

We drive again, making our way through pastures. "I know it frosted last night because what was green-tipped grass is now brown-tipped grass," Mitzi says. I get in and out of the passenger side to open and close gates as we enter and leave pastures. Along the edge of one field is a length of steel pipe that an oil company contractor left behind when the company stopped operating. It ran miles of natural gas pipe all over her land after Mitzi leased her gas rights. Then one day, the company left. "The man who had it said I can have it now; he's not coming back for it," Mitzi says. The pipe would be a windfall, useful

for rebuilding fences. She's cautious, though, about taking possession of it prematurely. "I'm not going to take it until I have something in writing."

Nearby is a taut, sturdy-looking, six-strand barbed wire fence. "That's my new fence," Mitzi says. It runs to the corner of the far end of the pasture. Its wood and barbed wire predecessor sags and tilts parallel to it. We cross through more land and get to the farthest reach of her property. The fence here is open and broken under a tilting, half-felled mesquite tree. "Goddamn," Mitzi says. "There's one of my heifers on Fern's side." The heifer is well into the neighbor's pasture, eating recently sprouted and tasty Hay Grazer, a kind of hay grown for cows. "The weather has been cool and then warm," Mitzi says, "and something about the hot again makes it grow this Prussic acid. You can't let cattle graze it at all now because there's the high probability of Prussic acid when the grass is short like that. And that'll kill a cow. When it's tall, you can bale it and it's just fine."

King gets out of the truck and pulls at broken wooden fence posts and snarls of downed barbed wire under the tree. "She went through here, Momma," he says. "Right through the fence," Mitzi says. "Sometimes cows jump fences." She backs up three hundred feet and calls out the window: "Mommas…wooo-whoo…suck-suck…Mommas…woo-whoo…suck-suck."

The heifer raises her head and starts walking and then speeds up until she reaches the fence line. She carefully steps over knocked-over posts and the tangle of barbed wire and beelines for Mitzi's truck that is bumping through the pasture.

Mitzi drives back the way she came, and the heifer trots behind us.

# ABOUT THE AUTHOR

**A**lyssa Banta is an award-winning photojournalist and writer. Her work has taken her all over the world, where she has photographed for international publications and aid agencies. She lives in her hometown of Fort Worth, Texas.

*Visit us at*
www.historypress.com